William L. Pressly

JAMES BARRY

The Artist as Hero

The Tate Gallery

cover:
James Barry
'King Lear Weeping over the Body of Cordelia' 1786–7
(detail, Cat.no.47)

back cover:
James Barry
'Satan and his Legions Hurling Defiance Toward
the Vault of Heaven' *c.* 1792–4
(Cat.no.50)

frontispiece:
James Barry
'Self-Portrait, A Sketch' *c.*1780
(detail, Cat.no.93)

ISBN 0 905005 09 0
Published by order of the Trustees 1983
for the exhibition of 9 February – 20 March 1983
Copyright © 1983 The Tate Gallery

Published by the Tate Gallery Publications Department
Millbank, London SW1P 4RG
Designed by Caroline Johnston
Printed by Balding + Mansell Limited, Wisbech, Cambs

JAMES BARRY

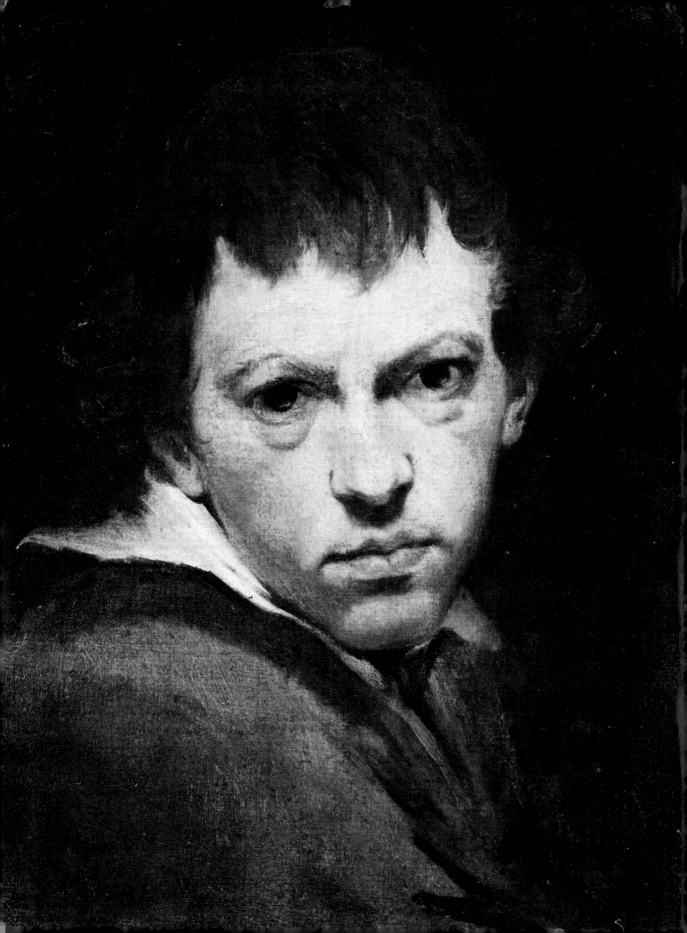

CONTENTS

ACKNOWLEDGEMENTS

Taking George Cumberland's comment on Barry as my guide – 'whatever his defects may be, they are defects arising from very uncommon attempts, and, like the errors of philosophers, are respectable' (*The Morning Chronicle*, 2 May 1781) – I have tried not to edit the artist's works but to show him whole by including all of his significant paintings, drawings and prints. Those private owners and institutions that have loaned works to this exhibition have been unfailingly helpful over the years, and I am extremely grateful for their continuing generosity. Needless to say without their support an inclusive showing of Barry's art would have proved impossible. I am also deeply grateful to the Royal Society of Arts for opening its Great Room in order that the artist's most ambitious paintings can be seen in the interior for which they were created. I would like to thank the Society's Council, David Allan, the Curator-Librarian, and Christopher Lucas, the Secretary, for helping to bring about this opportunity, which appropriately occurs on the occasion of the bicentennial of the paintings' first public exhibition.

This catalogue is intended as a departure from my book on Barry in that it contains a great deal of new observations and information: it is in no way simply a condensed version of the earlier text. I am indebted to a number of people who have helped me to obtain a fresh perspective and uncover new materials, and I would like to thank in particular the following individuals for their contributions: G.E. Bentley, Jr, David Bindman, Alison Carroll, John Grant, Sidney Kilgore, Lord Killanin, Gloria Kury, Christopher Mendez, Jules Prown, and Sidney Sabin. The staffs of the Yale Center for British Art, the Lewis Walpole Library, the Courtauld Institute Photographic Archive, and the Witt Library have also been of great assistance. Finally I would like to express my deep appreciation to my wife and to my parents for their continuing help and support.

It has also been a great pleasure for me to work with the staff at the Tate Gallery, and I am very much in debt to Ruth Rattenbury, who was responsible for coordinating and installing the exhibition. I would particularly like to thank Martin Butlin, Keeper of the British Collection. From the beginning he has enthusiastically supported this project, and I have profited greatly from his advice and experience.

William L. Pressly

FOREWORD

'History painting and sculpture should be the main views of any people desirous of gaining honours by the arts.' So said James Barry (1741–1806), but his attempt to establish the Grand Style in History Painting in eighteenth-century Britain ended in sad failure.

Expelled from the Royal Academy in 1799, sinking into the melancholic state that he captured so remarkably in his own self-portrait paintings and drawings, Barry nevertheless lies buried next to Reynolds in St Paul's Cathedral. Born with few advantages, of humble Irish family, he did not profess the Protestant faith to which the majority of the gentry and merchant classes owed their allegiance, but, the 'really industrious, virtuous and independent Barry' (to quote William Blake) deserves our attention today because of his passionate conviction that art could and should play a social and political role.

Barry's vast painting of 'King Lear weeping over the Dead Body of Cordelia' (1786–7) has for two decades now hung on the walls of the Tate Gallery: those attending lectures at the Royal Society of Arts will know the extraordinary mural decorations, illustrating 'The Progress of Human Culture', that Barry made for the Society's Great Room in 1777–1784.* Otherwise, certain prints apart, Barry's work is not well known – partly because he did so little. This exhibition brings together for the first time all the important paintings, drawings and prints that can be traced.

It has been selected and catalogued by Dr William L. Pressly. Dr Pressly's book, *The Life and Art of James Barry*, published in 1981 by Yale University Press, was the study for which everyone was waiting, and the Tate Gallery is most grateful to Dr Pressly for his dedicated scholarship and friendly co-operation in making the exhibition possible.

We are also indebted to all the lenders, both public and private, some of whom have lent very extensively from their collections. Without their co-operation and generosity this exhibition could never have taken place.

Alan Bowness, *Director*

*During the period of the exhibition at the Tate, the Royal Society of Arts has generously offered to open the Great Room on Monday afternoons from 13.00 to 17.00 hours. Other times can be arranged by appointment.

THE LIFE

James Barry's career has mythic overtones, his life imitating to a remarkable degree those biographical patterns traditionally ascribed to men of genius. While to a certain extent he may have self-consciously attempted to fit these established moulds, his personality did conform closely to stereotypical preconceptions. The eldest of five children, he was born on 11 October 1741 in Cork, Ireland, to John and Juliana Reardon Barry. His father, a coasting trader between Ireland and England, hoped that his son would become a sailor as well, but from an early age Barry showed a fierce determination to become an artist. Responding to an intense inner voice, he defiantly overcame his father's opposition. He was determined to follow in the footsteps of the great artists of the past by pursuing the genre of history painting. Like such revered classical painters as Apelles, Zeuxis, Parrhasius and Timanthes and such Renaissance Old Masters as Michelangelo, Raphael, Annibale Carracci and Poussin, he wished to paint scenes embodying noble virtues told in the language of the heroic figurative tradition. Cork obviously lacked the resources he needed to pursue this exalted goal, although its very isolation as a cultural backwater made his desire burn with that much purer a flame.

In 1763 at the age of twenty-two, Barry set out for Dublin, and upon his arrival he immediately made a mark as a promising young talent when he submitted his picture 'The Baptism of the King of Cashel by St Patrick' to an exhibition held by the Dublin Society for the Encouragement of Arts, Manufactures and Commerce. For this canvas he was awarded a special premium for history painting, and three Irish parliamentarians purchased the work for the House of Commons. In addition, he attracted the support of Edmund Burke, who had just returned to Dublin, where he was to remain until May of the following year. Burke arranged for the young artist to precede him to London in the spring of 1764 to work for James 'Athenian' Stuart, who, along with Nicholas Revett, was preparing material for the on-going volumes of *The Antiquities of Athens*.

Even in Cork Barry had realized the necessity of travelling to Rome with its wealth of ancient and modern art if he was to have the opportunity to achieve his ambition, but, without financing, such a remote destination seemed beyond his reach. In London he continued to chafe at the paucity of resources available to him, but once again Edmund

Burke came to his aid, financing, along with his kinsman William Burke, a lengthy continental tour. Barry departed from London in October 1765. He first spent ten months in Paris, an unusually long stay, and here he preferred the severe, high-minded pictures of Poussin and Le Sueur of the seventeenth century to those contemporary works in what was to him the extravagant and frivolous Rococo style. From the beginning he sent back long letters to the Burkes and his other friends, and this correspondence, the first body of his writings to survive, reveals his considerable abilities as an art critic. Not only do these letters display a decisive intelligence, but one can for the first time perceive the depth of his commitment to the cause of High Art.

By October 1766 Barry had made his way to Rome, the artistic capital of Europe. He was literally dazzled by his sustained contact with those works about which he had read so much. He enthusiastically wrote back to a friend in Ireland how classical art had enflamed his imagination: 'really and indeed I never before experienced any thing like that ardor, and I know not how to call it, that state of mind one gets on studying the antique. – A fairy land it is, in which one is apt to imagine he can gather treasures, which neither Raffael nor Michel Angelo were possessed of.'[1] Because no great masterpieces of ancient painting had survived, the study of classical art revolved around sculpture. To rectify this deficiency he looked to the Venetian painter Titian for mastery in colouring. By the end of his stay in Rome, he was of the opinion that this programme was the most beneficial: 'Seeing and examining have brought me into that state of mind, that if any man was hardy enough to assert that the study of the antiques and Titian alone (exclusive of all other painters) was the surest and most likely method of producing perfection, I would not, I could not contradict him.'[2] It is interesting that Raphael and Michelangelo were not included in this panegyric, but the truth is that his debt to them and his rivalry with them was of such magnitude that he must have found it hard to acknowledge with any enthusiasm their enormous influence.

Barry's devotion to the formal and ethical properties that he found in antique art places him squarely in the group of painters that with hindsight has been labelled Neoclassical. His goal was the reformation of modern culture through the revival of the principles of classical art, but underlying his reverence for the antique past were his deep feelings of insecurity about the present. Unlike their classical counterparts, the works of the great Renaissance painters were very much in evidence, and he felt daunted by their all too visible excellence. By maintaining that the lost great works of antiquity had been superior to these modern

masterpieces, there was no reason why he could not surpass these works in the present. Thus, his dedication to the rediscovery of the principles of classical art was one way of finding the courage to compete with the Renaissance Old Masters.

In Rome, Barry lived near the English coffeehouse in the Piazza di Spagna, which formed the centre of the British artistic community. During the day he studied the finest examples of classical sculpture and Renaissance painting, while in the evenings he, like many of his colleagues, took advantage of the opportunities to sketch from the nude figures in the Accademia del Nudo and the French Academy. His contacts were international: he was particularly friendly with the Scottish painters John and Alexander Runciman, the English sculptors James Paine, Jr and Joseph Nollekens, the French painters Louis Gabriel Blanchet and Dominique Lefèvre, and the Savoyard painter John Francis Rigaud, and would seem to have known the Swedish sculptor Johan Tobias Sergel.

It was extremely difficult for foreign painters to secure patronage in Rome. They could not look to the native inhabitants for commissions, and the British artists had to compete for the attention of their wealthy countrymen making the Grand Tour. In addition, they were all artists of similar ambition, and Barry felt acutely the ensuing tensions, disclosing to an old friend, 'We are in number about thirty students, English,

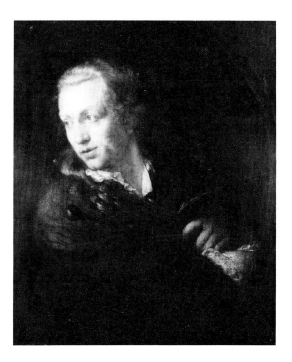

Louis Gabriel Blanchet
'Portrait of James Barry' *c.*1767
The Royal Society of Arts, London

Scotch, and Irish; and as there is in our art every thing to set the passions of men afloat, all desiring consequence and superiority; it is no wonder if distrust, concealed hatred, and ungenerous attempts, are perhaps oftener experienced, than friendship, dignity of mind, or open square conduct.'[3] Barry, however, held an advantage over many of his colleagues. Through the Burkes and their associates, he had the connections to help launch him into the proper social circles, but he was temperamentally unsuited to take advantage of such opportunities. Within a short period of time, he had quarrelled with all the influential guides and dealers whose help he needed in receiving commissions from the English nobility making the Grand Tour. He complained to the Burkes, 'My enemies . . . so contrived it as to make my profession of no profit to me in Rome.'[4] He even feared that his crusading role against the avaricious dealers and those artists who servilely curried their favour made it likely that he would be assassinated. Throughout his career, his exaggerated sense of self-importance was to envenom his relationships with his peers. Early on Burke foresaw the destructive patterns into which his protégé so easily slipped, admonishing him when he was still in Rome,

> Depend upon it, that you will find the same competitions, the same jealousies, the same arts and cabals, the emulations of interest and of fame, and the same agitations and passions here, that you have experienced in Italy; and if they have the same effect on your temper, they will have just the same effects on your interest; and be your merit what it will, you will never be employed to paint a picture. It will be the same at London as at Rome; and the same in Paris as in London: for the world is pretty nearly alike in all its parts: nay, though it would perhaps be a little inconvenient to me, I had a thousand times rather you should fix your residence in Rome than here, as I should not then have the mortification of seeing with my own eyes, a genius of the first rank, lost to the world, himself, and his friends, as I certainly must, if you do not assume a manner of acting and thinking here, totally different from what your letters from Rome have described to me.[5]

Before his departure from Rome on 22 April 1770 Barry had completed one major history painting, his 'Temptation of Adam' (no.1), which he sent back to London for exhibition. He then travelled for the next nine months through northern Italy in order to round out his studies. His longest stay was in Bologna, where he was granted a diploma by the Accademia Clementina, and for the academy he painted his picture 'Philoctetes on the Island of Lemnos' (no.2).

Arriving back in London early in 1771, he embarked on the most productive period of his career; after five and a half years of training on

Nathaniel Dance, attributed to,
caricature of Barry in Rome
British Museum

the Continent and almost thirty years of age, he was eager to begin. A
fellow artist, Ozias Humphry, scribbled in his notebook late in 1772,
'B[arry's] application is without End he never wastes one Minute: all his
time is turn'd to some acct. and his only object seems to be, to raise an
Eternal Character for art.'⁶ From 1771, beginning with 'The Temptation
of Adam', through 1776, he exhibited a total of fifteen works at the Royal
Academy: ten history paintings, one drawing of a historical subject,
three portraits and one historical portrait. By 2 November 1772 he had
been made an associate member of the Royal Academy, and by 9
February of the following year he was elected a full academician. He was
also one of the originators of an abortive attempt to decorate St Paul's
Cathedral with scenes drawn from the Bible, and in 1775, with the
publication of his first book *An Inquiry into the Real and Imaginary
Obstructions to the Acquisition of the Arts in England*, he again valiantly
tried to promote history painting in Great Britain.

In 1776 Barry turned to printmaking, and proceeds from the sale of his
prints helped support him while he was at work on the most ambitious
project of his career, a series of six pictures for the Great Room of the
[Royal] Society of Arts. In 1774 the Society had approached a number of

artists, Barry among them, to decorate jointly the meeting room in its new building in the Adelphi constructed by Robert and James Adam. The artists declined the invitation, but in 1777 Barry approached the Society on his own, volunteering to assume the task single-handedly. The Society accepted his offer, agreeing to pay for the canvas, colours and models, and later pledged to pay him the profits deriving from two exhibitions of his work once it was completed. Barry is said to have undertaken this ambitious scheme with only sixteen shillings in his pocket, and, during the seven years he took to complete it, he was forced to live an existence of extreme austerity, willingly enduring hardships in order to seize such a promising opportunity. The work was well enough advanced by 1783 that the first exhibition opened on 28 April, and the second exhibition was held in the following year. In all he was to receive just slightly over £500, this at a time when Reynolds charged 200 guineas for a single full-length portrait. The paintings won wide critical acclaim, but, profoundly discouraged by his continuing lack of adequate financial support, Barry was never again to work with the same intensity that he had in the years following his return from Rome.

James Northcote
'James Barry in Church'
National Gallery of Ireland, Dublin

In Rome, Barry had proven himself a discriminating and articulate observer of the various schools of art, and, when the post of professor of painting to the Royal Academy became available, he announced his candidacy. Elected on 4 March 1782, his primary duty was to deliver annually six lectures which would offer to the students a critical survey of past art and would explain principles of design, composition, chiaroscuro and colouring. For some time he had been quarrelling bitterly with Sir Joshua Reynolds, and in his lectures he abused his colleague, even though Reynolds as president of the Academy was often in attendance. Later in 1790, Reynolds ran afoul of the Academy when he unsuccessfully supported Joseph Bonomi's election as an academician, and he even resigned his office for a short period of time after this insulting rebuff. During this affair, however, Barry became one of Reynolds' staunchest supporters, and, because he now defended the president as heatedly as he had formerly denounced him, he was chosen to deliver the Academy's eulogy after the president's death in 1792.

Barry's relationships with his colleagues at the Royal Academy continued to deteriorate after he had defied many of its most influential members by supporting Reynolds. In 1794 his house was robbed of

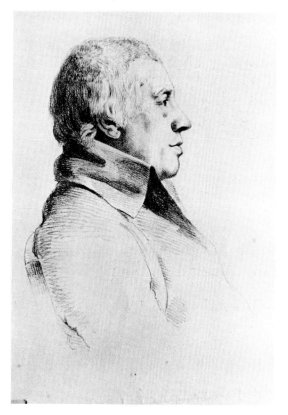

George Dance, 'Portrait of
James Barry' 1793
Royal Academy of Arts, London

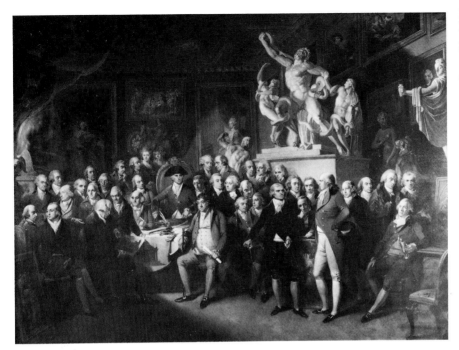

Henry Singleton, 'The Royal Academicians Assembled in their Council Chamber . . . in 1793' *Royal Academy of Arts, London*

almost £300, and he made the extraordinary charge that the burglary had been instigated by some of his fellow academicians who wished to frustrate his career. In his book *A Letter to the Dilettanti Society*, published in 1798, he made public many of his criticisms of the Academy's policies, and in his lectures delivered to the students early in 1799 he indulged in even more inflammatory accusations. Working largely behind the scenes, men such as Joseph Farington and the president Benjamin West, who had succeeded Reynolds, engineered to have Barry removed from his office. In fact this cabal was so successful that on 15 April 1799 Barry became the first and only artist ever expelled from the Royal Academy.

At the same moment that Barry's involvement with one artistic establishment was coming to a disastrous end, he was to cement his relationship with another. In the summer of 1798, he retouched parts of his painting 'Elysium and Tartarus' in the Society of Arts, and on 16 January 1799 the Society honoured him by voting him a gold medal and an award of 200 guineas. In addition, it made him a perpetual member not subject to contributions. In the summer of 1801, he again made what were for the most part minor additions, retouching all three of the last paintings in the series, and he also petitioned unsuccessfully to replace two portraits by Gainsborough and Reynolds that hung in the Great Room with subjects of his own choosing.

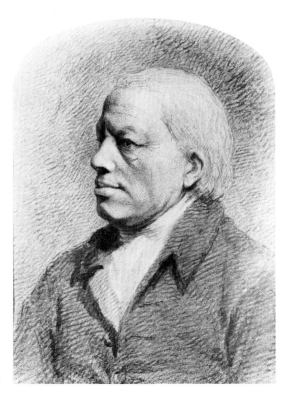

William Evans, portrait of
Barry from a life mask,
National Portrait Gallery, London

From 1783, when he had for the most part completed his murals at the
Society of Arts, until his death twenty-three years later Barry was to
finish only four major history paintings: 'King Lear Weeping over the
Body of Cordelia' (no.47) and 'Iachimo Emerging from the Chest in
Imogen's Chamber' (no.48) for Boydell's Shakespeare Gallery, and
'Jupiter and Juno' (no.86) and 'The Birth of Pandora' (no.85), pictures
that were never sold in his lifetime. Around 1792, he also embarked on an
ambitious scheme, undoubtedly inspired by Henry Fuseli's example, to
illustrate John Milton's epic *Paradise Lost*, but he was never able to bring
it even close to completion. He remained active as a printmaker, but here
too he never matched the energy of his initial burst of enthusiasm, which,
beginning in 1776, had lasted for only three years. His writings were to
take up an increasing amount of his time, diverting his energies away
from painting and embroiling him in emotionally draining disputes.
More and more, he chose to return to the series at the Society of Arts,
incessantly tinkering with this his most ambitious work, either retouch-
ing the paintings themselves or introducing changes through prints that
amended selected details. Yet, although he increasingly turned inward,
unable and unwilling to produce at his earlier pace, the quality of his
work only improved. Paintings such as the late version of 'Jupiter and

Juno' and the self-portrait as Timanthes (no.94) and prints and drawings such as 'Satan, Sin and Death' (no.51) and 'Passive Obedience' (no.92) are among his finest and most innovative creations.

One thread that runs through Barry's career is his belief that, because art's mission was to instruct, the artist should involve himself in the advocacy of social reforms. His own political allegiances are manifest in his choice of friends as well as in his subject matter. Early in his career he gravitated to such political radicals as Richard Price and Joseph Priestley, and later on he was an intimate of such reformist thinkers as William Godwin and his wife Mary Wollstonecraft. In the very last years of his life, one of his closest friends was the Venezuelan revolutionist General Francisco Miranda, who was then living in London after having fought for the French Republic. Barry's identity as an Irish Roman Catholic provided the driving force behind his productions; his devotion to the principles of equality, justice, and religious toleration gave meaning and energy to his entire career.

From 1788 until his death Barry lived at 36 Castle Street East. Here, feeling beleaguered by his enemies, he sunk into an increasingly paralyzing despondency. Writing in 1829, the poet Robert Southey described his depressed condition about the year 1802:

> I knew Barry, and have been admitted into his den in his worst (that is to say, his maddest) days, when he was employed upon his Pandora. He wore at that time an old coat of green baize, but from which time had taken all the green that incrustations of paint and dirt had not covered. His wig was one which you might suppose he had borrowed from a scarecrow; all round it there projected a fringe of his own grey hair. He lived alone, in a house which was never cleaned; and he slept on a bedstead with no other furniture than a blanket nailed on the one side. I wanted him to visit me. 'No,' he said, 'he would not go out by day, because he could not spare time from his great picture; and if he went out in the evening the Academicians would waylay him and murder him.'[7]

Southey continued that Barry's recovery from a severe illness, which apparently occurred in January 1803, helped to cure him of his worst hallucinations. However, the artist remained plagued from within by a deep melancholia and from without by the malicious pranks of neighbourhood urchins who singled out his deteriorating house for special abuse.

In 1804 when he was still a young boy, the prominent lawyer William Henry Curran lived in the same neighbourhood as the artist. He had been told that Barry's delapidated house, the target of frequent attacks, was occupied by an old wizard, or necromancer, or Jew. Then when

accompanying two Irish gentlemen on a visit to see Barry, he found himself to his amazement standing in front of this somewhat terrifying, derelict structure:

> The area was bestrewn with skeletons of cats and dogs, marrow-bones, waste-paper, fragments of boys' hoops, and other playthings, and with the many kinds of missiles, which the pious brats of the neighbourhood had hurled against the unhallowed premises. A dead cat lay upon the projecting stone of the parlour window, immediately under a sort of appeal to the public, or a proclamation setting forth, that a dark conspiracy existed for the wicked purpose of molesting the writer, and injuring his reputation, and concluding with an offer of some pounds as a reward to any one, who should give such information as might lead to the detection and conviction of the offenders. This was in Barry's hand-writing, and occupied the place of one pane of glass. The rest of the framework was covered with what I had once imagined to be necromantic devices – some of his own etchings, but turned upside down, of his great paintings at the Adelphi.[8]

Barry continued to work sporadically in this squalid setting. Then in 1805 came the opportunity to break away from these depressing surroundings. Thanks to the efforts of David Steuart Erskine, eleventh

Barry's house in Castle Street, 1806
(illustration in the *European Magazine*)

Earl of Buchan, and a committee from the Society of Arts, an annuity of £120 was raised, a sum that would guarantee him a new beginning in more suitable quarters. The artist, however, died on 22 February 1806 before receiving even the first payment. The day before his funeral, he lay in state in the centre of the Great Room at the Society of Arts. Then after an elaborate procession, he was interred in the crypt of St Paul's Cathedral beside Sir Joshua Reynolds. Three years later appeared another major tribute on the publication of *The Works of James Barry* (no.106). Although not fully comprehending his achievement, it is clear that his contemporaries recognized his importance as an artist and wished to commemorate both the work and the man.

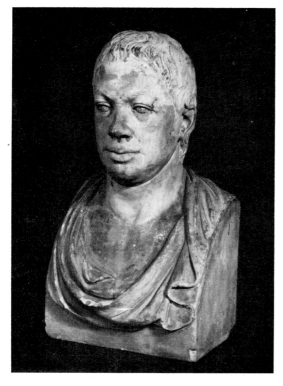

Bust of James Barry,
coade stone, 1819
St Paul's Cathedral, London

1 Barry to Dr Sleigh, November 1767, *The Works of James Barry*, London, 1809, I, p.139.
2 Barry to the Burkes, 8 September 1770, *Works*, I, p.208.
3 Barry to Dr William O'Brien, 26 February 1768, *Works*, I, p.148.
4 Barry to the Burkes, 8 April 1769, *Works*, I, p.160.
5 Edmund Burke to Barry, 16 September 1769, *Works*, I, p.155.
6 'Notebooks of Ozias Humphry', British Library, London, p.4.
7 Robert Southey to Allan Cunningham, 23 July 1829, *The Life & Correspondence of the Late Robert Southey*, ed. by the Rev. Charles Cuthbert Southey, London, 1850, VI, p.54.
8 William Henry Curran, *Sketches of the Irish Bar*, London, 1855, II, pp.171–2.

THE ARTIST AS HERO

Early in his career James Barry wrote that 'History painting and sculpture should be the main views of every people desirous of gaining honour by the arts. These are tests by which the national character will be tried in after ages, and by which it has been, and is now, tried by the natives of other countries.'[1] In the eighteenth century there was no higher calling for an artist than to attempt history painting. As traditionally defined, its subject matter was drawn from a standard repertoire of literary sources composed of the Bible, classical history and mythology, and epic poetry. Its purpose was to elevate and instruct by showing man at his most heroic. Not only was it the measure of a nation's worth, but it also played a decisive role in determining its character. Like his contemporaries William Blake and Jacques Louis David, Barry was thoroughly committed to the artist's role as prophet and teacher. He saw the artist as society's most important figure, more important than the poet, writer, musician, theologian or statesman. His extreme commitment to painting was obviously self-aggrandizing, but, fuelled by this fierce intensity, he created some of the most powerful and arresting paintings of his generation.

There was one historical subject on which Barry worked throughout his entire career. In Rome he conceived the idea of executing a large, ambitious painting of the birth of Pandora with all the important gods and goddesses in attendance, and in 1775 he exhibited one of his

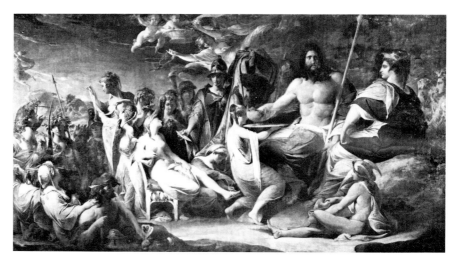

Cat.no.85

preparatory drawings at the Royal Academy in an unsuccessful bid at securing a patron. Sixteen years later he had finally embarked on the canvas (no.85, see also colour plate) which he did not complete until less than two years before he died. He was the first modern artist to treat this subject on so grand a scale, and one reason that it held such a strong appeal for him was that it offered a sublime vehicle for his views on the role of art and artists, an interpretation that may not on first view be readily apparent. In this regard of special interest is the role he assigned to Minerva. The classical Greek sculptor Phidias had already closely associated Pandora and this goddess when he adorned the pedestal of his statue of Minerva or Athena in the Parthenon with a relief illustrating Pandora's birth. In his painting Barry places Minerva in the centre of the composition, her gift being the most important (no.85 detail). She holds in her right hand the shuttle of a loom, and in her left she holds aloft a

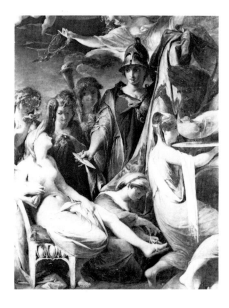

Cat.no.85 (detail)

tapestry. In his various accounts of his painting, Barry emphasized that for the Greeks Minerva personified wisdom and presided over weaving or the art of painting. He made clear that here she is instructing Pandora in her matrimonial duties, but, more than this, she is instructing her in the art of painting, from which, at least according to the artist, all virtue naturally flows. The subject of the tapestry is 'the story of Jove fulminating the Titans, or the punishment of that pride and arrogance which was likely soon to become apparent in the descendants of poor Pandora.'[2] Thus, as demonstrated by the tapestry, the function of

Cat.no.85 (detail)

painting is to reveal virtue and punish vice. It is the most precious of gifts, the one that will lead Pandora and her descendants from error.

The prototypical artist is also present in this picture in the character of Vulcan (no.85 detail), who is the supreme artificer, Pandora herself being his greatest creation. Surrounded by images of the evolution of life from lower to higher forms, Vulcan as artist is positioned at the very heart of life's mysteries. His powers can challenge those of Jupiter himself.

For Barry, the artist-creator is the ultimate dispenser of wisdom, being that mortal who is most godlike in his abilities. His mission is to reveal high-minded moral truths that will instruct and enlighten his audience. In his own art, even such a charming mythological scene as 'Venus Rising from the Sea' (no.3) is not meant as a diverting classical fiction but as an ennobling essay on beauty and love. Not surprisingly, many of his works, which appear to promote only abstract virtues, also contain more pointed messages as to the conduct and reform of contemporary affairs. As an Irish Roman Catholic, he felt acutely his country's political and religious oppression, and in his art he continually championed the cause of civil and religious liberty. It was in his prints, the most didactic of media, that he offered his first explicit social commentary. In 'The Phoenix or the Resurrection of Freedom' (no.21), published in December 1776, he provided lengthy captions bemoaning the repressive English government which had caused Liberty to expire in the British Isles only to be reborn in republican America. In the following two years he published 'Job Reproved by his Friends' (no.24) and 'The Conversion of Polemon' (no.26), works which at first sight appear to have little or nothing to do with modern life but which are in fact populated with contemporary figures such as Edmund Burke, William Pitt the Elder, and Charles James Fox. The prints are excellent examples of Barry's use of multiple levels of reality which turn

obstensibly straightforward historical subjects into personal parables that the viewer must struggle to comprehend.

At the same time as Barry was executing these aquatints and etchings, he had also embarked on the ambitious series of six history paintings for the Society of Arts, a series which composes the greatest historical cycle created by an eighteenth-century British artist. His programme is a complicated one, requiring him to accompany the paintings with a lengthy description (see no.99). His series illustrates how both societies and individuals have achieved greatness in the past and how contemporary England can best realize a more glorious future. The first three paintings trace the progress of civilization in ancient Greece, beginning with Orpheus leading a primitive people out of barbarism into a more civilized condition (no.28A). The second painting, 'A Grecian Harvest-Home' (no.28B), depicts a peaceful, agrarian society celebrating

Cat.no.28A

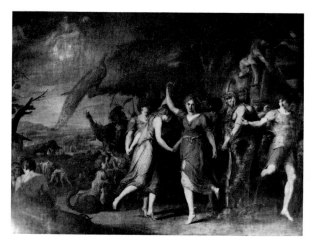

Cat.no.28B

Cat.no.28c

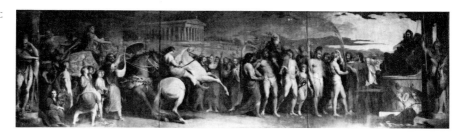

its abundant harvest, and the third (no.28c) encapsulates Greek society at its competitive best. The setting is an idealized Olympic Game in fifth-century Greece, in which the finest minds and most famous athletes are in attendance. The fourth and fifth paintings (nos 28d and 28e) focus on contemporary England, while the last one in the series, 'Elysium and Tartarus or the State of Final Retribution' (no.28f), brings together in Elysium 'those great and good men of all ages and nations, who were cultivators and benefactors of mankind'.[3] In Barry's conception Christians and classical pagans mix freely. Of course such a mixture is common in the humanistic tradition where the classical world is seen to complement that of the Bible. Sibyls and prophets sit comfortably together in Michelangelo's Sistine Ceiling, while 'The School of Athens' is a fitting companion to 'The Disputa' in Raphael's Stanza della Segnatura. What is unusual in Barry's work, however, is the extent to which the classical world supplants that of the Bible. He did not introduce into the painting Moses or the prophets or any New Testament characters as identifiable figures, envisioning them instead as inhabiting the indistinct, remoter regions closer to the Divinity. The classical world no longer merely complements that of the Bible but becomes a means of representing it, just as the nomenclature of Elysium and Tartarus becomes a way of expressing the Christian concepts of heaven and hell. Looking back at the first three paintings in the series outlining the progress of Greek civilization, it becomes evident that here too the classical world supports a Christian message. Like the prints 'Job' and 'Polemon', these paintings contain a concealed commentary that is essential to understanding their full meaning.

In the first painting, Orpheus' pose is based on traditional renderings of St John the Baptist, the forerunner of Christ, and on closer inspection it becomes apparent that Christ himself appears in 'A Grecian Harvest-Home'. The detail showing the mother with a child on her lap playing with a bird on a string and with an older child beside them (no.28b detail) is based on the religious prototype of Mary with the infant Christ and St John the Baptist, the bird on a string signifying the journey of the soul

through the Passion, Death and Resurrection.[4] To make his allusion to the infant Christ even clearer, Barry added an ox and ass (the ass is further in the distance), a rustic who stands behind the ox who could double for St Joseph, and a crude shed surmounted by a peacock symbolizing immortality, imagery that is traditionally associated with scenes of the Nativity, as can be seen for example in Fra Angelico's and Fra Filippo Lippi's 'The Adoration of the Magi' (fig.1). In 'Crowning the Victors at Olympia' the allusion is to the Roman Catholic Church, a reference that is in this instance confirmed more by textual than visual clues. For his literary source Barry turned to Gilbert West's dissertation on the Olympic Games published in 1749. In his account West associated the Olympics with Roman Catholicism by pointing out the similarities between the powers of the popes and those of the Olympic judges and between such practices as the crown of martyrs, the palm, and Extreme Unction and Olympic rituals. That Barry embraced such comparisons is proved by his analogy made in his writings between the sacred territory of the Eleans and the papal states[5] and by his dedication of his etching showing the principal group of Olympic victors to the papal government (fig.17).

As in his prints, Barry's series at the Society of Arts conceals as much as it reveals, in this case offering a hidden Christian progress which begins with St John the Baptist, the forerunner of Christ, moves on to

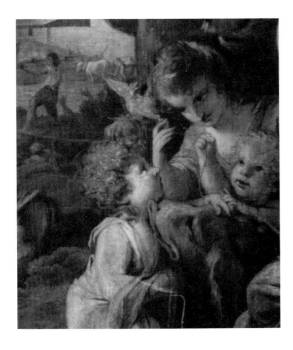

Cat.no.28B (detail)

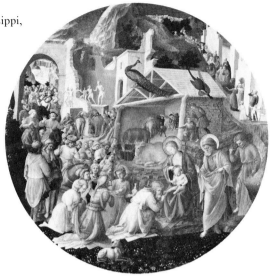

fig.1 Fra Angelico and Fra Filippo Lippi,
'The Adoration of the Magi' *c*.1445

Christ himself, and then culminates in the institution of the papacy. One reason, of course, was to avoid censorship. Had the Society guessed the artist's intentions it seems unlikely that it would have permitted the display of paintings with such an unacceptable meaning, and Barry must have enjoyed covertly extolling the Roman Catholic Church in the chambers of a prestigious English institution whose membership was overwhelmingly Protestant. One too should keep in mind his persecution mania. The Gordon Riots, which were directed against Roman Catholics, had taken place in 1780 while Barry was at work on this series, and these riots would have reinforced his belief that it was dangerous as well as inadvisable to celebrate the papacy.

There is, however, another more important reason why the artist chose to disguise his intent. History painting was meant to instruct its audience, but this goal was best achieved not by providing simplistic painted homilies but by challenging the viewer to penetrate the narrative to discover deeper levels of meaning. The act of interpretation was itself a part of a painting's content. In offering a profounder truth accessible only to a small elect, Barry was supported by a long tradition of esoteric interpretation. In his own day, no one embodied this tradition better than William Blake. In 1799 when the Rev Dr John Trusler sent back to Blake, with numerous criticisms, a watercolour, the first of a pair that he had commissioned, Blake replied to his disgruntled patron,

> I feel very sorry that your Ideas & Mine on Moral Painting differ so much as to have made you angry with my method of Study. If I am

wrong, I am wrong in good company. . . . But you ought to know that What is Grand is necessarily obscure to Weak men. That which can be made Explicit to the Idiot is not worth my care. The wisest of the Ancients consider'd what is not too Explicit as the fittest for Instruction, because it rouzes the faculties to act. I name Moses, Solomon, Esop, Homer, Plato.[6]

Blake could have as easily included in his list no less an authority than Christ. When the Disciples asked Jesus why his meaning was not readily apparent, he replied, 'Therefore speak I to them in parables: because they seeing see not; and hearing they hear not, neither do they understand' (*St Matthew* 13:13). As sanctioned by this ancient, hermeneutical tradition, Barry's meaning is deliberately obscure in order that its mysterious, secret sense might be reserved for the privileged few and kept out of the hands of the profane outsiders.

In order to undertake the extensive cycle of history paintings at the Society of Arts, Barry made considerable financial sacrifices. Fully dedicated to his heroic role as a history painter, he willingly based his conduct on his perception of greatness. He adopted an ascetic way of life in the pursuit of his ambitious goals, renouncing financial success and embracing poverty as the lot of genius. Although he constantly complained about the lack of patronage for history painting in England, he could not tolerate any interference in his work, and, because of his deep psychological need to retain full control over his creations, he was hardly a receptive candidate for conventional forms of patronage. In addition, he was extremely secretive about his work in progress. Feeling intense rivalry toward other painters, he was unwilling to risk having anyone steal his conceptions. Such a temperament is not unusual for an artist, and Barry may even have to a certain extent modelled himself after Vasari's description of Michelangelo as an intense, suspicious misanthrope. Yet, while Barry could not help but conform to his conception of how a great artist should behave, he was not assuming an artificial pose. From the beginning his personality fitted very closely the conventional portrait of the anatomy of genius.

Despite his belief in his own abilities and his willingness to endure hardships, Barry could not help but be affected by a chronic lack of support. His paintings often met with critical acclaim, but there was little real enthusiasm or even understanding for what he was trying to accomplish. Feeling a profound sense of discouragement in the face of this public indifference, he increasingly withdrew from society.

The theme of the persecuted genius is presumably as old as the concept of genius itself, and Barry wholeheartedly endorsed the

conception of the artist as suffering hero. From the beginning of his career, he had perceived conspiracies ranged against him, and as early as 1767 in Rome he had expressed fears over possible assassination attempts. For him, greatness not only meant that the artist would be misunderstood and alienated, but also that he would be persecuted by his jealous inferiors. Superiority invited martyrdom, and through his often outrageous conduct he ensured that he would never lack enemies.

On one level the artist as a second creator who is attempting to rival God himself runs the risk of provoking the Deity, a most powerful enemy indeed. The greater the artist, the greater the danger that he will be punished for his bold effrontery. Barry never consciously admitted his demiurgic ambition, but in a work such as 'Satan and his Legions Hurling Defiance toward the Vault of Heaven' (no.49), one can sense his deep sympathy for Satan, who stubbornly competes with the Almighty.

Rather than dwell on the artist's relationship to the creator, Barry chose to focus obsessively on the superior man's relationship to his fellows. His work is filled with examples of the persecuted and betrayed. To name only a few drawn from a wide variety of sources: Philoctetes (no.2), Lear (nos 5 and 63), Job (no.24), William Pitt the Elder (no.27), Orpheus (no.28A), Imogene (no.48), Christopher Columbus (no.38), Scipio Africanus (no.40), Agrippa (no.42), Jonah (no.73), Agrippina (no.91), and St John the Baptist (no.60). On the two occasions that he depicted scenes from the lives of creative figures, he chose Tasso (no.71) and Milton (no.56), each of whom provides an excellent example of the persecuted genius.

Of course, the supreme example of a great man who suffered for his virtuousness is offered by the life of Christ, and when contemplating a subject for St Paul's Cathedral, Barry chose the moment showing Christ rejected by the Jews, when the Saviour's envious rivals incite the majority to kill him (no.12). For Barry, the rejection of the wise and blameless by the jealous and ignorant was one of the central messages of Christianity. After he was expelled from the Royal Academy, he executed a drawing entitled 'Judas Returning the Bribe of the Thirty Pieces of Silver' (no.61), and in an inscription he makes clear that he is equating his own 'martyrdom' at the hands of the Academy with that of Christ at the hands of Judas and the chief priests and elders. This association is all the more appropriate in that Barry had been paid as professor of painting thirty pounds a year for delivering his lectures to the students.

A few years later, shortly before his death, Barry executed a complex allegorical drawing (no.92) which encapsulates his conviction that the

heroic man of superior knowledge and virtue is a victim in a frightening and chaotic world. The large male figure, supported by an angel, shrinks back from the scene before him. Images of enslavement, death and destruction crowd the edges of the drawing, while the centre itself is only a dense black cloud. The most prominent of the oppressive figures are those at the lower right who represent the state and the church and are supported in their misconduct by self-serving artists (Rubens) and writers (Spenser).

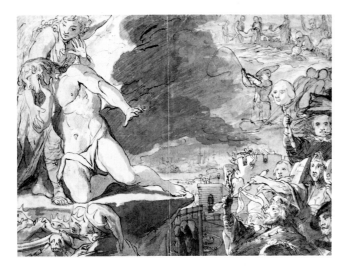

Cat.no.92

The figure of the hero once again resonates with Christ-like connotations. In particular, his situation recalls the Agony in the Garden, where Christ recoils in the face of his agonizing fate. In St Luke's account a lone angel strengthens him in his resolve to fulfil his painful destiny. An engraving after Le Brun's painting of this scene (fig.2) shows how closely Barry's image parallels this Christian subject. If Barry in fact knew this specific work, he could not have helped but appreciate such a detail as the cloud metamorphosizing into a serpent which recalls his own dramatic use of a threatening snake in his self-portrait of about this same time (no.94). In addition, scenes depicting Christ in the Garden of Gethsemane often show Judas approaching in the distance with the multitude which has come to seize the Saviour; such a detail recalls the menacing figures crowded together in Barry's design. Behind the artist's conception can also be found a hint of Christ as judge in the Last Judgement, where he rejects the ungodly with his left hand. Virtue's ultimate triumph is assured, but in Barry's drawing it is the agony that

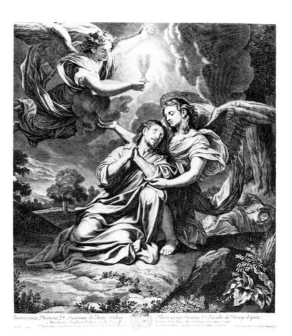

fig.2 after Charles Le Brun
'The Agony in the Garden'
engraving *Bibliothèque
Nationale, Paris*

must be endured along the way that is most forcibly expressed. He was
hardly alone in associating the role of the artist with a Christ-like destiny,
but he brought an intense originality to this archetypical imagery.

Among Barry's most remarkable creations are his self-portraits, and
not surprisingly they too offer a dramatic record of his own agonizing
struggle. There are a number of intimate self-portraits in which his pain
is made explicit. These include the haunting oil study in the Victoria and
Albert Museum (no.93), the brooding figure in the drawing at the
Ashmolean (no.95), the weary, melancholy scholar at the Royal Society
of Arts (no.96), and the mezzotint loosely based on it showing a scowling
face (no.97).

In addition to these works, there are four self-portraits in oil which can
be considered public performances, presenting the artist as he would
hope to appear to a wider audience. Fortunately, as far as is known, there
are no missing paintings in this category, and, when combined with the
other self-portraits mentioned above, they form an extensive and
revealing exploration of the artist's pysche. Surprisingly, it is the public
self-portraits that are ultimately more disturbing and complex than the
private images.

Barry's first self-portrait (no.15, also see colour plate) was described in
the sale of the contents of his studio after his death as having been painted

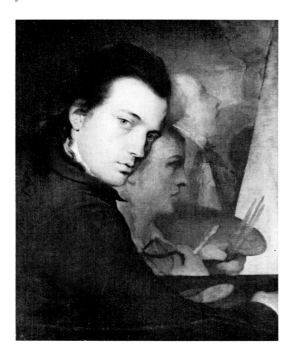

Cat.no.15

in 1767. Idealizing his own features, he portrays himself as a budding genius at work on a canvas depicting two of his friends, James Paine, Jr and Dominique Lefèvre. Passages in his friends' portraits are unfinished, as if he were still in the act of painting this picture within the picture. Furthermore, Paine and Lefèvre are shown before canvases of their own on which they are sketching the Belvedere Torso. Though squeezed into the upper right corner, the Torso is an awesome, towering presence, an Olympian beacon for the admiring artists gathered below. Although the painting is small in scale, it is a highly ambitious design exhibiting a complex, dynamically compressed structure, the artist's confirmation of his having fully matured as a painter.

The next major work containing a self-portrait is 'Portraits of Barry and Burke in the Characters of Ulysses and a Companion Fleeing from the Cave of Polyphemus' (no.20, also see colour plate), which was exhibited at the Royal Academy in 1776. It is a highly unconventional historical portrait that inexplicably seems to have created little comment among his contemporaries. On one level it shows Ulysses and his companions escaping from Polyphemus; on another it is autobiographical, showing Burke cautioning the impetuous artist in a situation that is dangerous for both of them, probably an allusion to their opposition to

fig.3 Leonardo da Vinci, 'St John the Baptist'
c.1513–16 *The Louvre, Paris*

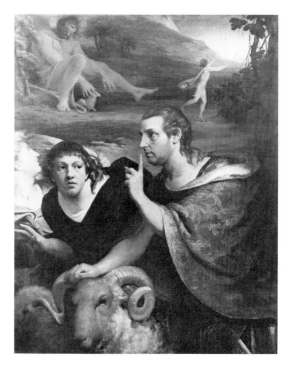

Cat.no.20

the government's prosecution of the American war. However, there would seem to be yet a third level of interpretation. Burke's cautioning gesture, prominently positioned in the painting's centre, also conjures up religious associations as if he were pointing heavenward as well as restraining his friend. It is a gesture that is reminiscent of a pose frequently encountered in depictions of St John the Baptist, as can be seen for example in Leonardo da Vinci's celebrated canvas (fig.3). (It was, of course, in the following year that Barry began his series of paintings at the Society of Arts in which the pose of Orpheus is also deliberately based on well-known prototypes of St John.) On closer inspection Barry's own portrait (no.20 detail) resonates with religious connotations. The perspiration on his brow is a highly unusual detail, one which, to my knowledge, cannot be found in any other historical portrait with the exception of those of Christ in scenes of the Passion (see, for example, fig.2). The artist's dark blue robe and guileless features along with the rams and grape-bearing vines would reinforce a reading associating him with the Saviour. Thus, the painting should also be interpreted as Burke, a St John the Baptist type preparing the way for Barry, whose life as an artist is one that is dedicated to the imitation of Christ with all its terrifying connotations. Above and behind is the

threatening presence of the brutish humanity that both Christ and the artist must struggle to redeem. This is indeed a heroic self-projection, but one that also insists on enormous self-sacrifice in keeping with the artist's view of his role as an inspired prophet.

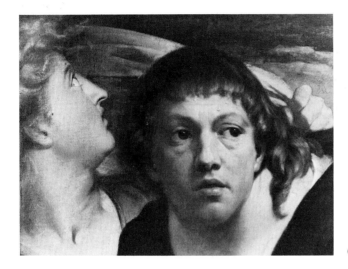

Cat.no.20 (detail)

In a lecture given at the Royal Academy, Barry commented in the context of sepulchral monuments that 'It should be permitted only to a hero to commemorate a hero.'[7] Of course, his murals at the Society of Arts are filled with portraits of heroes, past and present, and none is more interesting than when Barry undertakes to depict his heroic self. At the lower left-hand corner of 'Crowning the Victors at Olympia', next to the statue of Hercules treading down Envy, sits Barry as the Greek artist Timanthes (no.28C detail). He holds his recreation of a painting by Timanthes that had been described by Pliny: 'There are also other examples of his genius, for instance a quite small panel of a Sleeping Cyclops, whose gigantic stature he aimed at representing even on that scale by painting at his side some Satyrs measuring the size of his thumb with a wand. Indeed Timanthes is the only artist in whose works more is always implied than is depicted, and whose execution, though consummate, is always surpassed by his genius.'[8] Barry's self-projection as Timanthes, appearing as it does in his most ambitious work, can in some senses be considered his official self-portrait, taking precedence over the other images.

In the spring of 1804, the Society of Arts approached Barry for a self-portrait that could appear as an engraved frontispiece to the next volume

Cat.no.28c (detail)

of its *Transactions*. Writing in the third person, the artist replied,

> The only portrait Mr Barry has of himself is the head which he
> painted many years since, & copied at the time into the picture of the
> Olympic Victors. Notwithstanding the wear & tear in such a fragil
> thing as the human countenance, yet as Mr Barry's friends thought
> it still like him, he without in the least touching the head, finished
> the rest of the picture sometime last summer by painting in the
> hands, drapery, cyclops &c.[9]

The resulting canvas is the self-portrait now at the National Gallery of
Ireland (no.94, also see colour plate). Because the picture is unusually
large for just the study of a head (30 × 25 in), it would seem that Barry
intended from the beginning to round it out into a finished work. In fact,
this would appear to be the case with another head executed for the series
at the Society of Arts. The 'Portrait of Dr William Hunter' is identical in
size to the Dublin self-portrait, and while the head, though retouched,
appears to be by Barry, the remainder of the painting was finished at a
later date by another hand.[10] It is important to remember, however, that
although the Dublin self-portrait is based on the earlier image in
'Crowning the Victors at Olympia' (the head of course is preparatory to
it), it is in no way a literal transcription of the mural. Rather it is an
independent work of art and can be viewed as the ultimate elaboration of
the official self-image.

In the upper left corner appears a simplified version of the base of the
statue of Hercules trampling on the serpent of Envy. Hercules had long

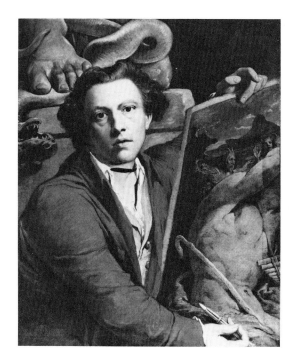

Cat.no.94

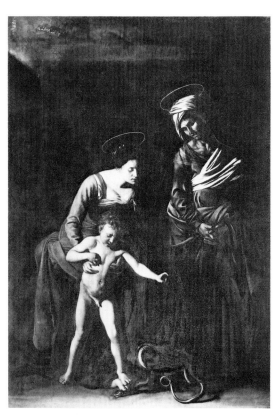

fig.4 Caravaggio,
'Madonna of the Serpent' 1605
Borghese Gallery, Rome

been a symbol of the virtuous hero who struggles against Vice. As described by Horace, the envy he aroused in others made them constantly attack him, and he eventually conquered Envy only when he died and his greatness could no longer provoke the living. Barry often employed a close-up focus and an abrupt cutting of forms to enhance a work's emotional impact. Here the condensation of images results in the startling juxtaposition of the serpent's head with his own right ear. Envy literally becomes his muse, as he listens intently to its intoxicating hissing. The evil conduct of others reinforces the hero's virtue: greatness demands opposition.

In the combat of Hercules with the sinful serpent, Christian parallels are once again evoked. Barry alludes to the struggle between the serpent and a righteous foot in his painting 'The Temptation of Adam' (no.1), when he placed Eve's raised heel close to the snake's head in anticipation of God's prophecy,

> Between Thee and the Woman I will put
> Enmity, and between thine and her Seed;
> Her Seed shall bruise thy head, thou bruise his heel.
> (*Paradise Lost*, Book x, lines 179–81)

In addition, there are works by other artists of Christian combats that are analogous to that of Hercules. Barry almost certainly knew Caravaggio's painting 'The Madonna of the Serpent' (fig.4), in that it was then, as now, in the Borghese Palace in Rome. In this painting both Christ and Mary trample upon their ancient foe. Pietro Testa's print (fig.5), on the

fig.5 after Pietro Testa, 'Christ Trampling the Serpent' engraving by Johannes Caesar Testa *British Museum*

other hand, combines the rest on the flight into Egypt with a scene of Christ alone vanquishing the serpent, and in this instance the connection between Christ and Hercules is made explicit. The classical hero appears in the relief at the right attacking the Hydra with its multiple serpent heads.

In the self-portrait the painting within the painting conjures up even more complex associations. Appropriately, one model for the cyclops is Polyphemus, who, as in Annibale Carracci's 'Polyphemus and Galatea' (fig.6), was depicted with a pan-pipe and a shepherd's staff. The association with Polyphemus is made even stronger by the fact that Barry has altered the poses of the two foremost satyrs so that they now recall the figures of Burke and himself in the earlier canvas 'Ulysses and a Companion'. However, the Polyphemus-like cyclops is now unmistakably a noble rather than a brutish figure. Pliny also commented that 'He [Timanthes] painted a hero which is a work of supreme perfection, in which he has included the whole art of painting male figures,'[11] and Barry would seem to be recreating this heroic nude as well. By cropping the canvas and having the cyclops' thumb lost to view, he wittily recalls Pliny's praise of Timanthes that 'more is always implied than is depicted'.

For a model for the cyclops, Barry turned to the Belvedere Torso

fig.6 Annibali Carracci,
'Polyphemus and Galatea' 1600
Farnese Gallery, Rome

(fig.7). In doing so, he linked this, his last self-portrait, to his earliest of 1767. Of course, the Belvedere Torso is itself a fragment of a statue of Hercules. In one of his lectures, Barry stated that 'Polyphemus might be able to perform as many feats of strength as Hercules, but we detest his brutal, savage, disposition, and reserve our love and admiration for the hero whose actions were directed by a humane and generous philanthropy.'[12] The savage brute has now been transformed into the humane hero. It is as if the painting 'Ulysses and a Companion' had been turned inside out. The giant is now in the foreground with the cautioning figures behind. Barry and Burke as satyrs no longer flee but stealthily approach the grand figure before them. Just as the satyrs stand in awe of the heroic figure, the viewer, in his turn, stands in awe of Barry's painting; the satyrs' response is meant to mirror the viewer's own. He, in his turn, may now wish to approach to measure the artist's proferred thumbs.

Barry is seated between his own painted sculpture and his recreation of Timanthes' painting. His prowess as a draughtsman is also alluded to in that he holds a porte-crayon. The porte-crayon and the phallic staff rising from the cyclops' lap both point back to him, suggesting that he is indeed a potent creator. His head is not unlike that of his earlier self-

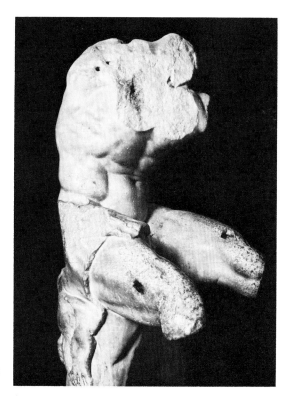

fig.7 Belvedere Torso
Vatican Museum, Rome
[reversed photograph]

portrait in 'Ulysses and a Companion'. He again is a wise innocent with Christ-like associations. Though dressed casually in contemporary attire, the blood red colour of the coat and the slash across his neck created by the black tie cord are unsettling details in light of this association. The serpent is also a sinister presence and even the Hercules-cyclops exudes a threatening power.

In this work as in his art as a whole, Barry boldly defines himself in terms of an imaginative vision of antiquity, a vision, however, that is deeply embedded in a Christian context. By means of this authoritative structure constructed from the noble past he is able to address the present with heroic conviction. The works of art clustered closely about him add to his stature, making him seem even more imposing. But at the same time this self-made world is a confining one as the surrounding works press in upon him. Since the greater the art, the more envied and hated is its creator, Barry must take refuge in that same godlike talent that has put his life at risk. The artist as hero is a genius who is also a victim; his creations are his glory and the cause of his monumental despair.

1 'An Inquiry', in *Works*, II, p.248.
2 'Letter to the Dilettanti Society', in *Works*, II, p.595.
3 'An Account', in *Works*, II, p.361.
4 For numerous examples of this motif, see Herbert Friedmann, *The Symbolic Goldfinch*, The Bollingen Series, 1946.
5 See 'An Account' and 'Letter to the Dilettanti Society', in *Works*, II, pp.435 and 526 respectively.
6 William Blake to the Rev. Dr Trusler, 23 August 1799, *The Letters of William Blake*, ed. by Geoffrey Keynes, 1970, p.29.
7 Lecture IV, in *Works*, I, p.472n.
8 Pliny, *Natural History*, trans. by H. Rackham, 1968, Book XXXV, 74.
9 Barry to the Society of Arts, 2 May 1804, copied in 'Minutes of the Society of Arts', 6 June 1804.
10 Reproduced and discussed in Pressly, *The Life and Art of James Barry*, 1981, p.109.
11 Pliny, Book XXXV, 74.
12 Lecture II, in *Works*, I, p.402.

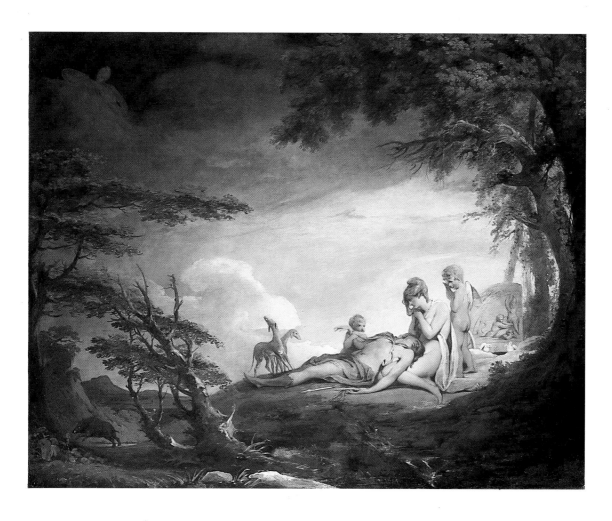

THE DEATH OF ADONIS 1775
(Cat.no.7)

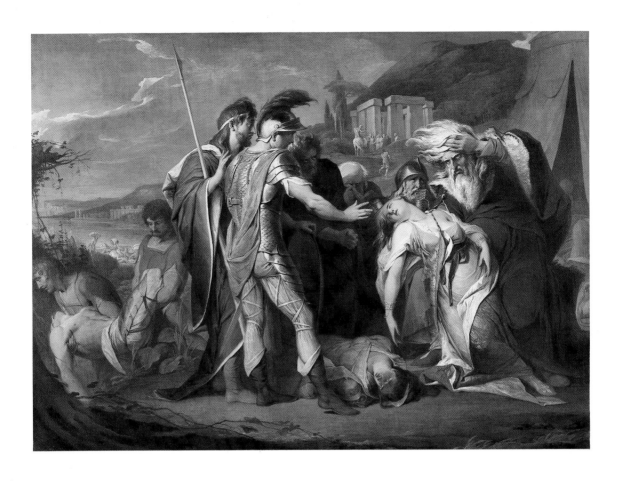

KING LEAR WEEPING OVER THE BODY
OF CORDELIA 1786–7 (Cat.no.47)

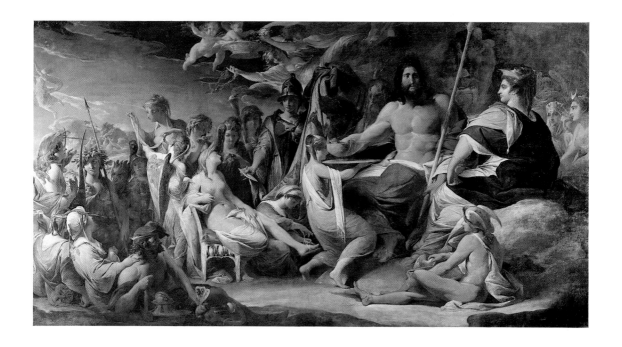

THE BIRTH OF PANDORA 1804
(Cat.no.85) [photographed during restoration]

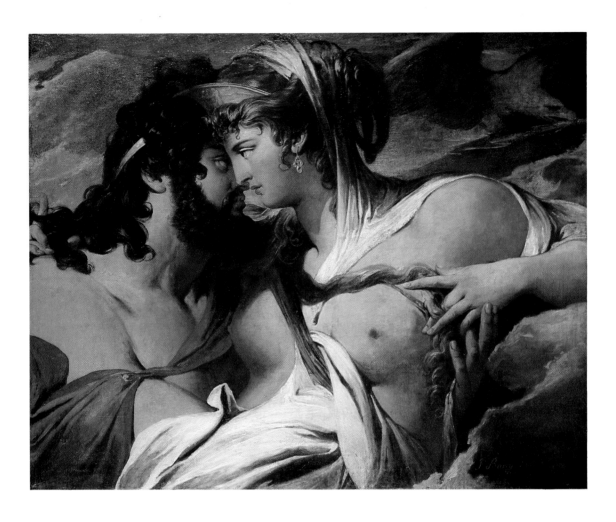

JUPITER AND JUNO ON MOUNT IDA
*c.*1785–1805 (Cat.no.86)

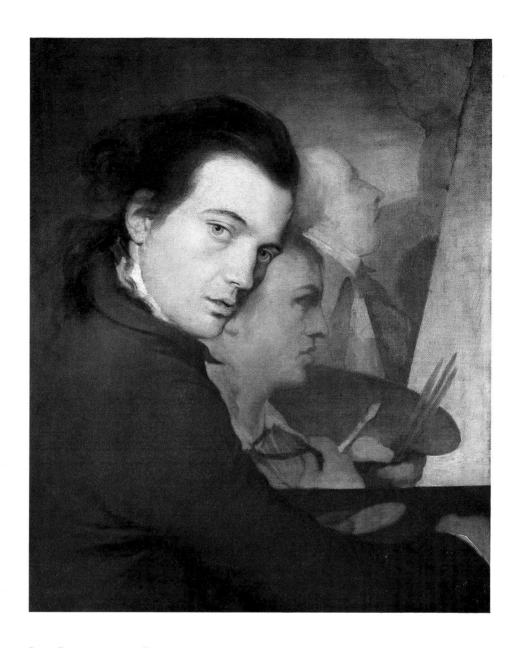

SELF-PORTRAIT WITH PAINE AND
LEFÈVRE *c.*1767 (Cat.no.15)

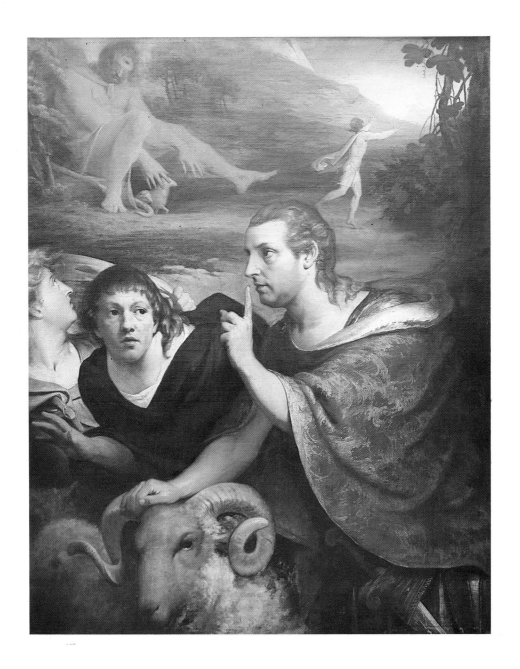

PORTRAITS OF BARRY AND BURKE IN THE
CHARACTERS OF ULYSSES AND A COMPANION
FLEEING FROM THE CAVE OF POLYPHEMUS 1776
(Cat.no.20)

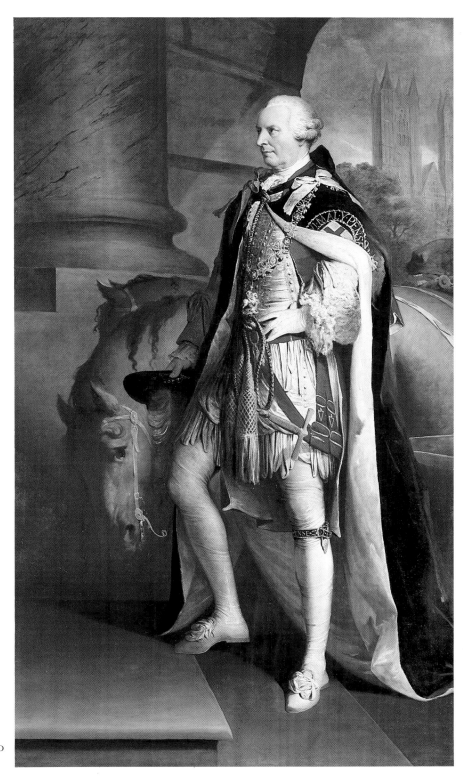

HUGH, FIRST DUKE
OF NORTHUMBERLAND
*c.*1784–6 (Cat.no.45)

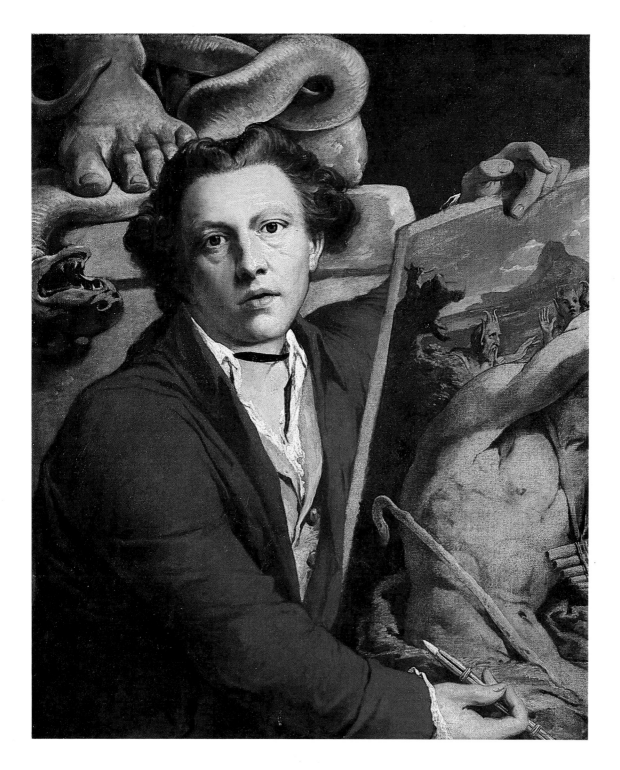

SELF-PORTRAIT 1803 (Cat.no.94)

CATALOGUE

DIMENSIONS – All works are measured in inches with centimetres in brackets. The height precedes the width. The measurements of the prints are to the platemark.

PRESSLY NUMBER – These numbers refer to the catalogue entry for each work in the author's book *The Life and Art of James Barry* (New Haven and London, 1981). 'P' before the number denotes the 'Catalogue of Paintings', 'D' the 'Catalogue of Drawings' and 'PR' the 'Catalogue of Prints'. In the case of the prints, the roman numeral following the entry number denotes the state of the impression included in the exhibition. The entries in the book contain full information about inscriptions, provenance, exhibitions, literature, and engravings and copies after a particular work that will not be duplicated here. However, when new information has come to light, this material has been included.

I EARLY HISTORICAL PAINTINGS, 1767–1776

Even as a young man in Cork, Barry had decided to attempt history painting, the most exalted of artistic genres, and later when studying in Rome, he wrote back to Edmund Burke and his family of his determination: 'I am forming myself for a history painter: my studies have been so directed as to carry me as safely as I can through a little path, where, notwithstanding the great number of painters in the world, I am not likely to be jostled down by too much company' (Barry to the Burkes, 8 April 1769, *Works*, I, p.159). Because of the lack of patronage and the difficulty of the undertaking, few painters had the courage to abandon more profitable genres in the pursuit of historical subjects. Barry also recognized that the Great Style was in decline; none of his continental contemporaries could match the grandeur of the Old Masters of the sixteenth and seventeenth centuries.

In England the situation was somewhat different. Outside decorative schemes for large interiors, the practice of history painting had been practically non-existent. Despite the pioneering achievements of William Hogarth and Francis Hayman in the 1740s and 1750s, it was in Rome rather than London that British artists, surrounded by the great art of the past and supported by like-minded colleagues, firmly established a native school in this genre. Every British history painter of importance who emerges in Barry's generation with the exception of John Hamilton Mortimer made an artistic pilgrimage to Rome. Among this number are Gavin Hamilton, who first arrived in Rome around 1748 and was to spend most of the remainder of his career there; Nathaniel Dance, who arrived in 1754 and stayed for almost twelve years; the American Benjamin West, who settled in London in 1763 after spending three years in Rome; the Swiss Angelica Kauffmann, who arrived in London in 1766 after having been in Rome from 1763–4; the Scotsman Alexander Runciman, who studied there from 1767–71; the Swiss Henry Fuseli, who resettled in London in 1779 after having worked in Rome for eight years beginning in 1770; George Romney, who was there from 1773–5; and Joseph Wright of Derby, who visited Rome from 1774–5. After his own arrival back in London in 1771, Barry quickly emerged as one of the more important members of this small, select group.

Barry's first history paintings after his apprentice years in Ireland generally tend to feature only one or two large scale figures engaged in moments of high drama, and his conceptions are solidly based on those Grand Manner models supplied by antique sculpture and modern painting. When undertaking a composition that involved larger groupings, as in 'The Death of General Wolfe', he clearly had greater difficulty. The types of subject matter that he chose expanded considerably in these early years. He began with traditional subjects but was careful to choose ones that had not been frequently depicted. Thus, while 'The Temptation of Adam' was a familiar choice, giving it a Miltonic emphasis was not, and while such subjects as 'Philoctetes' and 'Venus Rising from the Sea' had been made famous by the Greek artists Parrhasius and Apelles respectively, they had not been overworked in Barry's own day. He then gravitated toward more sentimental narratives, which seemed to enjoy greater public support, and his 'Death of Adonis' is one of the finest examples of this type. Finally, in 'King Lear and Cordelia', he attempted a Shakesperian scene in a remarkably original manner, breaking new ground in terms of both the subject matter and its treatment.

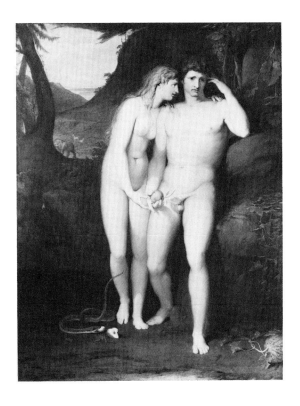

1 THE TEMPTATION OF ADAM 1767–70

Exhibited at the Royal Academy in 1771
Oil on canvas, 91¾ × 73½ (233 × 183)
Pressly: P5 [to be added to 'Exhibitions':
 Sydney, *Sydney International Exhibition*,
 1879(6); Melbourne, *Melbourne
 International Exhibition*, 1880; Adelaide,
 National Gallery of South Australia,
 inaugural exhibition opening on 18 June
 1881(1)]
National Gallery of Ireland, Dublin

On 23 May 1767, Barry wrote Edmund Burke and his family from Rome that he had undertaken a painting of Eve tempting Adam. From the beginning he intended this picture as his first work to be exhibited in London, and the finishing touches were not completed until shortly before his departure from Rome in 1770. As can be seen in a drawing by Charles Brandoin (fig.8), the painting enjoyed a prominent position in the Royal Academy exhibition of the following year. It was well received, although one critic chose to add a caveat: 'The only objection to this piece is, an insufficiency of drapery; a fault common to most young painters, immediately after the tour of Italy, on account of the difference of climate' (*The Gazetteer*, 8 May 1771). Of course, the painting's genesis had nothing to do with a specific scene that Barry may have witnessed in a hot climate but was instead a product of his desire to paint idealized nudes in accordance with the heroic figurative tradition sanctioned by the humanistic theory of art.

The painting depicts the fall of man. In an inversion of the divine plan, the female, who is representative of sensual pleasures, now governs the male, in whom the intellectual faculties should be uppermost. The leaves of the apple that Eve coaxes Adam to bite cover his genitals in anticipation of the shame they are both to experience after disobeying God's decree. As he made clear in the entry in the catalogue to the Royal Academy exhibition, Barry's textual source was Milton's *Paradise Lost* rather than the Bible (this picture is in fact the first exhibited painting of a Miltonic subject). Such a choice is a reflection not only of the artist's wish to appeal to nationalistic sentiments but also of his recognition of the greater subtlety and complexity of Milton's account. In *Paradise Lost*, Adam agonizes over his

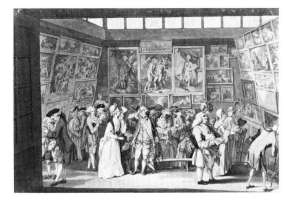

fig.8 Charles Brandoin, 'The Royal Academy Exhibition, 1771'

decision and takes the fatal bite out of misguided love rather than to satisfy carnal appetites:

> On th' other side, *Adam*, soon as he heard
> The fatal Trespass done by *Eve*, amaz'd,
> Astonied stood and Blank, while horror chill
> Ran through his veins, and all his joints relax'd;
>
>
>
> Speechless he stood and pale, till thus at length
> First to himself he inward silence broke.
>
>
>
> . . . I feel
> The Link of Nature draw me: Flesh of Flesh,
> Bone of my Bone thou art, and from thy State
> Mine never shall be parted, bliss or woe.
> (*Paradise Lost*, Book IX, lines 888–91, 894–5, 913–6)

Relying on abstracted contours, Barry bonds the torsos, arms and heads of the two figures together in a unifying oval, literally imaging the phrase 'Flesh of Flesh, Bone of my Bone thou art'. To the left, storm clouds appear in the sky, and the lion in the middle ground will soon turn on the deer with which he had formerly lived in peaceful harmony. To the right, Adam's side of the canvas, are found the more positive images of grapes and a gourd, redemptive symbols of the Eucharist and Resurrection.

2 PHILOCTETES ON THE ISLAND OF
 LEMNOS 1770

Oil on canvas, $89\frac{3}{4} \times 62$ (228 × 157.5)
Pressly: P6
Pinacoteca Nazionale, Bologna

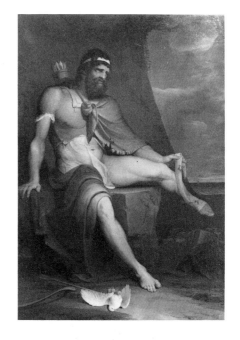

This canvas, painted for the Accademia Clementina in Bologna when Barry was made a member, is on the same ambitious scale he had chosen for 'The Temptation of Adam'. Based on translations of two Greek texts, Glaucus' epigram on Parrhasius' lost picture and Sophocles' play, the painting depicts the Greek warrior Philoctetes alone on the Island of Lemnos. Philoctetes had sailed with the Greek expedition mounted against Troy, but was bitten by a serpent on the journey. The wound proving for the time to be incurable, he was abandoned by his comrades to endure recurring bouts of extreme pain, provisioned only with the magical bow and arrows that never missed their target bequeathed to him by his friend Hercules. After ten years had passed the Greek army, upon learning that his bow and arrows

fig.9 Antonio Lombardo,
'Philoctetes'

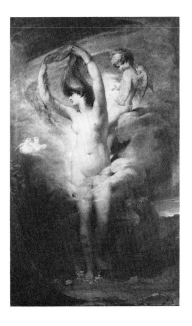

were necessary for victory, sent Ulysses and
Diomedes to return with him. After he had been
healed, Philoctetes joined in the fight, slaying Paris
and preparing the ground for the defeat of Troy. In
the painting, Philoctetes' condition is similar to that
of Barry's heroic and melancholy Adam. Both men
are the victims of a serpent but will eventually find
glory and redemption through suffering.

Barry's painting is the first post-classical picture
of this subject, and his interest in it must have been
aroused by the writings of two contemporary
German critics, J.J. Winckelmann and Gotthold
Ephraim Lessing, who had discussed this episode in
books published in 1755 and 1766. The artist treats
Philoctetes' agony, a potentially horrific subject,
with the 'noble simplicity and sedate grandeur' that
Winckelmann felt characterized the great art of
antiquity. Underlying his conception is Antonio
Lombardo's classicising, sixteenth-century relief of
this same scene (fig.9), as well as such revered
antique sculptures as the Laocoön and the Belvedere
Torso (fig.7). However, by emphasizing the hero's
pain and isolation, he also paid close attention to
Edmund Burke's definition of the sublime in his
book *A Philosophical Enquiry into the Origin of Our
Ideas of the Sublime and Beautiful*. In the background
is a stormy sky, and, again following Burke's dictum
that sad and fuscous colours are evocative of sub-
limity, the foreground is painted in earthen tones.
Barry's later versions of this subject (see nos 69 and
70) were to become even more dramatic along the
lines advocated by Burke, but he was never to
sacrifice the hero's dignity. His interpretations stand
in marked contrast to that of the Danish painter
Nicolai Abildgaard, who, in a canvas executed in
Rome in 1774–5, showed Philoctetes twisting in a
whirlwind of pain.

3 VENUS RISING FROM THE SEA

Exhibited at the Royal Academy in 1772
Oil on canvas, 103 × 67 (260 × 170)
Pressly: P7 [to be added to 'Literature':
 Dorinda Evans, 'Raphaelle Peale's "Venus
 Rising from the Sea": Further Support for
 a Change in Interpretation', *The American
 Art Journal*, XIV, Summer, 1982, pp.63 and
 69 n.14].
*Hugh Lane Municipal Gallery of Modern Art,
Dublin*

This painting is of Venus Anadyomene, an epithet that alludes to her having risen out of the sea at her birth. Barry's interpretation follows descriptions of Apelles' celebrated picture which was said to have shown Venus wringing her wet hair. He also turned to other classical texts for various details, passages from Lucretius' *De Rerum Natura* and Hesiod's *The Theogony* having suggested the dispersing clouds, calm sea, rainbow, mating birds, and the plants which spring up at the touch of her foot upon the shore. For the goddess' rounded, ample proportions, he chose the statue of the Venus de' Medici as his model, noting, 'as I thought something of the mother was perceivable about the breasts and abdomen of this admirable piece of Greek workmanship, I was resolved to bestow somewhat more of freshness, and the virginal character, upon my own work' (*Works*, II, p.146).

Just as 'Philoctetes' was an essay in the sublime, 'Venus Rising from the Sea' is an essay in Burke's aesthetic category of the beautiful. Indeed, in its impact the picture is a visual translation of Burke's lyrical response to feminine beauty: 'Observe that part of a beautiful woman where she is perhaps the most beautiful, about the neck and breasts; the smoothness; the softness; the easy and insensible swell; the variety of the surface, which is never for the smallest space the same; the deceitful maze, through which the unsteady eye slides giddily, without knowing where to fix, or whither it is carried' (*Enquiry*, ed. by J.T. Boulton, p.115). Venus' body responds to aesthetic rather than anatomical con-siderations, pictorial demands outweighing any concern for truth to nature. Her form possesses a malleable, abstract fluency as it ascends to the voluptuous cascade of curly hair framed between her remarkably pliant arms. Her gentle, sensuous curves, always changing but never abruptly, are re-peated throughout the picture in such details as the rainbow, Cupid's bow and wings, the tree trunk, cooing birds, admiring seahorses, and the billowing clouds that surround her. The artist's study of Titian is evident in the colouring with its subtle, warm modulations. There is, though, an abrupt contrast between the area beneath the clouds and that above, and the artist Nathaniel Dance complained that in later years Barry 'had spoilt the picture by rubbing a brick dust colour over the upper part of the figure' (*Farington Diary*, 21 April 1807). Even so, Cupid's arrow continues to find its mark, lodging itself in the breast of whoever stands before the captivating goddess.

The painting met with almost universal praise, although Horace Walpole did raise a dissenting voice, finding the line between the heroic and the ridiculous closer than he would have liked. Writing to his friend William Mason, he described how he must prepare himself for the first exhibition of Barry's paintings at the Society of Arts in order to avoid repeating his earlier offence: 'I must astringe my mouth . . . with alum, lest I laugh and be put into purgatory again myself, as I was for the same crime when I first saw Barry's Homeric Venus standing start naked in front, and dragging herself up to heaven by a pyramid of her own red hair. I had never seen nor heard of the man, and unfortunately he stood at my elbow' (*Horace Walpole's Correspon-dence*, 1955, XXIX, p.298). Walpole, however, was decidedly in the minority, and a few years later, when Thomas Proctor saw this picture, he underwent what is tantamount to a religious conversion, abandoning his post in a merchant's counting-house to devote himself to history painting and sculpture.

'Venus Rising from the Sea' was also the most frequently engraved of Barry's works, and through these prints it influenced artists in both France and America. The American Raphaelle Peale in fact incorporated Barry's Venus into his canvas 'Venus Rising from the Sea – A Deception' (fig.10), which he exhibited in 1822 at the Pennsylvania Academy of

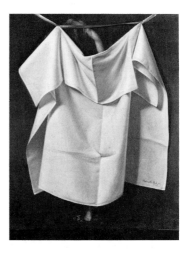

fig.10 Raphaelle Peale
'Venus Rising from the Sea – A Deception'

the Fine Arts. The painted cloth, which covers all but the extremities of Peale's adaptation of this figure, is a witty reference to Pliny's story of a classical Greek master who executed a curtain so skilfully that he deceived a rival artist. Yet Peale signed the corner of the cloth, emphasizing its existence as a painted image and clearly marking this portion of the composition as his own. To 'remove' this cloth is to reveal Barry's 'Venus', which in this instance embodies the classical tradition of the idealized nude extending from Apelles to the present. Peale must therefore have also intended his picture as a sardonic comment on his American audience's prudish reluctance to embrace this aspect of the Grand Style.

4 THE EDUCATION OF ACHILLES

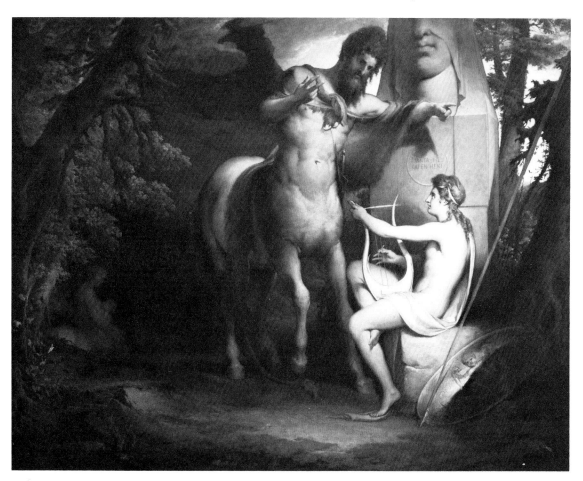

4 THE EDUCATION OF ACHILLES

Exhibited at the Royal Academy in 1772
Oil on canvas, $40\frac{1}{2} \times 50\frac{3}{4}$ (103 × 129)
Pressly: P10
Yale Center for British Art, New Haven (Paul Mellon Fund)

Chiron, a centaur who was renowned for his good-ness and wisdom, was a teacher of a number of celebrated heroes. Here he instructs the youthful Achilles in the use of weapons, in the arts, symbo-lized by the lyre, and in mathematics, represented by the Euclidean diagram traced on the ground at the end of Achilles' robe.

This subject was a common one, and Barry had even seen at firsthand the Pompeian fresco of Chiron and Achilles when he visited Naples in January 1769. His treatment, however, is highly original in that it strikes a mysterious and evocative chord. In spirit his picture is more closely attuned to the tragic charac-terization of the mature Achilles found in Homer's *Iliad* rather than to the less gloomy accounts of his early education found in Pindar's *Third Nemean Ode*, Statius' *Achilleid*, and Philostratus the Elder's *Imagines*.

For the first time in Barry's art, landscape plays an unusually prominent role in establishing the picture's mood. To the left and right are trees with menacing, spiky dead limbs; above dark clouds descend oppressively low in the sky; and below the ground is flecked with red, blood-like stains. Barry purposely ignored conventional renderings of cen-taurs in order to elongate Chiron's torso so that he now towers over his pupil, who, by the same token, is unusually frail and effeminate, his gracefully elegant curves providing a youthful, male counterpart to Venus' beauty in 'Venus Rising from the Sea'. Chiron points to the spear at the right, but the shadow of his hand ominously points to Achilles, who is fated to die in battle. The infant Hercules strangling the serpents appears on the shield, a subject that offers a heroic prototype for the youthful warrior. Perhaps too it is a reminder of Chiron's own violent end. Though immortal, he was wounded accidentally by Hercules, and rather than let him suffer eternally from an incurable wound, Jupiter permitted him to die.

Over all hovers the mysterious, monolithic herm, on which is inscribed in Greek, 'All things: one and in one'. Although it is no longer possible to be certain, the ring encircling the inscription may indicate a serpent with a tail in its mouth, which, for Barry, symbolizes 'the eternity of the supreme mind or intellect' (*Works*, II, p.592). The herm itself represents Minerva, the goddess of wisdom, and it is based on a passage in Plutarch's *Isis and Osiris*. Plutarch said of the Egyptian priesthood that it advocated a philosophy in which truth was skilfully concealed. Writing in 1798, Barry even quoted Plutarch's account of an inscription on a statue of Minerva, identified as Isis, in the Egyptian city of Sais, which read, 'I *am* whatever *was, is* and *will be*, and my vail no mortal hath raised' (*Works*, II, p.591). The herm in this painting represents this veiled, enigmatic wisdom, and it bears mute witness to the belief that ultimate knowledge is only to be found in the transcendance of liberating death. This is a far more personal and evocative use of antique imagery than anything being attempted by Barry's con-temporaries, and significantly this work was the first history painting he sold in London.

5 KING LEAR WEEPING OVER THE BODY OF CORDELIA

Exhibited at the Royal Academy in 1774
Oil on canvas, $40 \times 50\frac{1}{2}$ (101.5 × 128)
Pressly: P14 [annotated at lower left: '105']
Kathleen, Countess Plunkett

This painting is remarkable both for its choice of subject and for its design. All acted versions of *King Lear* in the eighteenth century called for a happy ending, in that it was felt to be inappropriate to permit the innocent Cordelia and her noble father to die at the end. Barry was the first to paint the last act as Shakespeare wrote it, selecting that tragic moment when the aged king dies from grief with the body of his daughter in his arms. For his conception he was influenced by paintings of Christ's body cradled in Mary's lap, in particular Annibale Carracci's 'The Dead Christ Mourned', then in the collection of the Duke of Orleans and now in the National Gallery, London. But his interpretation is even more extreme than Carracci's in its depiction of unbearable grief. Lear is deliberately oversized, and his wild streaming hair and agonized features are unusually extrava-gant. The dramatic cutting of the frame forces the figures close up against the picture plane, making the

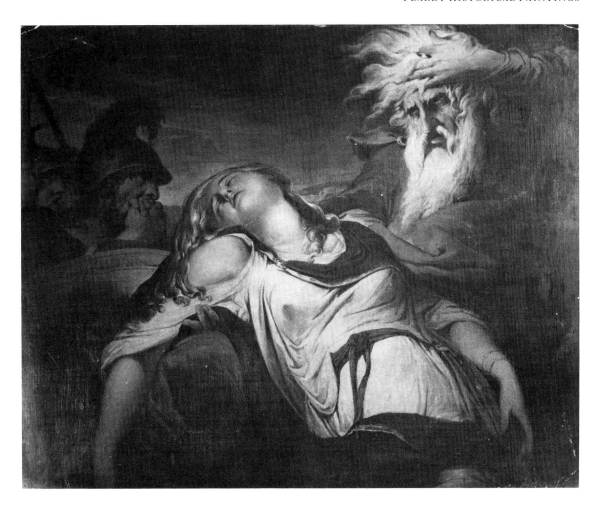

emotional impact for the viewer even more intense. Barry stresses as well the differences between the two principal protagonists: Cordelia serene and relaxed in death, Lear contorted in agony. Cordelia's flesh is also deathly pale and her garments are composed of cool whites and blue-greens. Lear, on the other hand, has a ruddy complexion executed with heavy brush-strokes, and he wears a warm deep red coat. One critic, troubled by the painting's originality, complained that the artist had grossly overstepped Shakespeare's intentions:

Had Shakespeare's Ideas been as demoniac and extravagant as Mr Barry's, we should never have enjoyed those artless Scenes which compose his inimitable Lear. The Artist certainly meant it as a Burlesque: Cordelia represented by a Fat Billingsgate Fish-woman overpowered with Gin, and Lear personated by an old Cloaths-man, or Jew Rabbi picking her pocket. Even this can carry no Idea of the Extravagance of this Production (*Public Advertiser*, 3 May 1774).

This subject seems to have had a special significance for Barry, for he returned to it on several occasions (see nos 63, 64, 47 and 74). The lines illustrated are among Lear's last, and the artist may well have identified with this anguished cry against an unendurable Providence:

Howl, howl, howl, howl, – O, you are men of stone
Had I your tongues and eyes, I'd use them so,
That heaven's vault should crack, She's gone for
 ever. –

6 MERCURY INVENTING THE LYRE

Exhibited at the Royal Academy in 1774
Oil on canvas, 24½ × 29½ (62 × 75)
Pressly: P15
Lord Egremont

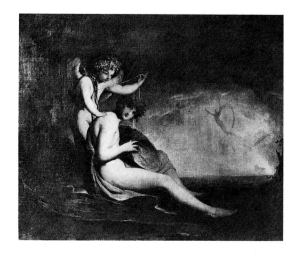

The painting shows Mercury discovering the prin-
cipal of the lyre when he strikes musical notes on the
fibres of a hollow tortoise shell. Cupid offers him the
string of his bow that he might improve his instru-
ment. Thus, the subject is the birth of music (and
with it epic poetry or sacred song) under the
inspiration of love. In the background Night flees at
the upper left, while to the right Aurora precedes the
horses drawing the chariot of Apollo, the sun god.
Apollo's presence is appropriate in that he is soon to
receive the newly invented lyre from Mercury.
Ultimately the painting depicts the dawn of civili-
zation, the beginnings of man's slow ascent from
darkness to light.

When Edmund Burke saw this picture of the
inventive Mercury, he remarked, 'Aye, that is the
fruit of early rising, there is the industrious boy! I
will give you a companion for it, – paint Narcissus
wasting his day in looking at himself in a fountain –
there is the idle boy!' (*Works*, I, p.239). Barry only
half-heartedly pursued Burke's suggestion, ap-
parently destroying his painting of Narcissus at a
later date. A far better pendant for this picture of the
birth of music and epic poetry would have been the
origin of painting.

When 'Mercury Inventing the Lyre' was exhi-
bited at the Royal Academy, Horace Walpole, who
was perhaps unaware of the full connotations of the
subject, dismissed this work in his copy of the
exhibition catalogue as 'quite mad'. Another critic
had a more specific complaint, stating that Cupid's
face was 'infamously foreshortened' (*The Public
Advertiser*, 3 May 1774). Barry in fact later repainted
this head, and the pentimento of the original fillet is
clearly visible. Portions of the sky may also have been
repainted, in particular dawn's purple streaks at the
right.

The figure of Mercury is fittingly based on
classical sources, in particular the marble relief
'Endymion Sleeping' in the Capitoline Museum in
Rome. It has the same roundness of form as the
Endymion and retains the sense of a shallow spatial
field with the figure in a single plane parallel to the
picture's surface. Barry's treatment, however, is

even more abstract than that of his source. He suppresses anatomical detail, and the extremities of feet and fingers are moulded into fluid, attenuated forms. This same quality of graceful elegance, a hallmark of his early style, was also present in the figure of the youthful Achilles. In this instance the rendering of Mercury is even more ethereal and dream-like in mood, explaining perhaps Walpole's uneasiness in front of such an intensely poetic image.

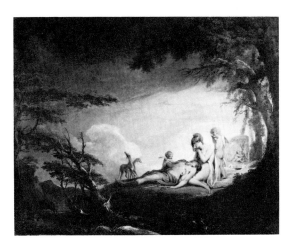

7　THE DEATH OF ADONIS

Exhibited at the Royal Academy in 1775
Oil on canvas, 39⅜ × 49⅝ (100 × 126)
Pressly: P17
National Gallery of Ireland, Dublin

As recounted by Ovid in his *Metamorphoses*, Adonis, ignoring Venus' warnings about hunting dangerous game, met his death while pursuing a wild boar. In the painting, the goddess has hurried to her lover's side, and from his blood, which flows down to the water below, she will create the anemone. Adonis' armed spirit would seem to appear in the clouds at the upper left, as he departs from this world.

In no other painting by Barry does landscape play such a major role. To the right the diminutive figures are placed on a knoll nestled within trees, while to the left a bay with mountains, in front of which is silhouetted the departing boar, provides an expansive setting. In colouring and treatment the landscape is indebted to Salvator Rosa. The figures themselves are unusually refined and delicate; even Adonis' hunting horn and spear seem more toy-like than real. About them, dead trees are mixed with live ones, denoting the transience of life but also its constant renewal. Throughout too are sprinkled autumnal reds, a reminder of the shedding of blood which in this instance is as much a rebirth as a dying. Barry emphasizes the sentimental nature of this drama, depicting an elegiac pastoral bathed in the glow of the setting sun rather than a heroic tragedy.

8　THE DEATH OF GENERAL WOLFE

Exhibited at the Royal Academy in 1776
Oil on canvas, 58½ × 93 (148.6 × 236.2)
Pressly: P18 [to be added to 'Literature':
　Dennis Montagna, 'Benjamin West's "The
　Death of General Wolfe": A Nationalist

Narrative', *The American Art Journal*, XIII,
Spring 1981, pp.77 and 80]
*New Brunswick Museum, New Brunswick,
Canada courtesy Dr J.C. Webster*

This painting, which depicts General Wolfe dying
at the Battle of Quebec in 1759, is Barry's only can-
vas treating a modern subject in the rhetoric of his-
tory painting. Two Louisbourg Grenadiers support
Wolfe, while to the left stand a grieving naval officer
and a midshipman. Behind them can be seen sailors
pulling cannons up the cliff forming the north bank
of the St Lawrence River with a glimpse of the masts
of the anchored fleet beyond. At the lower left,
daringly cropped by the frame, are the bodies of two
of the vanquished – a French officer and his Indian
ally. At the right Lt Browne points to the troops
advancing across the Plains of Abraham toward the
upper town of Quebec as he brings news of the
British victory to the expiring general.

In choosing this subject Barry was following in the
footsteps of Benjamin West, who had exhibited a
similar painting at the Royal Academy in 1771
(fig.11). Though there had been earlier pictures of
Wolfe's death, West was the first to raise this scene to
the level of a history painting, and Barry obviously
intended his canvas as a challenge to his rival's highly
popular interpretation. Because history painting was
meant to portray an idealized truth, contemporary
subjects, which were uncomfortably close to every-
day reality, had traditionally been thought unsuit-
able for such august treatment. In his conception of
this event, West deliberately departed from mun-
dane facts in order to achieve that higher truth
required by academic theory. One such departure
was his inclusion of a large number of prestigious
onlookers whose presence underscores the scene's
sober dignity. Barry obviously objected to the
introduction of so many likenesses, not only because
few of these men were actually present at the
general's death but also because they threaten to turn
the painting into a group portrait. However, even
while attempting to recreate a more accurate cast of
characters, he too employs the ennobling rhetoric of
history, but his work, unlike West's, ultimately fails.
His mannered poses and pathetic gestures were
uncongenial to this type of modern subject, and he
afterwards avoided similar scenes of contemporary
events, turning down in 1782 an opportunity to
travel to America to paint the exploits of George
Washington.

Along with 'The Death of General Wolfe', Barry
exhibited one other painting, 'Ulysses and a
Companion'. Given his intense interest at this
time in the American colonies' struggle for greater
freedom (see, for example, nos.21, 24 and 26), both
these works may in fact subtly refer to political
developments in America (for such an interpret-
ation of 'Ulysses and a Companion' see no.20). At
the time Barry began his painting of Wolfe's
victory, American troops were pressing into Canada
under the command of the Irish-born General

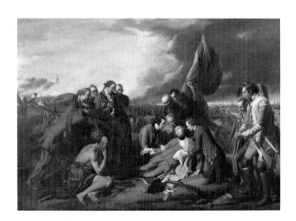

fig.11 Benjamin West 'The Death of General Wolfe'

fig.12 Henry Walton 'Plucking the Turkey'

Montgomery, who, in his turn, was to lay siege to Quebec. If the artist conceived this painting in anticipation of another victory of the attacking forces, which at the moment he began this work appeared highly likely, he was to be disappointed as Montgomery's army was defeated with the general himself dying in the assault. The interjection into these paintings of hidden allusions to the disintegrating situation with America would not have been unprecedented. At that same moment Henry Walton exhibited at the Society of Arts a genre scene of a woman plucking a bird (fig.12), and while at first glance this appears to be a simple, dignified subject without any ulterior motives, the fact that the comely maid is plucking a turkey (a bird that was so closely associated with America that Benjamin Franklin advocated its adoption as the national symbol over that of the bald eagle) gives it a political dimension as well. Because Walton's picture is a pro-English statement reflecting popular sentiment against the ungrateful colonies, its meaning is not so well hidden.

EARLY HISTORICAL DRAWINGS

The artist Ozias Humphry wrote in 1772, 'It is a constant maxim w[ith] B.[arry] in making designs and after having first made a rude imperfect sketch of the Idea to get an outline from it correct or nearly so w.th a lead pencil or Crayon and then to fix it w.th a pen & ink – he recommends to avoid a multiplicity of lines but to get every thing correctly as possible with one' ('Notebooks of Ozias Humphry', British Library, pp.3–4). Humphry's statement makes clear, as does the evidence of the drawings themselves, Barry's efforts to achieve a simplified linear style. The emphasis in his early designs is on surface patterns composed of fluid, unbroken contours rhythmically flowing with a frieze-like clarity. Barry's expressive, abstract style with its stress on linear purity forms part of a reformist impulse which, as Robert Rosenblum has documented, influenced much of the art of the late eighteenth century. His early drawings, however, are particularly noteworthy for their almost fragile delicacy: the lines are thinly drawn and the figures are pliant and languid, exhibiting the graceful refinement of Hellenistic sculpture or of such Mannerist sources as the works of Parmigianino.

9 STUDY AFTER MICHELANGELO'S ADAM IN 'THE CREATION OF MAN' *c.*1767–70

Pen and ink and pencil, $10\frac{1}{2} \times 16\frac{1}{4}$ (267 × 413)
Pressly: D102
Private Collection on loan to Gainsborough's House, Sudbury

This drawing is a copy after Michelangelo's celebrated figure of Adam in 'The Creation of Man' in the Sistine Chapel. The sublime, monumental cycles of Michelangelo's ceiling frescoes and Raphael's nearby Vatican Stanze provided a major source of

inspiration for artists of this generation. Although this is an early work, there is nothing tentative about its execution. It is an elegant study drawn with firm, precise outlines. Because Barry relies heavily on line rather than subtle gradations in tone, his modelling of the figure is more schematic than Michelangelo's. It is also interesting to see him employing soft, parallel hatching at such an early date, a technique that he was to use more extensively and forcibly in later years.

In 1801 Barry issued a print focusing on Jonah (no.73), another figure in Michelangelo's Sistine Ceiling. Of interest is how different is his choice of a male nude from the frescoes. In the early work he selects a figure that is classical and serene in conception, possessing an appealing melancholy languor, while the later figure is more extravagant and distorted in its pose and more animated in its execution, an example of Michelangelo's *terribilità*, which Barry in later years had come to admire so greatly.

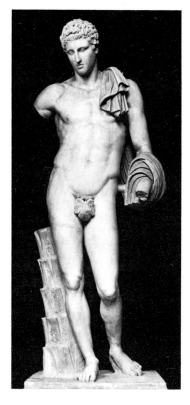

fig.13 Belvedere Antinous

10 MELEAGER *c*.1767-70

> Pen and brown ink on Italian watermarked paper, $8\frac{3}{4} \times 6\frac{5}{8}$ (22.2 × 17)
> On verso: another study of the head of Meleager
> Pressly: D1
> *Visitors of the Ashmolean Museum, Oxford*

Following Winckelmann's suggestion that the statue in the Belvedere courtyard of Antinous, a deified favourite of the Emperor Hadrian, was in fact a representation of Meleager, the renowned hunter who slew the Calydonian boar, Barry based his conception on this famous work (fig.13). His rendering, a free adaptation, corrects faults that he found in the original: 'The Meleager (commonly called the Antinous of the Belvedere) I often, as well as many others, thought had a little caricatura in the sway of the attitude. Upon a very narrow inspection, I see it was occasioned by the restoring and putting of the figure together' (*Works*, I, p.168). The menacing boar's head, on the other hand, is probably based on the rendering to be found in the Pighini Meleager. Although the artist has made a half-hearted attempt to sketch in a minimal landscape setting, his figure of Meleager appears frozen in time and space like the antique statue on which it is based.

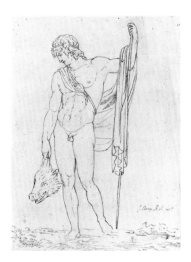

10

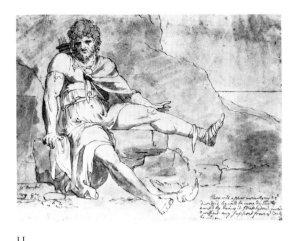

11

11 PHILOCTETES ON THE ISLAND OF LEMNOS 1770

Pen and brown ink and grey wash on Italian watermarked paper, $8\frac{1}{4} \times 11\frac{1}{4}$ (21×28.7)
Pressly: D6
Private Collection

This drawing is a preliminary study for the painting of the same subject (no.2). In this instance Barry chose a horizontal rather than a vertical format, thereby placing greater emphasis on the wounded foot. The inscription at the lower right reveals to what extent he was trying discretely to emphasize the pain inherent in his subject in accordance with Burke's pronouncements on the sublime: 'There will appear more Agony & ye disorderd leg will be more distinctly mark'd by having it stretched out in air & without any support from ye rock he sits on.' Philoctetes' head is downcast, and the mood is one of private torment, while in the painting he looks heavenward, suggesting that there is a spiritual dimension underlying his profound suffering.

This drawing is a more forceful and ambitious study than anything Barry had attempted up to this time, at least that has survived. Like the 'Adam' and the 'Meleager', it is heavily dependent on outline, although, in keeping with Burke's criteria for the sublime, the line here is more jagged and broken. The smooth, continuous contours of the earlier works have been intentionally discarded in favour of a staccato rendering. He also now tentatively employs wash to suggest volume, but the handling is more perfunctory than that of the 'Ecce Homo' (no.12), executed just a few years later.

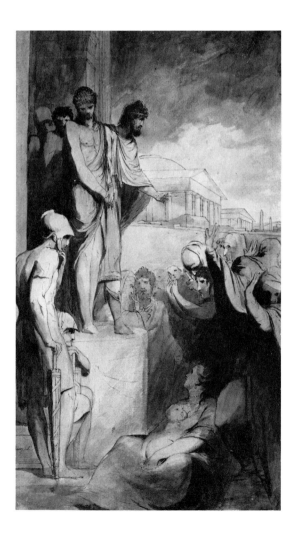

12 ECCE HOMO c.1773

Pen and brown ink and brown wash, $17\frac{1}{2} \times 10\frac{1}{4}$ (44.5×26.1)
Pressly: D10
Trustees of the British Museum, London

In 1773 the dean and chapter of St Paul's Cathedral approved a plan, which had originated with Barry, designating six Royal Academicians to decorate St Paul's with Biblical pictures approximately fifteen to twenty feet in height. Barry, Reynolds, West, Angelica Kauffmann, Cipriani, and Nathaniel Dance were the participating artists, but the project never materialised as it was eventually vetoed by the Archbishop of Canterbury and the Bishop of London.

Barry's contribution was to have been 'The Jews Rejecting Christ when Pilate Entreats his Release', for which this drawing is a preparatory study. Traditionally, this often painted moment in the Passion is entitled 'Ecce Homo' (Behold the Man), which are the words spoken by Pilate when Christ is brought before the people. The drawing shows Christ bound by the wrists and wearing the crown of thorns with Pilate at his side. Behind him stands the criminal Barabbas, whom the people call on Pilate to release in Christ's stead. It is probably the High Priest Caiaphas who is shown at Pilate's feet stirring up the crowd.

Barry's conception with its willowy figures and receding architecture is based on Tintoretto's 'Christ before Pilate', but his rendering is so highly classicized that the subject matter was at one time identified as 'The Old Horatius Presenting his Son to the People to Save him from the Lictors'. The first of the large classical buildings in the background resembles the Pantheon, while the obelisks offer more of a reminder of Pope Sixtus V's Rome than they do of ancient Jerusalem. For Barry, the classical and Biblical worlds were never far apart: both were exemplars of a heroic antiquity embodying universal truths. The drawing is executed in unusually thin and delicate lines, its vertical dimensions accentuating the figures' elongated, tapering forms. The architecture with its simplified geometries is executed in the purist of outlines in contrast to the dramatic, chiaroscuro effects of the foreground wash.

13 ST MICHAEL OR THE FALL OF SATAN

Early 1770s
Pen and brown ink and black chalk with white highlights on beige paper, oval,
$30\frac{1}{4} \times 19$ (76.8 × 48.8)
Pressly: D9
Visitors of the Ashmolean Museum, Oxford

According to the inscription on the 1777 print of St Michael casting out Satan (no.23), this was the subject that Barry intended for St Paul's Cathedral. His drawing of this scene is unusually large and ambitious, and it may well predate the 'Ecce Homo'. However, it probably only supplanted this last subject as the one for St Paul's when the artist, angered over the veto of the Bishop and Archbishop, decided to show the forces of good triumphant over error.

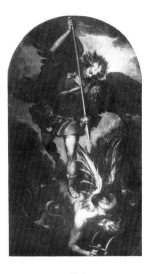

fig.14 Denys Calvaert,
'St Michael'

The subject is from *The Book of Revelation*, and there were a number of impressive prototypes for this familiar scene on which Barry could draw. His interpretation comes closest to that of Denys Calvaert's altarpiece of St Michael in the Church of St Peter at Bologna, a work which he would have seen during his stay in that city in the latter part of 1770. Barry, however, replaced the spear with lightning bolts, and he abandoned the Baroque projection of Calvaert's design in favour of a figure which, with the exception of its right leg, remains basically in a single plane. His drawing with its subtle, rhythmic tensions, often conveyed through the finest of lines, exhibits a graceful precision. St Michael is a serene and majestic hero who is as beautiful as any classical warrior. Later in his print of 1777, Barry discarded the decorative oval format and the distracting angelic choir, while executing the figures and background in a more dramatic fashion.

14 ST SEBASTIAN *c.*1776
Pen and brown ink and grey wash (green stain at feet and legs, dark stain near top),
$10\frac{5}{8} \times 6\frac{7}{8}$ (27 × 17.6)
On verso: another study in reverse of this same subject
Pressly: D13
National Gallery of Ireland, Dublin

The Emperor Diocletian ordered St Sebastian, a commander of a company of the Praetorian Guard, to be bound and shot to death with arrows when he refused to renounce his faith in Christ. Abandoned for dead, the saint survived this first attempted execution, only to be clubbed to death when he again defiantly appeared before the emperor. Because there are no arrows in Barry's drawing, the subject has sometimes been identified as Prometheus, but the drawing's relationship to the print of St Sebastian (no.62) leaves no doubt as to its subject matter. Barry emphasizes the private anguish of the saint's ordeal. Alone in a remote wood, the melancholy victim endures with heroic restraint.

Barry signed the recto at the lower right. The lines on the more schematically rendered verso, which may have come later, are extended in such bold strokes that portions have stained through to the other side. In a disembodied sketch at the lower right of the verso, he also tried an alternate position for St Sebastian's head, a solution that he ultimately rejected.

verso *recto*

II EARLY PORTRAITS, 1767–1776

All Barry's early portraits whose locations are known are exhibited here; it is a small but distinguished group. At least five other portraits from this early period are now missing, but the number was never very large. For all practical purposes Barry was to abandon the painting of commissioned portraits after this early creative burst with the exception of those few works that evolved out of the study of heads for the series at the Society of Arts. To explain his small output, some of his contemporaries maintained that he would contemptuously dismiss potential patrons with the comment that such work was beneath his dignity as a history painter and that they should go see the fellow in Leicester Fields, meaning Sir Joshua Reynolds. Probably closer to the truth is that he would have welcomed patrons, but his irascible temperament and delapidated studio discouraged those who might have sat to him.

Of those sitters that Barry did paint, most were well-known to him, coming out of the circle of Edmund Burke's family and friends. Because of this, he felt a strong empathy for his subjects enabling him to capture a sense of their inner character. Relying on his training as a history painter, he also excelled in his ability to ennoble and dignify his sitters, and his approach to composition was often fresh and original. Although his production in this genre was exceedingly small, he did create a handful of masterful works, and it can only be regretted that he had so few opportunities.

15 SELF-PORTRAIT WITH PAINE AND
 LEFÈVRE c.1767

Oil on canvas, $23\frac{1}{2} \times 19\frac{1}{2}$ (59.7 × 49.5)
Pressly: P37
National Portrait Gallery, London

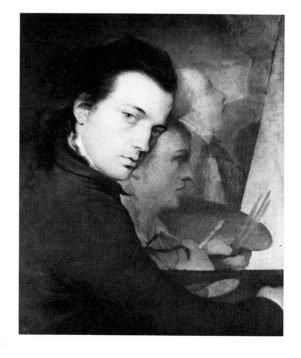

Dated 1767 in the Christie's sale of Barry's effects, this picture is the artist's earliest self-portrait. Even if there were earlier ones that have subsequently disappeared, it is doubtful they could have been of this quality. Executed when he was studying in Rome, it is a testament to his having come of age as an artist.

Barry shows himself in the act of painting two fellow artists in a picture within the picture. According to the entry in the Christie's catalogue, the other portraits are of James Paine, Jr (1745–1829) and Dominique Lefèvre (c.1737–69). Paine holds a palette and brushes, and Lefèvre, the last of the three figures, clasps a portfolio. Barry knew and admired Paine, who was in Rome studying to become a sculptor (see *Works*, I, p.82), and a comparison of Paine's features with Reynolds' portrait of him and his father of 1764, now in the Ashmolean Museum, Oxford, confirms the identification. Lefèvre was a

respected member of the French Academy who had won the Prix de Rome in 1761.

Both Paine and Lefèvre are shown admiring the Belvedere Torso (fig.7), which is in the upper right corner of the painting within the painting and which they are apparently in the act of sketching on the canvases before them. For Barry, this sculpture was the greatest surviving work of antiquity, the modern artist's primary source of inspiration. As he later told the students at the Royal Academy, 'When I speak of the superior intelligence of design in the antique statues, I would be understood to mean a few only. The Torso of the Belvedere, is as to perfection really *unique*. There is nothing that can be put into the same class with it' (*Works*, I, p.447). His enthusiasm for this work was not unusual, Michelangelo's well-known admiration having secured its fame. Since Barry looks out into the viewer's space in order to paint his friends with the Belvedere Torso beyond, then the Torso should be perceived as towering behind and above the viewer as well.

Barry's head, an idealized portrait of himself as a youthful genius, is clearly distinguished from those of his two friends, who exist on a different plane of reality. Yet all three heads are juxtaposed closely together, establishing a rhythmic progression: Barry's head is tilted downward and is seen in a three-quarter view; Paine's is level and in profile; and Lefèvre looks up and back toward the Belvedere Torso. The Torso itself is partially eclipsed by Paine's and Lefèvre's canvases and is squeezed into the upper right corner. These tight juxtapositions and the ensuing sense of compression are elements that Barry exploits to even greater effect later in his career.

16 EDMUND BURKE *c.*1771

> Oil on canvas, 30 × 25 (76 × 63.5)
> Pressly: P38
> *Provost, Fellows and Scholars of Trinity College, Dublin*

Compositionally, this portrait of Edmund Burke (1729–97), Barry's friend and supporter, is similar to the 'Self-Portrait with Paine and Lefèvre'. The figure is seen almost from behind with one arm cutting across the foreground, while the head is turned back toward the viewer. In the Christie's sales catalogue of 1807, one of the paintings is described as, 'Edmund Burke, demonstrating his positions on

the Sublime and Beautiful, painted about the year 1771' (lot 71). If this entry can be identified with this portrait, and on stylistic grounds the 1771 date is a highly likely one, then Burke is elaborating on those aesthetic categories of the sublime and beautiful that he had already discussed in his book of 1757, a book that had had a strong impact on the young painter.

Employing a subdued and limited palette, Barry shows the philosopher-statesman sunk in reverie in the privacy of his study. It is a highly intimate portrayal of a great man to whom he was profoundly indebted. However, it is of interest that there is no record of Burke having ever owned a portrait of himself by Barry, and apparently this particular painting remained in the artist's possession. Barry's intolerance of his indebtedness to Burke had completely poisoned their relationship within a few years after his return from Rome. In 1774 he again painted Burke's portrait, this time for their mutual friend Dr Richard Brocklesby, but this commission, although eventually completed, embroiled the artist and his sitter in a bitter quarrel.

17 JOHN NUGENT *c.*1771–2

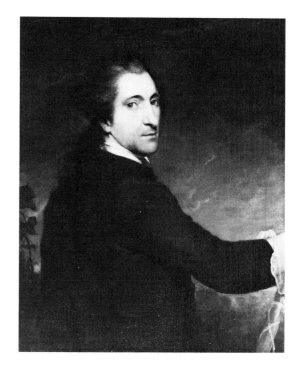

> Oil on canvas, 30 × 25 (76 × 63.5)
> Pressly: P42 [Provenance: By descent to the
> sitter's daughter Mary, who married in 1824
> the Ven Isaac Wood (1795–1865) of Newton
> Hall, Cheshire; by descent to her son
> Edmund Burke Wood of Moreton Hall,
> Chirk, Shropshire; by descent to his
> daughter Mary Stephanie Burke Wood;
> sold Christie's, 20 November 1981 (131)]
> *Private Collection*

John Nugent (1737–1813), a Surveyor of Customs, was Edmund Burke's brother-in-law, and his friendship with the artist dates from Barry's earliest years in London. The twisting pose seen from a modified back view recalls that used in the 'Self-Portrait with Paine and Lefèvre' and 'Edmund Burke'.

This is Barry's only known early portrait that depicts the sitter in a landscape, but the vine at the left is practically a signature, appearing in a number of the artist's historical works. The Christie's sales catalogue of 1981 describes Nugent as holding the hilt of a sword, but he more likely grasps a walking stick, its appearance being similar to the cane with braided cord in Reynolds' 'Portrait of Colonel

George Morgan' of 1788, now in the National Museum of Wales. Because the painting's dimensions fit a standard size, it does not appear to have been trimmed, the radical cutting of the right hand by the picture frame having been intentional. The portrayal of a gentleman in a landscape with arm extended, his hand resting on a walking stick, is a common one in British portraiture at this time, but Barry offers a fresh and unconventional variation by choosing a back view, by dramatically cropping the figure, and by having the sitter dwarf the trees which can be glimpsed beneath his arm.

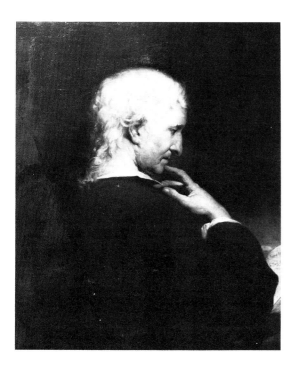

18 CHRISTOPHER NUGENT, M.D. 1772

Exhibited at the Royal Academy in 1773
Oil on canvas, 30 × 25 (76 × 63.5)
Pressly: P43
Victoria Art Gallery, Bath City Council

Christopher Nugent (*c*.1715–75) was the father of John Nugent and the father-in-law of Edmund Burke. When Barry moved to Suffolk Street around the summer of 1772, Nugent lived across the road from him. A Roman Catholic physician, he was a member of the Club along with men of the stature of Dr Johnson, Reynolds, Burke and Oliver Goldsmith.

Barry presents Nugent philosophically musing over an open book, and he exhibited this portrait at the Royal Academy in 1773 along with that of Giuseppe Baretti (no.19), who is also shown reading. The painting is the same size as the other family portraits of Dr Nugent's son (no.17) and of his son-in-law (no.16). The connection in fact with Burke's portrait is unusually strong, and it may even have been that Barry intended to exhibit these last two works as pendants before he painted the picture of Baretti.

'Christopher Nugent, M.D.', the finest of the early portraits, is an image of timeless nobility. There is an unusual sensitivity in both its execution and conception. The principal focus is on the head, which is linked to the cropped book at the lower right through Nugent's gaze and his elegantly posed hand. His hair is beautifully rendered, its cascade of curls gracefully flowing down as in a Roman portrait bust. The rich skin tones are subtly modulated with the deep russet of the gown carried over into the face, and the dark shadows beneath the eyebrows enhance the mood of solemn meditation.

19 GIUSEPPE BARETTI

 Exhibited at the Royal Academy in 1773
 Oil on canvas, 28 × 24 (71.1 × 61)
 Pressly: P44
 John Murray

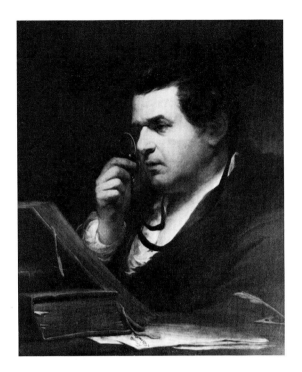

Barry presents the Italian Giuseppe Baretti (1719–
1789), who, as the painting suggests, was notoriously
short-sighted, as both a scholar and an author.
Baretti lived in London from 1751 until 1760, when
he returned to Italy, but by 1766 he was back in
England, where he was to live for the remainder
of his life taking only occasional trips abroad. By
1773 when this picture was exhibited at the Royal
Academy, he had published a number of important
works, including *A Dictionary of the English and
Italian Languages* and *An Account of the Manners and
Customs of Italy*. Barry, however, calls attention to
his periodical *Frusta Letteraria*, which Baretti had
published in Venice from 1763–5 until the auth-
orities suppressed it because of its abusive treatment
of other literary figures. Four years later in London
Baretti was again embroiled in difficulties, but this
time of a different and more serious nature, having
killed a man with his knife in a street scuffle.
Fortunately, with the support of such friends as Dr
Johnson, Reynolds and Burke, he was acquitted of
the charge of murder. Argumentative, proud, frank
and truculent, his personality was not unlike that of
Barry's own. Looking at this portrait, one can feel the
force of Dr Johnson's remark to Boswell: 'Sir, I
know no man who carries his head higher in con-
versation than Baretti. There are strong powers in his
mind. He has not, indeed, many hooks; but, with
what hooks he has, he grapples very forcibly.'

 Barry submitted this portrait along with that of Dr
Nugent to the Royal Academy exhibition of 1773,
and because they were entered late, one assumes that
it was the 'Baretti' that was not completed until the
last moment since the 'Dr Nugent' is dated 1772.
The portrait remained in the artist's possession and
must have been intended from the beginning as an
exhibition piece to accompany its companion. Like
the 'Dr Nugent', it is a heroic and monumental
conception, and, in both cases, one is reminded of
Barry's comment about the Earl of Chatham: 'mo-
dern degeneracy had not reached him . . . the features
of his character had the hardihood of Antiquity' (see
no.27).

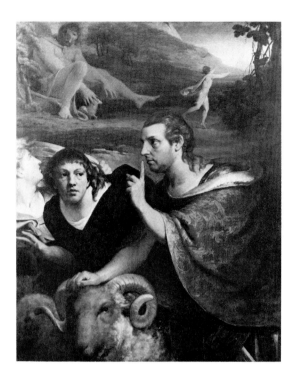

20 PORTRAITS OF BARRY AND BURKE IN THE
CHARACTERS OF ULYSSES AND A
COMPANION FLEEING FROM THE CAVE OF
POLYPHEMUS

Exhibited at the Royal Academy in 1776
Oil on canvas, 50 × 40 (127 × 100.8)
Pressly: P48
Crawford Municipal Art Gallery, Cork

This picture is simultaneously a history painting showing a famous episode from Homer's *Odyssey* and a group portrait showing Edmund Burke and Barry together. On one level, Ulysses and his companions are escaping from imprisonment at the hands of the brutal cyclops who was eating his way through the entrapped Greeks. After having blinded Polyphemus, they escaped from his cave by clinging to the bellies of his sheep as he turned his flock out to pasture. On another level, Burke and Barry are fleeing some contemporary danger, probably having to do with their opposition to the government's prosecution of the American war. Burke is assigned the role of Ulysses, and his cautioning gesture is typical of his relationship with the artist, for whom he was always counselling moderation. His head so closely resembles that of Barry's earliest portrait (no.16) that it may well have been based on it, even though it is more realistically rendered than before. Perhaps the artist wished to surprise Burke with this characterization of him as a resourceful leader at a time when their friendship had already experienced severe strains.

Unlike Reynolds' celebrated attempts at historical portraiture, Barry insists on distinguishing between the two genres. As in a portrait, he and Burke are cut by the bottom edge of the frame, while the cyclops and the on-going escape are positioned behind. In addition, the realistic, sharply focused treatment of his own head and Burke's is contrasted with the highly idealized features of the figure beside them and with the dream-like quality of the background hovering over their heads.

Barry's solution to the issues raised by historical portraiture was highly unorthodox; indeed this work is without precedence in the history of art. The other painting that he exhibited at the Royal Academy in 1776, 'The Death of General Wolfe' (no.8), is also an experiment in the introduction of contemporary

portraits into a historical composition. However, while this last work is a modern subject executed in the rhetoric reserved for history painting, 'Ulysses and a Companion' is a classical subject populated with modern figures. It is painted in brighter colours than had been usual for Barry up to this time, and the hallucinatory quality of this haunting image of a terrifying flight from danger makes it one of the more curious and disturbing portrayals of the eighteenth century. Operating simultaneously on a number of levels, it is a work of unsettling, psychological complexity, heralding the explorations of the inner life of the artist associated with Romantic portraiture of the nineteenth century.

III PRINTS AND PROPAGANDA, 1776–1778

Barry turned to printmaking in part out of a desire to communicate more forcibly his strong opinions about social injustice. Because they were relatively inexpensive and could be produced in great numbers, prints could reach a larger and more diverse audience than could paintings. They also allowed for a more literal presentation of didactic messages and could incorporate within their imagery lengthy explanatory texts that were impossible in the higher realm occupied by oils. In this medium there was already a long tradition of political and social commentary which had reached new heights in England in the work of William Hogarth. Because 'The Resurrection of Freedom' is Barry's most direct attack on the contemporary establishment, it is comparable to a print such as Hogarth's *The Times*,

Plate I of 1762, yet it lacks Hogarth's black humour and ironic cutting edge. Even in such a topical work as this Barry's group of solemn mourners possesses a sober, heroic dimension that is absent from the vast majority of overtly political prints of his generation. Works such as 'Job Reproved by his Friends' and 'The Conversion of Polemon', on the other hand, can be read entirely as straightforward historical subjects drawn from the Bible and from classical literature. On another level, however, they are as topical as 'The Resurrection of Freedom', also offering support to England's liberal politicians. In addition, all of the prints in this section are of a large size, their message being proclaimed as one of importance, all the more so because they directly or indirectly address modern issues.

21 THE PHOENIX OR THE RESURRECTION OF FREEDOM 1776

Etching and aquatint (brown ink)
$17 \times 24\frac{1}{8}$ (43.1 × 61.3)
Pressly: PR8 II
Trustees of the British Museum, London

This print is a biting indictment on the condition of contemporary England. Inscribed in the lower margin is an address to Liberty who has expired in England only to be reborn in North America: 'O Liberty thou Parent of whatever is truly Amiable & Illustrious, associated with Virtue, thou hatest the Luxurious & Intemperate & hast successively abandon'd thy lov'd residence of Greece, Italy & thy more favor'd England when they grew Currupt & Worthless, thou hast given them over to chains & despondency & taken thy flight to a new people of manners simple & untainted.' Reconstructing the fragmented writing on the tombstone at the left, one reads the king's damning message: 'Upon pain of my displeasure death and Torture I prohibit

my Subjects holding any Intercourse with those Audacious Assertors of human Rights on the other side of this Atlantic Given at our Palace.' The recomposed message on Britannia's bier is equally pointed: 'This Monument to the Memory of British Freedom a Currupt degenerate Nobility & Gentry, dissipated poor rapacious & dependent upon the Court'. At the right behind the image of Britannia, who died when freedom itself was extinguished, are the mourners Algernon Sydney, John Milton, Andrew Marvel, James Barry, and a seated John Locke. The first three men had all supported the Commonwealth (Sydney had even been executed for his beliefs), and Locke clutches his writings on government which also fostered republican virtues. Barry of course is the latest in this distinguished line of supporters of British liberties. The chained figure in front of the bier has a paper emerging from the back of his coat which alludes to the government's attempts at repression through violations of the Habeas Corpus Act. The numerous inscriptions make clear the role the ruling élite and the artistic establishment have played in debasing civilization in England. At the far left Father Time sprinkles flowers over the remains of those earlier civilizations of classical Athens, republican Rome, and Renaissance Florence in which liberty and the arts had for a time flourished together. Now Liberty, along with the phoenix, is reborn on top of the classical temple in North America, while the Three Graces dance along the shore.

In many ways, Barry's print is the artistic counterpart to Thomas Gray's poem 'The Progress of Poesy', published in 1757, in which poetry, a civilizing force associated with political freedom, moves, like the sun, from Greece to Italy to England. Barry too makes the association between liberty and the arts, but he extends their westward migration to America's shores. Later at the end of his third lecture to the students at the Royal Academy he was to state with equal clarity his conviction that a corrupt England could not support great art but there was hope that history painting might yet flourish in a vigorous and virtuous America.

The print of course makes a much more forceful attack on the contemporary establishment than does his lecture, and in this instance, deciding that discretion was the better part of valour, he did not sign his name. Only the publisher's name, John Almon, appears, and Almon, an active member of the

political opposition, already had a long history of boldly challenging the authorities. Yet, in the print at the bottom of the tombstone, Barry did inscribe the cryptic phrase 'U & C fecit' (i.e. U and C made this). Perhaps these initials refer to 'Ulysses and a Companion' (see no.20), in which case the chained figure with the long, straight nose may represent Edmund Burke.

22 STUDY FOR THE ETCHING 'THE PHOENIX
 OR THE RESURRECTION OF
 FREEDOM' *c.*1776

Pen and brown ink with brown wash, some underdrawing in pencil and red chalk,
$15\frac{5}{8} \times 23\frac{15}{16}$ (39.7 × 60.7)
Pressly: D14
Victoria and Albert Museum, London

This drawing is preparatory to the print. Because many of the lines are incised, the image was presumably traced so that it could be transferred on to the ground of the copperplate. With its effective use of wash, it is a finished work in its own right, an excellent example of the artist's early style, and Barry was pleased enough with it and so signed it on the base of the bier.

23 THE FALL OF SATAN 1777

Etching and aquatint (brown ink)
$33\frac{1}{4} \times 23\frac{15}{16}$ (84.4 × 60.8)
Pressly: PR9 II
Hunterian Art Gallery, University of Glasgow

Barry dedicated this print to the dean and chapter of St Paul's, who had approved the Royal Academicians' plan to decorate the cathedral with history paintings. It is meant to show what had been lost because of the misguided opposition of the Archbishop of Canterbury and the Bishop of London, who had blocked the scheme citing England's long-standing bias against religious imagery. At the same time the subject is itself a comment on how such prejudices should be overcome. On one level, then, it represents the militant artist scourging the errors of an unenlightened, hostile society.

The print differs considerably in effect from the earlier drawing (no.13) from which it evolved. St Michael's stance is more dynamic, and the rugged, dark, precipitous clouds provide a sublimer setting.

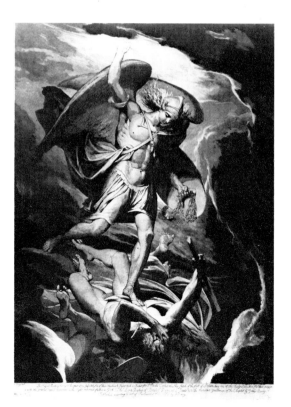

24 JOB REPROVED BY HIS FRIENDS 1777

Etching and aquatint (brown ink) (touched
proof), $22\frac{3}{8} \times 29\frac{3}{4}$ (56.9 × 75.6)
Pressly: PR10 II
*Yale Center for British Art, New Haven
(Paul Mellon Collection)*

Beset by disasters on all sides, the long-suffering Job
listens dejectedly to the reproving counsel of his
friends. To the left sit Eliphaz, Bildad, and Zophar,
while behind them the young man Elihu, who
lectures Job in his turn, leans on a staff. Job's wife
touches her husband's shoulder with one hand and
points heavenward with the other. In his book on the
sublime and beautiful, Edmund Burke used nu-
merous examples from *The Book of Job* to evoke the
sublime, awesome dimension of God's omnipotent
power, and, by dedicating his print to Burke, Barry

pays homage to his friend's work as an aesthetician.

This print, however, should also be read as a
political allegory. In a letter of 1800 Barry stated that
'The Conversion of Polemon' was executed as its
pendant. Because 'Polemon' is so clearly related to
contemporary politics, this association invites a
political reading of 'Job' as well. In the companion
print, Polemon represents Charles James Fox, while
Zenocrates, the standing, discoursing philosopher,
represents Burke. When one begins to look for
similar equations in 'Job', it becomes clear that the
features of Job's wife unmistakably resemble those of
William Pitt the Elder (see no.27). Burke should
perhaps be identified with the seated, discoursing
friend to Job's left, since this figure most closely
resembles that of Burke as Zenocrates executed in
the following year. Just as Burke is shown counsell-
ing Fox in 'Polemon', he and Pitt are shown here

counselling a suffering nation that has been afflicted by following the king's government into an unrighteous war with America, the disastrous consequences of which can be seen in the background. It is also possible that Job should be identified with Burke or perhaps even Barry, who, grieving over the misfortunes created by the American Revolution, is counselled by his reproving friends not to despair. All of these readings play havoc with the Biblical story, but, for Barry, in the realm of printmaking the contemporary political message takes precedence over the historical subject through which it is conveyed.

25 STUDY OF THE FIGURE OF JOB FOR THE ETCHING 'JOB REPROVED BY HIS FRIENDS' *c.*1777

Black chalk on coarse beige paper
$10\frac{7}{8} \times 15\frac{7}{8}$ (27.7 × 40.3) (irregular)
Pressly: D15
Visitors of the Ashmolean Museum, Oxford

This figure is a crude and forceful study executed on coarse, heavy paper. As with the drawing 'The Resurrection of Freedom' (no.22), the design is oriented in the same direction as it would appear when etched on to the plate. The print pulled from the plate is of course a reversed image. In both the drawing and the print, Barry portrays a bulky, grieving figure, withdrawn and humbled before the reproof of his friends. The near shoulder is expressively exaggerated and the hands are tightly clenched. To the right of the drawing he tried out an alternate head, and in the final version in the print he returned to the earlier closed mouth but retained the placement of the hood above the eyes, while adding to the height and complexity of its crown.

26 THE CONVERSION OF POLEMON 1778

Etching and aquatint (brown ink) (touched proof), $22\frac{1}{2} \times 29\frac{7}{16}$ (57.2 × 74.7)
Pressly: PR131
Yale Center for British Art, New Haven
(Paul Mellon Collection)

Returning home at dawn after a night of debauchery, the youthful Polemon attempts mockingly to disrupt the discourse of the philosopher Zenocrates, only to

be converted by his wise words. In a letter to Charles James Fox written in 1800, Barry explained his intentions. That Fox should be identified with Polemon is obvious from the dedication, but he went on to state that Zenocrates represents Edmund Burke. Barry claimed that the print was executed to persuade his radical friends, with whom he was a member of a club that met at St Paul's Coffeehouse, that they were mistaken in their assessment of Fox's character and abilities. At that moment the young politician was emerging in Parliament as a persuasive spokesman against the government's handling of the American war, but his indulgence in flamboyant and fashionable excesses in his personal life prevented Barry's friends from taking him seriously. The figure to the left of Zenocrates is probably Barry himself, silencing his companions in order that Burke might have time to persuade Fox to adopt more responsible behaviour. It is of course through this print that Barry convinced his friends of his point of view, its imagery having proved more powerful than any words, and he also obviously hoped that it would play a part in the attempted reformation of Fox's character already undertaken by Burke.

27 WILLIAM PITT, EARL OF CHATHAM 1778

Etching and aquatint (brown ink)
$17\frac{7}{8} \times 14\frac{7}{16}$ (45.5 × 36.7)
Pressly: PR14 1
Trustees of the British Museum, London

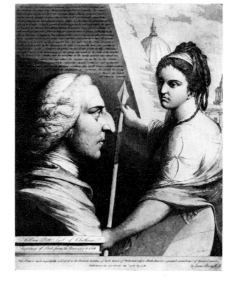

William Pitt the Elder died on 11 May 1778, and Barry issued this commemorative print four months later. He saw Pitt as the reincarnation of a towering, incorruptible antique figure: indeed in 'Crowning the Victors at Olympia' (no.28C) he was to place him in the procession in the character of Pericles, the celebrated Athenian statesman. Barry also uses the memory of Pitt, the uncompromising upholder of English democratic principles, to attack once again King George III and his government: 'his august mind over-awed Majesty, and one of his Sovereigns thought Majesty so impaired in his presence, that he conspired to remove him, in order to be relieved from his superiority'. When Barry later reissued this print in the early 1790s, he scratched out this reference to George's dismissal of Pitt as Secretary of State in 1761, probably not because of any change of heart but because he decided he should be more discrete in his comments about the sovereign.

IV THE PROGRESS OF HUMAN CULTURE

Begun in 1777 and first exhibited in 1783, the series of six murals at the [Royal] Society of Arts offer an Enlightenment programme, illustrating 'one great maxim of moral truth, viz. that the obtaining of happiness, individual as well as public, depends upon cultivating the human faculties' (*Works*, II, p.323). In the first three canvases, Barry shows how an earlier civilization of remarkable brilliance progressed from a primitive to a civilized condition; in the next two he gives examples of how improvement might best be achieved in contemporary England, particularly under the auspices of the Society; and he concludes with his selection of those great men throughout history who have contributed the most to benefit mankind. The paintings are twelve feet high, and stretch across the tops of all four walls unbroken by any windows or intruding door frames. Barry, however, did have to work around two portraits that were already in place. One was a posthumous portrait of the first president, Lord Folkestone, painted by Gainsborough, which hung over the fireplace in the centre of the west wall, and the other, a portrait of the current president, Lord Romney, by Reynolds, which hung opposite. Following the practice of Italian fresco painters, who had no choice but to execute their designs *in situ*, Barry worked on his canvases while they were set in the spaces for which they were intended. An aquatint (fig.15), published in 1809, shows how the room appeared shortly after the artist's death. Since that time the interior has been redecorated on a number of occasions. Although today the murals are positioned slightly higher than before, the amount of direct sunlight has been reduced, and the portraits by Reynolds and Gainsborough have changed places, this, the greatest series of history paintings produced in Great Britain in the eighteenth century, can still be seen little altered by the intervening years.

After the paintings were first exhibited, Samuel

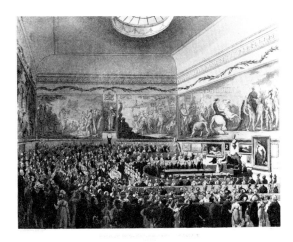

fig.15 A.C. Pugin, T. Rowlandson and J. Bluck, 'The Great Room of the Society for the Encouragement of Arts' 1809

Johnson remarked to Boswell, 'Whatever the hand may have done, the mind has done its part. There is a grasp of mind there which you find no where else.' The programme is complex and often highly personal in its meaning. Despite the fact that the artist wrote a lengthy book to accompany his pictures (see no.99), his full intentions can still be difficult to cipher. In addition, the paintings as a group are not closely integrated. Scenes from the past are mixed with poetic and allegorical subjects, and the picture 'The Distribution of Premiums' is not even a history painting at all but rather a group portrait. Barry's deep commitment and seriousness of purpose, however, as if by force of will, ultimately provides an underlying unity. Beneath it all is his conviction that art and artists play a fundamental role in the advancement of society, helping to ensure the pursuit of happiness of its members.

28 THE PROGRESS OF HUMAN CULTURE
Royal Society of Arts

These six paintings are represented in the exhibition by photographs.

They can be seen *in situ* in the Great Room of the Royal Society of Arts, John Adam Street, on Monday afternoons from 13.00–17.00 hours during the period of the exhibition, and at other times by special arrangement.

28A ORPHEUS 1777–84

> Oil on canvas, 142 × 182 (360 × 462)
> Pressly: P22

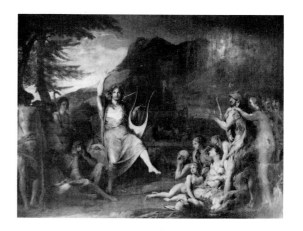

Orpheus is the greatest poet and musician of the classical world. He received his lyre from Apollo and was instructed in its use by the Muses. His abilities were such that he could not only enchant wild beasts but could also make rocks and trees uproot themselves to follow the sound of his music. Barry, however, stated that he did not wish to represent Orpheus in his traditional role 'as a man with so many fingers operating on an instrument of so many strings, and surrounded with such auditors as trees, birds, and wild beasts; it has been my wish rather to represent him as he really was, the founder of Grecian theology, uniting in the same character, the legislator, the divine, the philosopher, and the poet, as well as the musician' (*Works*, II, p.324). Around his head cluster clouds of inspiration, as he pours forth his civilizing songs to his enraptured audience, the savage Thracians. Like so many of Barry's protagonists, Orpheus, an inspired leader, was to die a violent death: the Maenads, angered by his teachings which emphasized Apollo over Bacchus, tore him limb from limb.

28B A GRECIAN HARVEST-HOME OR
 THANKSGIVING TO THE RURAL DEITIES,
 CERES, BACCHUS, ETC. 1777–84

> Oil on canvas, 142 × 182 (360 × 462)
> Pressly: P23

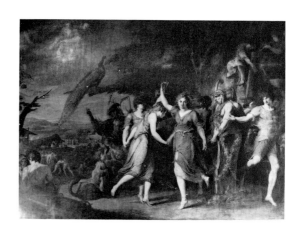

Young men and women dance around a double terminal figure of Sylvanus and Pan in this harvest festival celebrating the rural deities. Barry presents an agrarian paradise modelled on Virgil's *Georgics*, but underlying this celebration is the melancholy realization that with time this 'state of happiness,

simplicity, and fecundity' must come to an end. As
he pointed out, 'it is but a stage of our progress, at
which we cannot stop, as I have endeavoured to
exemplify by the group of contending figures, in the
middle distance, where there are men wrestling'
(*Works*, II, p.327). Competition and strife will
produce a still greater civilization, but there is a
profound sense of loss, as reflected in the pensive face
of the central dancer, at the thought that this idyllic
harmony must soon be left behind.

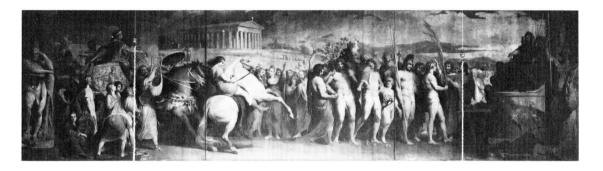

28C CROWNING THE VICTORS AT
OLYMPIA 1777–84

Oil on canvas, 142 × 515 (360 × 1308)
Pressly : P24

Barry recreates the golden age of fifth-century B.C.
Greece in which the finest athletes and thinkers are
brought together at one of the Olympic Games.
Framing the procession are a statue of Hercules
representing physical prowess and a statue of
Minerva symbolizing wisdom. Following Raphael's
example in 'The School of Athens', where the artist
along with other contemporaries appears in the
character of a classical scholar, Barry places himself
in the canvas, next to the statue of Hercules, as the
Greek painter Timanthes. The procession proceeds
from left to right as the victors advance toward the
judges. In the chariot decorated with images of
Minerva and Neptune is Hiero of Syracuse, the
winner of the chariot race. Beside him walks Pindar
playing his lyre and followed by a chorus. Next in
line is the victor of the horse race on a white, rearing
steed. Then, in the first pocket of spectators stands

Pericles with his hand raised, engaged in conversation with Cimon, a political opponent (Pericles' features are those of the Earl of Chatham). Behind him Aristophanes ridicules the immoderate length of his head, while Socrates looks on from the right.

The principal group of victors consists of Diagoras of Rhodes, a former champion, who is carried on the shoulders of his two victorious sons. The winner of the armed race is next in line, and in front of him the winner of the foot-race receives from one of the lesser judges an olive crown and palm branch. Scientists and philosophers are grouped together in the second pocket of spectators, and the three principal judges are enthroned to their right. Behind on the hill is the temple of Jupiter Olympius surrounded by the Altis.

This painting with its stately, frieze-like procession stretching over the entire wall, its large-scale, heroic nudes, and bright, vibrant colours has been the preferred work of the majority of commentators from Barry's day to this. A preparatory drawing for the painting, only one of two for the whole series to survive, is in the Victoria and Albert Museum.

28D COMMERCE OR THE TRIUMPH OF THE
THAMES 1777–84

Tower added in 1801
Oil on canvas, 142 × 182 (360 × 462)
Pressly: P25

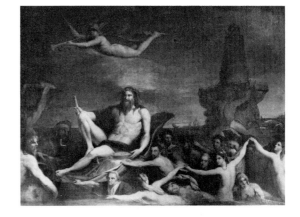

The personification of the Thames, propelled by illustrious British sailors, leads a procession of tritons and nereids who hold aloft various articles of English manufacture. At the left are the four major trading Continents: Asia, Europe, Africa and America. Barry wrote, 'The Thames is carried along by our great navigators, Sir Francis Drake, Sir Walter Raleigh, Sebastian Cabot, and the late Captain Cooke of amiable memory' (*Works*, II, p.332). Raleigh, wearing a hat, appears near the top of the Thames' shell-throne. He is followed by Drake with Captain Cook positioned at the bottom. Cook was killed in a skirmish with natives at Karakooa Bay in Hawaii on 14 February 1779, the news being sent overland as soon as his ships arrived at Petropavlovsk, Kamchatka. He does not seem to appear in the preparatory study for the mural now in

Design for the NAVAL PILLAR.
BRITANNIA VICTORIOUS

fig.16 James Gillray
Design for the Naval Pillar

the Art Institute of Chicago, and presumably Barry was inspired to include him on hearing of his dramatic death. Despite the artist's own description, Sebastian Cabot is not in the painting, Cook having probably replaced him.

Accompanying this procession is the musician Dr Charles Burney, who is playing a keyboard instrument of Barry's own design. Thus, even in this painting devoted to manufactures and commerce the arts strike a dominant chord. But by placing allegorical and historical figures together in the water, the artist created one of his more absurd compositions, providing an irresistible target for his critics. Horace Walpole wryly remarked, 'Doctor Burney is not only swimming in his clothes, but playing on a harpsichord, a new kind of water-music' (Walpole to William Mason, 11 May 1783, *Horace Walpole's Correspondence*, 1955, XXIX, p.300), and one lady let it be known 'that she was by no means pleased with Mr Barry, for representing the Doctor in company with a party of naked girls dabbling in a horse-pond' (E. Edwards, *Anecdotes of Painters*, London, 1808, p.308 n).

In the summer of 1801 Barry added the tower in the background. His conception was prompted by a competition opened in 1799 for a column commemorating Britain's naval victories over the French. Disappointed with the various proposals, he created his own painted memorial which combines, along with an ambitious programme of sculptural reliefs, a mausoleum, an observatory, and a lighthouse. He was not alone in conceiving this project on a gigantic scale. John Flaxman proposed a triumphal arch that, stretching across a wide road, would dwarf the traffic passing underneath, and also designed a colossal statue of Britannia for the top of Greenwich Hill. James Gillray too, fired by patriotic fervour, published his 'Design for the Naval Pillar' on 1 February 1800 (fig.16). Although this contains a number of humorous details, its motivating pride in Britain's naval supremacy is clear enough. Barry's naval pillar is no more realistic than Gillray's, but it is of megalomaniac proportions in that he pretends it to be taken literally. At the time of his death, he was also planning to introduce Admiral Nelson into the painting. What began as a work celebrating the promotion of peace and plenty under the stimulus of benign commerce became increasingly more martial and jingoistic in spirit under the influence of the continuing struggles with France.

28E THE DISTRIBUTION OF PREMIUMS IN THE
SOCIETY OF ARTS 1777–84

Portions added in 1789 and 1801
Oil on canvas, 142 × 182 (360 × 462)
Pressly: P26

This group portrait shows the Society gathered to
distribute its awards promoting the arts, agriculture,
manufacture, and commerce. It is composed around
four major groupings. From left to right, the pre-
sident, Lord Romney, congratulates two farmers,
one of whom is Arthur Young, while the Prince of
Wales looks on; next Elizabeth Montagu presents to
the Duchess of Northumberland a young girl who
holds up a sample of her work; Samuel Johnson
points out Mrs Montagu's beneficent example to the
Duchesses of Rutland and Devonshire; and on the
right are members admiring the drawings of the art
competitors. In the background on the left are
various types of machinery, while works of art
dominate the centre. With its grand, even if implau-
sible, setting, its animated heads and poses, and its
brilliant orchestration of colour, this work is a highly
distinguished group portrait with few peers in the
British School.

Essentially, the painting is about patronage, and in
particular about the patronage of the arts. The artist
not only highlights the Society's distribution of
premiums, but in the background on the right he
includes two other institutions. First comes his
interpretation of the riverfront of Somerset House,
which was already the new home of the Royal
Academy, and beyond is St Paul's Cathedral, which
in this context is to be seen as an institution with the
potential of promoting religious art.

28F ELYSIUM AND TARTARUS OR THE STATE OF
FINAL RETRIBUTION 1777–84

Portions added in 1798 and 1801
Oil on canvas, 142 × 515 (360 × 1308)
Pressly: P27

This painting contains one hundred and twenty-five
identifiable portraits of men of genius selected by
Barry to populate Elysium or heaven. This pantheon
encompasses a wide-range of cultures throughout
recorded history, and it was to spawn a number of
important imitators in the following century. For
example, in the Tate Gallery itself one might men-
tion John Martin's painting 'The Last Judgement'.

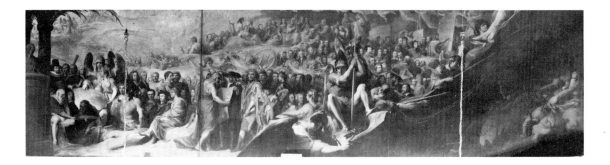

It is by far Barry's most extensive use of portraiture within the context of history painting, and one can sense his struggle to keep the numerous figures from overwhelming the design. In the foreground he has placed the emphasis on philosophers and statesmen in the belief that a society must first be grounded on principles of justice and freedom before the full benefits of civilization can be realized. Poets, writers, and artists dominate the upper regions, and at their apex sits Homer, who, though sightless, is the only figure in the mural to look up as if in a moment of inspiration.

God is placed outside the frame at the left, his radiating beams illuminating Elysium, while the terrifying abyss of Tartarus or hell is at the right, cut off from Elysium by a rocky ledge guarded by angels. These angelic guards are among the most impressive figures in the design, possessing a monumentality and grandeur that is rarely found among the works of British painters.

PRINTS AFTER THE PAINTINGS: THE SMALL AND LARGE SERIES

The project for the Society of Arts was to pre-occupy Barry for the remainder of his career. He not only retouched the paintings on several occasions but also over a number of years executed fifteen prints reproducing various aspects of this series, two sets of seven works each and a late, small reworking of a detail (no.76). In 1783 when the paintings were first exhibited, he had proposed only to produce a print after each mural. At that time he also announced, 'I shall at least execute a great part of the etchings myself, the inferior and more laborious part will be executed by others.' His plan to employ assistants apparently never materialized, and he was also forced to abandon his efforts to use an outside printer, eventually undertaking the etchings entirely on his own. Included in this first set was a

seventh print showing how he wished to complete the Great Room with portraits of the King and Queen, and although all the etchings bear the publication date 1 May 1791, delays in printing prevented him from distributing them until 23 April of the following year. Like most of Barry's prints after his paintings, these reproductions are not exact copies but rather offer slight variations on the original themes. Few of his contemporaries could find much to admire in them. The artist Henry Fuseli was of the opinion that Barry 'after the most heroic perseverance, produced a set of prints, though not absolute caricatures of the work, [were] sufficiently ludicrous to glut the wish of his most decided enemy' (Rev. Matthew Pilkington, *A Dictionary of Painters*, London, 1810, p.30). Even his friends hardly knew what to make of the series. One subscriber was so taken aback by their appearance that he forfeited the money he had already paid rather than pay the half he still owed.

> Mr. Young, a particular friend of his [this is almost certainly Arthur Young, the celebrated writer on agriculture], considering Barry's intended prints from his pictures in the Adelphi to be a national series which ought to be encouraged by the public, went to his house in Castle-street, Oxford-market, and paid half the subscription-money to ensure a set. When they were pronounced finished, he called to pay the remainder, and receive his prints; but, upon his expressing himself with some surprise as to their coarseness of execution, Barry asked him, if he knew what it was he *did* expect?' – 'More finished engravings,' replied Mr Young; who, after experiencing farther rudeness from the artist, took his departure, observing that he was very welcome to keep the money he had already received (J.T. Smith, *Nollekens and his Times*, London, 1828, 1, p.9).

Although these seven prints lack the polished finish of contemporary professional engravings, they still imitate too closely conventional practices and consequently are not among the artist's best works. He clearly found it difficult to reduce paintings conceived on such a heroic scale to the confining dimensions dictated by the size of his

press and copperplates. Having expended so much creative energy on the paintings themselves, there was undoubtedly little left for the prints after them. In contrast, the later Adelphi etchings are bolder in both conception and execution.

On 23 February 1793, within a year after he published his first set of etchings, Barry issued a large detail focusing on the group of legislators in 'Elysium' (no.36). This work allowed him to introduce Lord Baltimore into the cast of characters without retouching the painting, and initially he considered it as simply an extension of the original set of seven. Later, concerned that neither of the two largest paintings, 'Crowning the Victors at Olympia' and 'Elysium and Tartarus', could be adequately reproduced in a single plate, Barry decided to execute three more details, one showing the Diagorides victors in the first painting (fig.17) and the others, 'Reserved Knowledge' (no.37) and 'The Glorious Sextumvirate' (no.38), showing additional excerpts from the foreground of 'Elysium'. Each

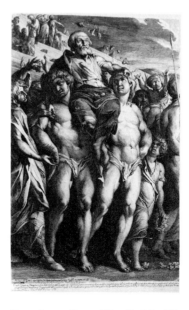

fig.17 James Barry, 'Detail of the Diagorides Victors' state IV *c.*1800

addition to this group of large details was always to be the last. In this instance, the three prints from 'Elysium' reproduce the whole of the lower left-hand side of the picture, but, when first conceived, they did not form an integrated unit. The right-hand edge of 'Reserved Knowledge' was not co-ordinated with the adjoining left-hand edge of 'The Glorious Sextumvirate', and the earliest surviving impression of this last work (fig.18) reveals that initially it did not merge with its right-hand neighbour 'Lord Baltimore'. However, the later, lettered state of the 'Sextumvirate', which was executed early in 1800 and is exhibited here, was altered to blend with 'Lord Baltimore', and on 25 July of that same year Barry published a narrow strip (no.39) which acts as a bridge between it and its other neighbour 'Reserved Knowledge'. At this point the series could be read as a close-knit, continuous frieze of the foreground figures. Then, about two years later he added two more prints (nos 40 and 42) which, positioned to the right of 'Lord Baltimore', continue and complete the recasting of Elysium's foreground. Barry referred to these seven details as the large set and the seven reproducing the entire series as the small set, a distinction that denotes his feelings about their respective merits as much as it does about their relative size. He felt that in the large set that 'less is lost, and a much more dignified and adequate idea of the work is com-municated' (Barry to the Society of Arts, 31 March 1801).

The six large details from Elysium should be read in their proper sequence within the painting (from left to right nos 37, 39, 38, 36, 40 and 42), but when viewed in the order in which they were ex-ecuted, one can see Barry's growth as a printmaker.

There is greater contrast in the prints of 1795 than in the 'Lord Baltimore' of 1793, and the spindly figures of the earlier design are replaced with more compact groupings. Executed around 1802, the final two works, with their alternating zones of light and shadow, are particularly majestic. The com-positions are as crowded as before but the bolder sense of pattern generates greater force and clarity. Now too the monumental scale of the foreground angels effectively contrasts with the receding enclaves of the blessed, and an awesome, plunging abyss replaces the stabilizing base of the earlier designs.

Mary Anne Bulkley, the artist's sister bought in at the Christie's sale the plates and remaining impressions for both the small and large sets of prints after the Adelphi paintings, and in 1808 she published the book *A Series of Etchings by James Barry, Esq. from his Original and Justly Celebrated Paintings, in the Great Room of the Society of Arts, Manufactures, and Commerce, Adelphi*. The works for this edition were printed by a Mr Dixon (presumably John Dixon, the copperplate printer whose address was then 29 Tottenham Street), and the book, which included brief explanatory texts, sold for five guineas stitched and six elegantly bound. The plates probably went through more than one printing, and while posthumous im-pressions are common, contemporary ones, par-ticularly of the large set, are not. The set of details exhibited here are all part of the group of prints that Francis Douce, Barry's close friend, be-queathed to the Ashmolean Museum. Even within this group there is wide variation in that the works are printed on a variety of papers and in black ink of differing tones.

29 ORPHEUS

First published 1792
Etching and engraving (black ink)
$16\frac{3}{8} \times 19\frac{7}{8}$ (41.6 × 50.5)
Pressly: PR17 I
Trustees of the British Museum, London

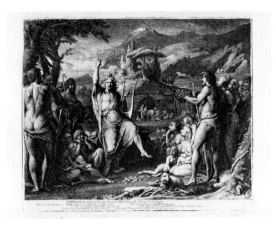

The print is a relatively faithful copy of the painting, although there are minor adjustments as in the introduction of Orpheus' flame-like hair. In the painting Orpheus is over-sized, and in the print the standing figures at either side have been enlarged to correct this discrepancy in scale, but they, along with Orpheus, now dwarf the seated figures in between.

30 A GRECIAN HARVEST-HOME

First published 1792
Etching and engraving (black ink)
$16\frac{5}{16} \times 19\frac{7}{8}$ (41.4 × 50.5)
Pressly: PR18 II
Visitors of the Ashmolean Museum, Oxford

Even more than in the 'Orpheus' there are numerous minor alterations, but the overall interpretation remains substantially the same. The group of dancers has been shifted to the left in order to give more space to the depiction of the aged master of the feast who is accompanied by his wife. The bird, which in the painting was tied to a string held by the mother and child, is now in a cage, but the association of the child with Christ remains in the introduction of the large bunch of grapes lying at his mother's feet. There is a preparatory drawing for this print in the Ashmolean Museum, in which an equally symbolic sheaf of wheat is in the place eventually occupied by the grapes.

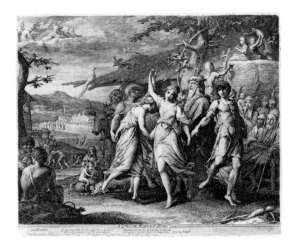

31 CROWNING THE VICTORS AT OLYMPIA

First published 1792
Etching and engraving (black ink)
$16\frac{1}{2} \times 36\frac{7}{16}$ (42 × 92.6)
Pressly: PR19 II
Trustees of the British Museum, London

For this work and 'Elysium and Tartarus', Barry could not retain the same proportions he had employed in the mural. The limitations imposed by his materials restricted the size of the print, and if the height were to remain in the same ratio to the length as it is in the painting, the figures would have been far

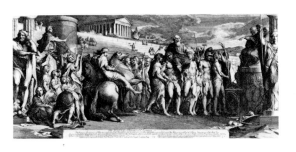

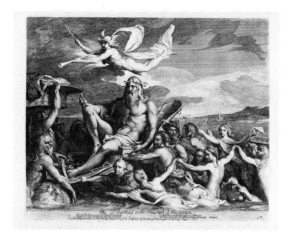

too small. Although overall the composition suffers from the resulting upward expansion, little detail is lost, and the stadium is in fact given greater prominence than before. A preparatory drawing for the print is in the British Museum.

32 THE THAMES

First published 1792
Etching and engraving (black ink)
$16\frac{3}{8} \times 19\frac{7}{8}$ (41.6 × 50.5)
Pressly: PR20 II
Trustees of the British Museum, London

The early states show how the painting appeared before the addition of the naval pillar, which was added to the plate probably late in 1801 or early in 1802 as Barry donated a revised impression to the Society on 3 February of the latter year.

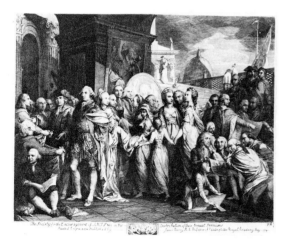

33 THE DISTRIBUTION OF PREMIUMS IN
 THE SOCIETY OF ARTS

First published 1792
Etching and engraving (black ink)
$16\frac{3}{8} \times 19\frac{7}{8}$ (41.6 × 50.5)
Pressly: PR21 I
Visitors of the Ashmolean Museum, Oxford

In 1801 Barry added a number of details to the lower corners of the painting, but, unlike the print after 'The Thames', in this instance he did not introduce these new elements into a late state of the etching. The execution is crude, and one can sympathize with Arthur Young's disappointment and surprise over the coarseness of the series as a whole. In this print, he is shown in profile at the upper left receiving a medal from the president, and he now looks more like an uncouth labourer than a propertied gentleman.

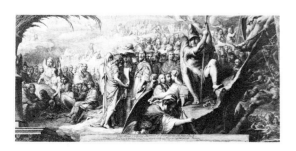

34 ELYSIUM AND TARTARUS

First published 1792
Etching and engraving (black ink)
$16\frac{5}{16} \times 36$ (41.5 × 91.4)
Pressly: PR22 V
*Yale Center for British Art, New Haven
(Paul Mellon Collection)*

Despite the compression necessitated by altering the ratio of the height to the width, few characters have been lost in this condensed version of the painting.

[89]

However, by placing the upper region further in the distance, Homer and his companions no longer play as significant a role, and the foreground angels loom even larger than before. A preparatory drawing for the print, the companion to the one for 'Crowning the Victors at Olympia', is also in the British Museum.

35 KING GEORGE AND QUEEN CHARLOTTE

First published 1792
Etching and engraving with open bite (acid applied directly to the plate with a brush) (black ink), $16\frac{5}{8} \times 20\frac{5}{16}$ (42.3 × 51.7)
Pressly: PR23 III
Trustees of the British Museum, London

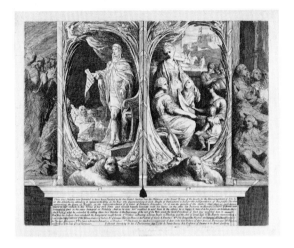

From the beginning Barry had hoped that Reynolds' portrait of Lord Romney, which hung over the fireplace in the centre of the east wall, and Gainsborough's portrait of Lord Folkestone, which hung opposite it, could be removed from the Great Room that he might replace them with works of his own design. This etching shows how he wished to complete the series with paintings of the King and Queen engaged in enlightened activities. The King's portrait, in which he is shown proferring a bill securing the independence of the judges, was to be placed between 'Orpheus' and 'A Grecian Harvest-Home', since, according to Barry, 'the independence and security of those who are appointed for the administration of justice, is the next thing which must be thought of, when Orpheus had persuaded his savages to associate into a civil polity' (*Works*, II, p.436). The Royal Academy of Arts owns a small, crude study for this portion of the design. As stated in the caption, the other portrait shows 'the Queen at Windsor in the Superintendence of a Scene of Domestic Education', and not surprisingly it is the art of painting that is most conspicuously featured. It was intended to hang between 'The Thames' and 'The Distribution' as youthful instruction provides the foundation for future success as is demonstrated in 'The Distribution'. Although in 1801 Barry was to propose yet another scheme of decoration (see nos 88 and 90), he was never permitted to replace the portraits by Reynolds and Gainsborough with works of his own.

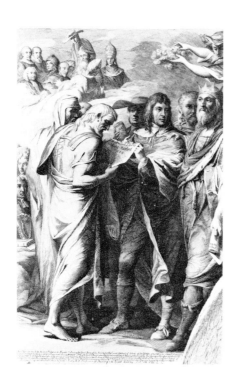

36 LORD BALTIMORE AND THE GROUP OF
 LEGISLATORS 1793

Etching and engraving (black ink)
29 × 18⅝ (73.7 × 47.2)
Pressly: PR24 I
Visitors of the Ashmolean Museum, Oxford

Barry undertook this print to correct what he felt had
been an egregious error in his selection of characters
for the group of legislators in the painting 'Elysium
and Tartarus'. Influenced by his subsequent read-
ing of George Chalmers' *Political Annals of the
Present United Colonies* (London, 1780), he sub-
stituted Cecilius Calvert, second Lord Baltimore, for
William Penn as the first establisher of a free society
in North America. Unlike Penn, Lord Baltimore
looks back to King Alfred, establishing even more
firmly the line extending from this early English
lawgiver to his later descendant. The famous Spartan
legislator Lycurgus reads with interest Baltimore's
code for Maryland, while Numa Pompilius, Penn
and Marcus Aurelius look on.

At the upper left, gathered around Pope Adrian,
are a group of figures of diverse backgrounds whose
lives were dedicated to religious and political con-
ciliation. Several of these figures had not appeared in
the painting, and one of those whom Barry chose to
introduce was Benjamin Franklin, a man whom he
must have known personally when they were both
members of the club of dissenters who met in the
1770s at St Paul's Coffeehouse. Franklin had died in
1790, and Barry based his portrait on the engraving
of 1777 by Augustin de Saint Aubin after a drawing
by Charles Nicolas Cochin in which he wears a fur
cap.

The print is also a reflection of Barry's growing
concern over the need for reform in Ireland. He
obviously relished the opportunity to replace the
Puritan William Penn with the Roman Catholic
Lord Baltimore as the creator of a wise and tolerant
government, and at the upper right the angel
strewing flowers wearing a tartan is none other than
the martyred Mary Queen of Scots, a Catholic queen
who in Barry's mind had those virtues so sadly
lacking in her tyrannical cousin Queen Elizabeth I.
At the far left, beneath the scientist Robert Boyle, sits
William Molyneux holding his book *The Case of
Ireland's Being Bound by Acts of Parliament in
England Stated*, which, published in 1698, proposes

measures that would help to alleviate Ireland's plight.

A fragment of a preparatory drawing for this work is in the Ashmolean Museum. Only the torn upper right-hand corner of the drawing remains, depicting those figures which appear in reverse at the upper left of the print.

37 RESERVED KNOWLEDGE *c.*1800

Etching and engraving (black ink)
$28\frac{1}{8} \times 18\frac{3}{8}$ (71.5 × 46.8)
Pressly: PR29 I
Visitors of the Ashmolean Museum, Oxford

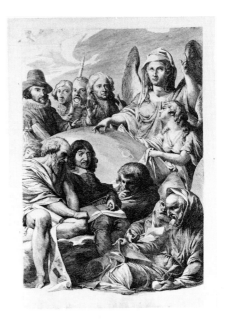

That which in this world has remained obscure, in Elysium or Heaven is made intelligible. In the upper register an archangel explains to the scientists Sir Francis Bacon, Copernicus, Galileo and Newton the laws governing the solar system that is unveiled before them. In the lower register sit the scientists and philosophers Thales, Descartes and Archimedes. To their right reclines the Franciscan Roger Bacon with his supporter Bishop Grosseteste at his side.

38 THE GLORIOUS SEXTUMVIRATE *c.*1800

Etching and engraving (black ink)
$28\frac{5}{8} \times 18\frac{3}{8}$ (72.8 × 46.8)
Pressly: PR30
Visitors of the Ashmolean Museum, Oxford

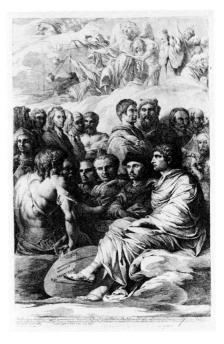

In the foreground sit Epaminondas, Socrates, Lucius Junius Brutus, Cato the Younger, Sir Thomas More and Marcus Junius Brutus, all men who had died in the defence of justice and liberty. Their selection was inspired by a passage in Jonathan Swift's *Gulliver's Travels* in which Gulliver summons up the dead: 'I had the Honour to have much Conversation with [Marcus Junius] *Brutus*; and was told that his Ancestor *Junius, Socrates, Epaminondas, Cato* the Younger, Sir *Thomas More* and himself, were perpetually together: A *Sextumvirate* to which all the Ages of the World cannot add a Seventh.' Behind them stand various philosophers, and in the clouds angels intercede on behalf of such pious pagans as Brahma, Confucius and Manco Capac. By 1795 Swift's sextumvirate had taken on an added dimension with the birth of the French Republic, which zealously celebrated the principles of liberty, fraternity and equality, particularly as embodied in the character of the stern republican Lucius Junius Brutus. Commenting on this print in his book *A*

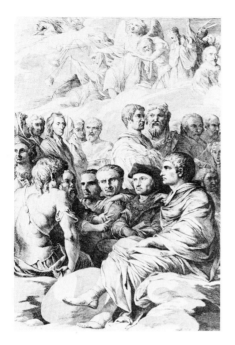

fig.18 James Barry, 'The Glorious Sextumvirate' 1795

Letter to the Dilettanti Society of 1798, Barry took pains to place the spirit of genuine Christianity at the centre of any fight for freedom, disassociating himself from the atheistic bias of the French.

Although the prints 'Diagorides Victors', 'Reserved Knowledge' and 'The Glorious Sextumvirate' all bear the publication date of 1 May 1795 they were first published without any lettering. Five years were to pass before Barry had devised suitable inscriptions, for he was not ready to donate a completed set to the Society of Arts until June 1800. An early, unlettered proof of the 'Sextumvirate' has recently re-emerged (fig.18), and it shows how much the print was altered in the final, lettered state. One change was prompted by the artist's introduction in 1800 to General Miranda of Venezuela, a celebrated revolutionary who had fought for the Republic of France and was eventually to die in his struggle against Spanish colonial rule. Barry wrote that it was the general who persuaded him to inscribe on Epaminondas' shield the tactics that won the Battle of Leuctra in order better to commemorate the Thebans' defence of their liberties against Spartan aggression (the plan of battle was added to the shield in the painting in the summer of 1801); the artist also dramatically altered the right-hand side so that the later state dovetails with the adjoining print showing the legislators grouped around Lord Baltimore. Initially he had included Molyneux and Boyle behind Marcus Junius Brutus, and above him in the clouds he had placed Hugo Grotius beside whom can be glimpsed Johan van Oldenbarnevelt and Bishop Berkeley. But in the final state all these personages, who were already present in 'Lord Baltimore', have been converted into unidentified figures.

39 QUEEN ISABELLA, LAS CASAS AND
 MAGELLAN 1800

Etching and engraving (black ink)
$27\frac{5}{8} \times 4\frac{13}{16}$ (70.2 × 12.2)
Pressly: PR31 II
Visitors of the Ashmolean Museum, Oxford

This print of 1800 depicts Queen Isabella, Magellan and Las Casas, none of whom had yet appeared in the mural 'Elysium and Tartarus' (Barry painted in Las Casas in the following year). Its positioning between 'Reserved Knowledge' and 'The Glorious Sextumvirate' is crucial to understanding its meaning. On the left the wings of the two angels and the back of

Roger Bacon seen in 'Reserved Knowledge' extend into the design. On a thematic level it is even more closely linked to its right-hand neighbour, 'The Glorious Sextumvirate', for Queen Isabella is in conversation with Christopher Columbus, who appears in this last work above Epaminondas' left shoulder. The Queen, who pawned her jewels so that Columbus could embark on his voyage of discovery, represents enlightened patronage. Magellan, who stands behind her, went on to capitalize on Columbus' discovery of the New World by circumnavigating the globe. Isabella, however, performs another role as well. Barry saw her as the Christian protector of the brutalized Indians, a cause to which the saintly Las Casas, who sits at her feet, devoted his entire career.

Barry's renewed interest in Spain and the New World appears to be directly related to his developing friendship with the Venezuelan General Miranda. In the *Commonplace Book* there is a letter from Miranda to Barry, inviting him to tea so that he might 'shew him (by the Authority of all the contemporary Spanish Writers) whoat a great Caracter and a *good man* D. Bartholome de *las Casas* Bishop of Chiapa was!' Also judging from the artist's notes, his principal text for his subject matter was Antonio de Herrera's *The General History of the Vast Continent and Islands of America* (London, 1725). In the case of Columbus the notes make clear that he was as interested in the man who had been brought back to Spain in chains as he was in the courageous explorer. In fact, the year before this print was issued he had optimistically compared his own expulsion from the Royal Academy with the explorer's fate: 'honest Columbus lived to see the time when his chains became an ornament which he was proud of wearing' (*Works*, II, p.636).

As he had over twenty years earlier in his print 'The Conversion of Polemon' (no.26), Barry dedicated this work to Charles James Fox, whom he felt was the English politician who best embodied the virtues extolled in this design. One can sympathize with Fox's bafflement over the print's meaning upon receiving an impression from the artist: 'The figures in the print appear to be in the grandest style, but I confess I do not yet perfectly comprehend the whole of the plan' (*Works*, I, p.288). The print is only intelligible when seen as a bridge between its larger neighbours, but even then it is still a decidedly eccentric production.

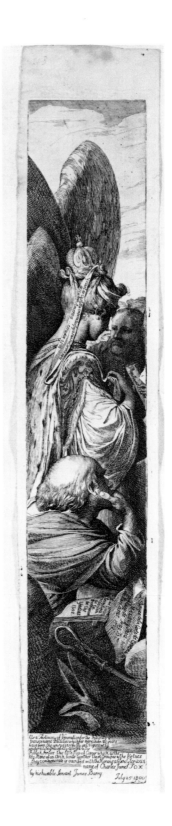

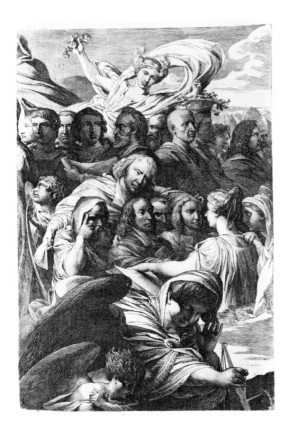

40 DIVINE JUSTICE *c.*1802

Etching and engraving (black ink)
$28\frac{11}{16} \times 19\frac{9}{16}$ (72.9 × 49.7)
Pressly: PR33
Visitors of the Ashmolean Museum, Oxford

Barry valued these large details of Elysium as aesthetically more pleasing than the print reproducing the entire painting since the figures are now on a much larger scale, but he also welcomed them for the opportunity they afforded of amending his cast of characters of the heroic dead. Like 'Lord Baltimore', the first print in the series, and 'Isabella', 'Divine Justice' introduces a number of new faces, the most prominent of whom is the Roman general Scipio Africanus. Positioned in the top rank of figures, the bald-headed general wears a severe frown, another example of a great man whose successes prompted ingratitude rather than praise. As in the painting, the judging angel is positioned at the bottom of the design, and the balance she holds tips toward Tartarus, indicating that evil is more frequently encountered than good. In this detail as in the print of 1792 the artist added a guardian angel, who anguishes over the fate of his charge.

This print and 'The Angelic Guards' (no.42) are linked closely together. As with the earlier works in the series, he planned to introduce an inscription, in this case 'on the vacant space of the rocks which extends thro' both the prints', but never found an appropriate quotation.

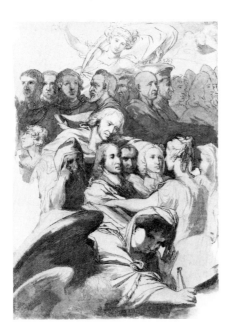

41 STUDY FOR THE ETCHING 'DIVINE JUSTICE' *c.*1802

Pen and brown ink and grey wash over pencil,
$27\frac{1}{2} \times 19$ (69.7 × 48.3) (extensive repairs)
Pressly: D45
Private Collection

The three artists Inigo Jones, Christopher Wren and William Hogarth are faintly sketched into the upper right corner, where they correspond with the upper register of artists in the adjacent image (no.42). Barry, however, dropped them from the print in order to open up the design, but at the far left he squeezed in the head of St Charles Borromeo and the cloak of Mary Queen of Scots in order to link the design more closely to 'Lord Baltimore'. This preparatory study and the companion study for 'The

Angelic Guards' (fig.19) have both been severely
damaged, generally in the same areas, but of interest
is how much of their rough treatment can be
attributed to the artist himself. They offer dramatic
physical evidence of the almost brutal vigour with
which he transferred his beautifully rendered
sketches on to the copperplates.

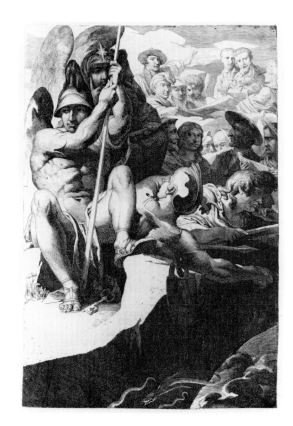

42 THE ANGELIC GUARDS *c.*1802

> Etching and engraving (black ink)
> $28\frac{5}{8} \times 19\frac{1}{2}$ (72.8 × 49.4)
> Pressly: PR34 I
> *Visitors of the Ashmolean Museum, Oxford*

Barry introduced only one new figure into this
portion of Elysium. In the group of illustrious
patrons in the middle register he placed at the far
right Marcus Agrippa, whose pugnacious head, seen
in profile, is probably based on a Roman coin. He
shows Agrippa holding his famous oration, which, as
Pliny says, eloquently argued in favour of the public
display and ownership of art in opposition to the
prevailing practice of banishing them to country
houses. Barry compared the intent of this oration to
his own book *A Letter to the Dilettanti Society*, and
Agrippa can be seen as yet another of his many
personas.

43 STUDY FOR THE ETCHING 'THE ANGELIC
 GUARDS' *c.*1802

> Pen and brown ink and grey wash with white
> highlights over black chalk
> $26\frac{1}{4} \times 19\frac{1}{2}$ (66.5 × 49.6)
> Pressly: D46
> *Trustees of the British Museum, London*

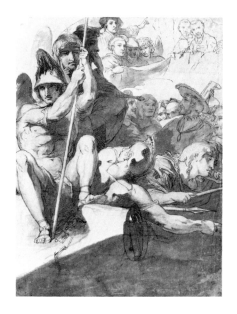

Both this drawing and the one at the Huntington
Library and Art Gallery (fig.19) are preparatory to
the print. In the study exhibited here, Lord Arundel,
who appears in the painting, is still present at the far
right; in the Huntington version, the final drawing
before the execution of the print, he has disappeared;
then in the etching, Agrippa takes his place. In both
studies for this etching and in the one for 'The
Judging Angel', Barry achieves a majestic breadth in
his handling of these subjects, employing bold
outlines and large areas of rapidly applied wash.

fig.19 James Barry, 'Study for Etching "The Angelic Guards"' *c.*1802

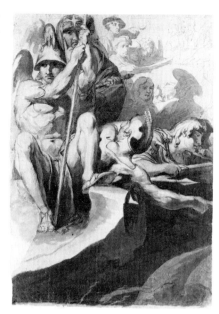

RELATED PORTRAITS

Barry executed a large number of unfinished portrait heads in preparation for his painting 'The Distribution of Premiums in the Society of Arts'. The only one of these oil studies to have survived unaltered is his 'Portrait of Samuel Johnson' (no.44), which, because of its excellent likeness of a famous contemporary, was singled out for special attention from an early date. At least three of the sitters commissioned Barry to turn his studies for the mural into independent paintings, and one of the works in this category to have survived is the magnificent 'Hugh, First Duke of Northumberland' (no.45). Although the painting of the Prince of Wales (no.46) was not a commissioned work, it too had its genesis in the prince's sitting to Barry in order that he might be included in 'The Distribution'.

44 DR SAMUEL JOHNSON, A SKETCH 1778–80

Oil on canvas, oval, $23\frac{7}{8} \times 20\frac{7}{8}$ (60.6 × 53)
Pressly: P50 [Literature: Herman W. Liebert, 'Portraits of the Author: Lifetime Likenesses of Samuel Johnson', in *English Portraits of the Seventeenth and Eighteenth Centuries*, The William Andrews Clark Memorial Library, University of California, Los Angeles, 1974, p.61, repr. pl.12]
National Portrait Gallery, London

The head of Dr Johnson (1709–84) is the preparatory study for his appearance in 'The Distribution of Premiums in the Society of Arts' (no.28E). In the painting he appears near the centre of the composition between the Duchesses of Rutland and Devonshire, but the profile sketched in and later painted out at the right of the oil study demonstrates that Barry had first intended to show Johnson next to a different figure, probably Mrs Montagu, to whom in the finished canvas he is shown pointing. Because that portion of the oil study which folds over the oval stretcher forms part of the painted surface, it is clear that this work has been reduced from a larger picture. Presumably, like the other surviving studies for 'The Distribution', it was originally rectangular in shape. The ochre colour of its prepared ground may form the underlying vibrant colour for the entire series at the Society of Arts.

Johnson, a friend of the artist, was an obvious choice for 'The Distribution of Premiums'. However, according to an account by Frances Burney of a dinner held in 1779, Barry did not always relish his friend's company: 'Dr Johnson was very sweet and very delightful indeed; I think he grows more and more so, or at least, I grow more and more fond of him. I really believe Mr Barry found him almost as amusing as a fit of the toothache!' (*Diary & Letters of Madame d'Arblay*, London, 1904, I, pp.265–6).

An etching by Anker Smith of the painting was published in 1808. One reviewer, though obviously hardly disinterested in his desire to promote Smith's print, enthusiastically endorsed the portrait:

> The present will be acknowledged by those who knew the original, to be a *speaking* likeness, and by much the best portrait of Dr Johnson which has yet been set before the public: it makes all others, notwithstanding that those after Reynolds and Opie are among the number, look sottish, blinking, or imbecile. This presents Johnson as he really was, and as we well remember to have seen him . . . when age had only begun to dim the lustre of his eye, through which still peered an intellect of so vigorous a character as almost forbade his companions to think that time and tea-drinking had at all relaxed the firmness of his muscles (*The Review of Publications of Art*, 1808, I, pp.221–2).

The portrait is a remarkably vigorous study very like another characterization of Johnson of about the same time, Joseph Nollekens' bust of 1776.

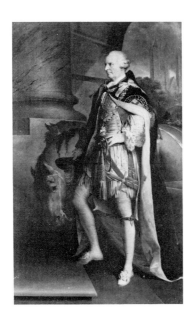

45 HUGH, FIRST DUKE OF
NORTHUMBERLAND *c.*1784–6

Oil on canvas, 93 × 58 (236.2 × 147.3)
Pressly: P64
Duke of Northumberland

Sir Hugh Smithson (1715–1786) married in 1740
Elizabeth, Baroness Percy, heiress to the Percy
property, and, having assumed the name and arms of
Percy in 1750, he was created Duke of Northumber-
land in 1766. In 'The Distribution of Premiums'
(no.28E), the duke is shown at the lower right
kneeling in parliamentary robes, his left foot placed
on a harpoon gun. But for this commissioned
portrait, Barry borrowed the pose of the Prince of
Wales from this same painting, attiring the duke, like
the prince, in Garter robes.

In 1778, the duke was made Master of the Horse, a
position that is alluded to in the portrait. As ex-
plained in an eighteenth-century source, the Master
of the Horse, who has full charge over the king's
stables, 'is esteem'd the third great Officer at Court,
giving Precedency only to the Lord Steward, and
Lord Chamberlain'. Furthermore, 'at any solemn
Cavalcade he has the honour to ride next behind the
King' (*The True State of England*, London, 1726,
pp.54 and 55). In the portrait, the duke pauses while
ascending the staircase of a regal portal, presumably
at the top of which awaits no less a personage than the
king himself. In the background appear the west
towers of Westminster Abbey, a building which was
near the king's residence at Buckingham House (now
Buckingham Palace). If the painting was not com-
pleted until after the duke's death in 1786, these
towers may also refer to his interment in St Nicholas'
Chapel within the Abbey.

According to 'Anthony Pasquin', the Duke of
Northumberland originally requested Barry to paint
a subject of his own choosing from English history in
which he should 'contrive to introduce a master of
the Horse in the grouping, and draw my portrait in
that character'. After repeated delays, Barry sent
word by a servant, 'Go to the Duke, your master,
friend, and tell him from me, that if he wants his
portrait painted, he may go to the fellow in Leicester-
fields [i.e. Sir Joshua Reynolds]; for that office shall
never be fulfilled by me' (John Williams, *An
Authentic History of the Artists of Ireland*, London,
1796, p.48).

Although the existence of this work undercuts

Pasquin's story, he was probably accurate in suggesting that the relationship between the artist and his patron was a strained one. Barry, however, certainly made up for any offence with this painting in that it is a completely successful attempt in the Grand Style. The figure of the duke stands out from the more muted background, and the brilliant reds and blues of his dress are played off against the sumptuous whites, which in several passages reflect back these vivid colours. With his leonine head and commanding carriage, the duke strikes an authoritative pose imbued with dignity and power. As Sir Ellis Waterhouse observed in his book *Painting in Britain*, the portrait possesses a kind of solemnity that even surpasses the work of Reynolds.

46 THE PRINCE OF WALES AS
ST GEORGE *c.*1789–90

Oil on canvas, 94 × 58 (238.7 × 147.3)
Pressly: P65
Crawford Municipal Art Gallery, Cork

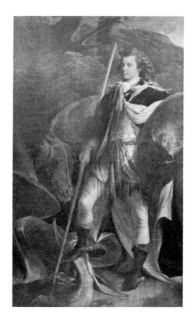

Barry depicts George, the Prince of Wales (1762–1830) in the role of St George, the patron saint of England. In his mural 'The Distribution of Premiums in the Society of Arts' (no.28E) he had placed the prince in a prominent position, but he was unable to finish the head until he could make a sketch from the life. George granted the artist at least two sittings at Carlton House over a period of six months in 1789. The head was then added to the mural early in 1790. Presumably Barry made use of the Prince's sittings to create at the same time this flattering allegorical portrait. The pose is taken directly from the one he had used for the Prince in the Society of Arts mural, and the fawning horse is borrowed from 'Hugh, First Duke of Northumberland'.

From November 1788 until February 1789, King George III suffered the first major attack of the illness that was to plague the remaining years of his reign, and, when Barry painted this portrait, it seemed as if the Prince's accession to the throne was imminent. The artist certainly would have welcomed such a change, since Prince George planned to replace the conservative administration led by William Pitt the Younger with a reformist one led by Charles James Fox. Painted on the shield in the portrait is the sun appearing from behind clouds, an allusion to the Prince's promising future. Surely Barry had in mind the lines spoken by Prince Hal, an earlier Prince of Wales who had up to that moment led a profligate life but was to redeem himself on becoming King:

> Yet herein will I imitate the sun,
> Who doth permit the base contagious clouds
> To smother up his beauty from the world,
> That, when he please again to be himself,
> Being wanted, he may be more wonder'd at,
> By breaking through the foul and ugly mists
> Of vapors that did seem to strangle him.
>
> (*King Henry IV, Part I*, Act I, sc ii, lines 220–6)

V THE BOYDELL SHAKESPEARE GALLERY

Unlike their French peers, British artists could not look to the state for commissions for history paintings, nor could they count on adequate support from ecclesiastical institutions. One of the most original attempts to exploit new areas of patronage, one that spawned several important imitators, was the Boydell Shakespeare Gallery. This project was conceived at a dinner held on 4 November 1786. Stimulated by the evening's conversation, Alderman John Boydell undertook to promote an ambitious programme of paintings illustrating Shakespeare's plays, and this scheme eventually involved most of the important artists of the British School of his day. In all, he commissioned one hundred large pictures along with a set of smaller paintings. His motives were patriotic, aimed at improving the state of the arts in England, but he obviously would not have undertaken such an adventure if he had felt it was financially unsound. Boydell, who was already a prosperous and well-established print publisher, counted on the sale of prints after the paintings to supply the necessary profits. To this end, he produced a folio edition after the large pictures, and the smaller series of paintings were engraved to illustrate a nine-volume edition of the plays. Eventually, however, the project, which could only fully evolve over a long span of years, began to falter, in part because the wars with France closed down the continental markets. But in 1805 the firm recouped its losses by persuading Parliament to let it dispose of its stock by holding a lottery.

Barry was among the first artists asked to participate in this venture. On 14 December 1786, Boydell paid him an instalment for his picture 'King Lear Weeping over the Body of Cordelia', which must have just been commissioned. This painting was completed by the following year, and it was among the thirty-four canvases that made up Boydell's inaugural exhibition opening on 4 May 1789. Barry's painting was one of the more important on

view, and when James Gillray satirized Boydell's project, he placed the principal figures from Barry's picture in a prominent position alongside characters excerpted from paintings by Fuseli and Reynolds (fig.20). In Gillray's interpretation, Lear's extravagantly wind-swept hair has become a large, billowing sack, while Cordelia is stripped bare in order to emphasize the seductive nature of her pose.

fig.20 James Gillray, 'Shakespeare Sacrificed; –or–The Offering to Avarice' 1789

Barry also executed for the Shakespeare Gallery 'Iachimo Emerging from the Chest in Imogen's Chamber'. This painting was on view by 1792; but as it was never engraved and does not appear either in the last catalogue of the collection of 1802 or in the sale of 1805, there must have been some disagreement that kept it from becoming a permanent part of the series. Barry had received 300 guineas

for his 'King Lear', a respectable sum but hardly comparable to the 1,000 guineas for pictures paid to Reynolds and West, and he may well have quarrelled with Boydell over the price of this second work. In any event, because of his paranoid disposition, he could never have been very happy about participating in a group venture of this magnitude.

Not all Shakespearian subjects are of course suitable for treatment in the Grand Style, and the Gallery contained many works that belong to more minor genres. Barry, however, continued to work on sublime, tragic subjects on a heroic scale, and, along with Fuseli and West, he was one of the few contributors who was able to perform successfully in this exalted mode.

47 KING LEAR WEEPING OVER THE BODY OF CORDELIA 1786–7

Oil on canvas, 106 × 144½ (269 × 367)
Pressly: P29
Tate Gallery

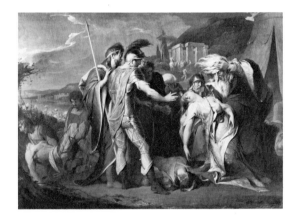

For his first painting for Boydell, Barry returned to his earlier depiction of a Shakespearian subject, expanding the format of his 'King Lear and Cordelia' exhibited in 1774 (no.5). In the process the cast of characters has been considerably enlarged. As before, the ever faithful Kent, tears rolling down his cheeks, is placed next to Lear and Cordelia. He is now followed by two captains with the large forms of Albany and the armoured Edgar anchoring the line of mourning spectators. The evil plotters punctuate this main grouping: at Lear's feet lie the bodies of his daughters Goneril and Regan; their confederate Edmund is carried off at the left; and to the right lies the soldier slain by Lear for having killed Cordelia. The landscape too plays a greatly expanded role, adding an ennobling breadth to the design. Barry deliberately classicized the Stonehenge-like structures in the background in order to associate the ancient Britons with the nobility and grandeur of Greco-Roman civilization.

The landscape is painted in an unusually light key, and throughout the canvas there are a number of discordant, vivid tones consisting of bright pinks, oranges and violets. Although the critics praised the picture for its learned conception and masterful drawing, they invariably had difficulty with its colouring, all voicing the same complaint that the artist had too wilfully turned his back on nature. One observer, probably referring more to the corpses and the men who carry them away, grumbled, 'One is apt

to think, on the first sight of this picture, that he [Barry] had studied the antient statues, till he had forgot the colouring of nature' (*The Morning Post*, 2 June 1789), and Humphrey Repton amusingly singled out another feature: 'that unnatural colouring which discovers itself in this Artist's works, makes Lear's hair a solid mass of alabaster; and some Wits will perhaps repeat the words of Lear, and say – "O you are men of stone!"' (*The Bee; or, a Companion to the Shakespeare Gallery*, London, 1789, p.51). Clearly Barry's contemporaries were unnerved by his unconventional rendering, which makes few concessions to their expectations. It remains, though, a work of compelling power that combines the intense emotions of heartbreaking grief with a majestic panorama conjuring up the glories of Britain's imagined past.

48 Iachimo Emerging from the Chest in Imogen's Chamber

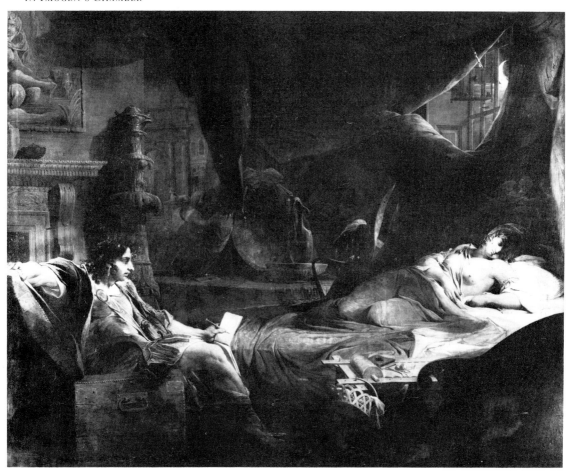

48 IACHIMO EMERGING FROM THE CHEST IN IMOGEN'S CHAMBER c.1788–92

Oil on canvas, $112\frac{1}{2} \times 142$ (286 × 361)
Pressly: P30
Royal Dublin Society

The painting depicts one of the more distressing moments in the tragi-comedy *Cymbeline*. As the play begins, Imogen, the daughter of Cymbeline, King of Britain, has married against her father's wishes and must say goodbye to her husband Posthumus, who, having been banished, departs for Italy. There Posthumus rashly lets Iachimo, an Italian gentleman, provoke him into wagering that Imogen will remain faithful during his absence. Iachimo journies to England to test the princess, but finding her virtue impregnable, he resolves on a new strategy, asking her to safeguard a chest for one night that he says is filled with expensive plate and jewels. Imogen has the chest placed in her bedchamber, and once she falls asleep Iachimo emerges from his hiding place to write down the room's contents. He also removes the bracelet on her arm, which Posthumus had given her, and notes the cinque-spotted mole on her left breast. Armed with these 'proofs', he returns to Italy and convinces Posthumus that Imogen has proven unfaithful.

As in 'King Lear', Barry illustrates a scene from a play that is set in British antiquity, in this instance the first century B.C. when Britain was falling within the orbit of the Roman Empire. If he chose this subject, his selection is somewhat surprising in that this scene, consisting of two figures in a bedchamber, is not one that lends itself readily to heroic treatment on a grand scale. A nocturnal scene is also a departure for him, and he would seem to have profited by the example of his contemporary Joseph Wright of Derby, who excelled in candlelight and moonlight effects. Barry obviously felt some uneasiness about this uncharacteristic attempt, for, while he was at work on it, he complained to the Duke of Richmond that such 'subjects afford more of the Gothic than of the heroic, are full of barbarisms and anachronisms of every kind, and come as much within the compass of the grossest ignorance, as of the most extensive knowledge' (*Works*, I, pp.274–5).

Despite the artist's reservations, the painting, rooted as it is in some of his deepest obsessions, possesses a gripping power. It is a Gothic nightmare depicting how the reputation of someone pure and blameless can be besmirched by poisonous slander which only found an opening in an act of generosity. The fact that the figures are set in opposing diagonals at opposite sides of the canvas helps to emphasize the many contrasts between them and one is reminded of Iachimo's closing remark, 'Though this a heavenly angel, Hell is here.' The only contemporary comment on the painting was a highly negative one, vociferously condemning Barry's conception: 'Every thing is distorted and extravagant. He has aimed at something extraordinary; and in truth something extraordinary has been done – for MADNESS seems to have ruled the hour of *conception*, and ERROR to have distributed the treasures of the *pallet*' (*The Oracle*, 30 April 1795). There is indeed something extravagant and extraordinary about this work, but ultimately this is the very reason that it succeeds in becoming something more than the over-inflated record of a stage set.

VI ILLUSTRATIONS TO PARADISE LOST
AND THE BIBLE, THE 1790s

With his painting 'The Temptation of Adam' (no.1), Barry had been the first artist to exhibit a Miltonic work, and in the 1790s he returned to *Paradise Lost* as a source of inspiration, undertaking an ambitious programme encompassing the entire epic. It seems doubtful that he began this project before 23 April 1792, as what appear to be the earliest sketches are on printed sheets bearing this date (see no.52). By 26 December 1794, he was able to write, 'The work is in good forwardness, and though at present a little interrupted by the consequences of the unlucky visit of the thieves who broke into my house, is nevertheless, with God's blessing, likely to go on' (*Works*, I, p.280). However, within five years he was clearly more despondent, complaining that the project, 'though so far advanced, has been, notwithstanding, unfortunately turned to the wall, with every melancholy appearance of abandonment and neglect' (Barry to George III, 4 August 1799, in *Morning Post*, 3 December 1799). If one excludes the earlier 'The Temptation of Adam', he apparently never did produce any finished paintings illustrating *Paradise Lost* and only two oil sketches, now missing, appeared in his posthumous sale. A number of drawings, however, have survived, along with several etchings that are among his most important works in this medium.

Barry's renewed interest in Milton was at this moment hardly unusual. In 1790 Henry Fuseli had begun work on his Milton Gallery, a major undertaking which, when it was first exhibited nine years later, totalled forty pictures. In addition, in the early years of the decade a number of other artists, including such figures as Thomas Stothard, George Romney and William Blake, were also illustrating scenes from *Paradise Lost*. Milton obviously benefited from the same nationalistic pride that had led so many to illustrate scenes from Shakespeare's plays. By lionizing these native literary geniuses, the artists were also bolstering their own image,

since there was no reason why a country that had produced these writers could not also produce a painter of comparable distinction. In addition, unlike Shakespeare's plays, *Paradise Lost* was a sustained epic, which, despite imagery that often did not translate easily into pictures, supplied subject matter that better befitted the Grand Style. It is also of interest that this work should have enjoyed such a resurgence in popularity at the time of the French Revolution. At this moment of crisis the figure of Satan as the embodiment of spirited revolt took on an added lustre.

The two oil sketches that were included in Barry's sale depicted scenes from the Garden of Eden: 'Adam and Eve, with Satan just Alighted from Paradise' (lot 68) and 'Eve and her Creation, Contemplating on her Form Reflected in the Water' (lot 81). When combined with 'The Temptation of Adam', they may have been intended as a trilogy showing the first appearance of evil in Paradise (Book IV, lines 284–392), Eve's vulnerability to sin from the moment of her creation (Book IV, lines 440–75), and the Fall itself (Book IX). While these lost oil sketches and the one completed painting stress mankind's descent into temptation, the majority of the prints and surviving drawings focus instead upon the figure of Satan, who was for the artist, even if only on an unconscious level, the hero of the poem. Blake's comment about Milton that 'he was a true Poet and of the Devil's party without knowing it' is certainly true when applied to Barry (*The Marriage of Heaven and Hell*, *c*.1790–3, p.6).

By the nature of its subject matter, *Paradise Lost* offered Barry an unparalleled opportunity to depict in a variety of aspects the heroic nude which had always been at the centre of the academic tradition and of his own art as well. His depictions of Satan and his fallen comrades differ substantially, however, from his handling of the nude in his earlier works. Gone are the elegant, attenuated figures with their gently undulating contours and thin,

delicate outlines. In their place is a style more closely modelled on Michelangelo's and Fuseli's muscular, dramatically foreshortened figures and on Edmund Burke's definition of the sublime with its call for 'a rugged and broken surface' (*Enquiry*, p.72). The contours are now thick and bold, drawn in coarse and jagged lines, while the anatomical distortions and the crude hatching and cross-hatching with their abrupt contrasts of light and dark are expressionistic in effect, imbuing these images with an impassioned force missing in the graceful refinement of the earlier paintings and drawings. The entire surface is filled so that the same pulsating rhythms that energize the figures extend throughout the dark and gloomy backgrounds as well. By contracting the space and radically cutting the figures, the artist fully immerses the viewer in this awesome, terrifying world, filling his mind with the grandeur and power of its raw, elemental energy.

Barry thought of his Miltonic series as the Christian counterpart to the classical story of Pandora, both subjects expounding on the fall of mankind. In elaborating the Christian account, he chose to illustrate *Paradise Lost* instead of the Bible because, as he had written earlier, he felt that Milton 'was the first man of genius who was able to make any poetical use (that was not more ridiculous than sublime) of the great personages and imagery of our religion: as it came to us from the Jews, who were never remarkable for art or picturesque ideas,

it had the character of that metaphysical, abstracted, gloomy people, strongly impressed upon it' (*Works*, II, p.238). Of course, by choosing Milton's narrative he was also able to depict subjects which, unlike those from the Bible, had not already been frequently attempted by the Old Masters.

In *The Works of James Barry*, Edward Fryer maintained that the artist intended to create an extensive religious programme showing the progress of theology as a complement to his progress of human culture at the Society of Arts and, toward this goal, was going to paint scenes from the life of Christ as a continuation of the 'Pandora' and the *Paradise Lost* series. However, while a project of this type may help to explain a work such as 'The Baptism of Christ' (no.59), the motivation underlying the drawing of 'Judas Returning the Bribe' (no.61) and perhaps even 'The Feast of Herod' (no.60) arises from the personal crisis of the expulsion from the Royal Academy rather than from any larger frame of reference. If Barry ever contemplated a progress of theology, and given Fryer's statement it would seem plausible that he did, he never got beyond a feeble beginning. The profound discouragement and melancholy that he experienced in his late years not only hampered his efforts in executing the Miltonic series but made it virtually impossible to pursue with any success an ambitious extension of this first plan.

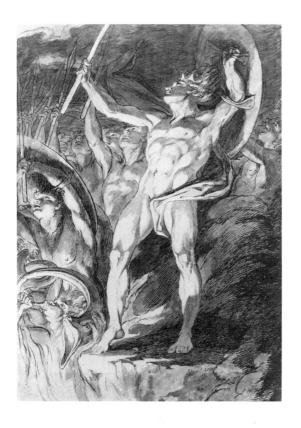

49 STUDY FOR THE ETCHING 'SATAN AND HIS
LEGIONS HURLING DEFIANCE TOWARD
THE VAULT OF HEAVEN' *c*.1792–4

Pen and brown ink and grey wash over black
chalk, 27 × 19½ (68.5 × 49.4)
Pressly: D48
Trustees of the British Museum, London

Barry stresses Satan's heroic qualities. After having
been routed out of heaven, he and his fallen com-
rades, though beaten and wracked by despair, rise up
off the fiery flood valiantly to shout their defiance
against the Almighty. Although surrounded by his
legions with Azazel unfurling their banner, Satan, as
Milton intended, remains the principal focus:

> . . . he above the rest
> In shape and gesture proudly eminent
> Stood like a Tow'r; his form had yet not lost
> All her Original brightness, nor appear'd
> Less than Arch-Angel ruin'd, and th'excess
> Of Glory obscur'd.
> (*Paradise Lost*, Book I, lines 589–94)

In the Milton series as a whole and in this drawing
in particular, Barry achieves a new level of emotional
intensity. These brawny male nudes, seen from a low
point of view and dramatically lit from beneath,
reveal the influence of Michelangelo's figures in the
Sistine Ceiling. In addition, the conception for the
figure of Satan is rooted in antique sources, parti-
cularly the colossal statues of the Dioscuri or Horse
Tamers on the Quirinal Hill in Rome, although
Barry introduces Mannerist distortions not present
in the classical models. It was the work of his
contemporary Henry Fuseli that opened his eyes to
the dramatic potential of this earlier Renaissance and
antique art at that same moment when William Blake
was also profiting greatly by Fuseli's example. In his
turn, Barry influenced Richard Westall's depictions
of Satan as a defiant hero in his illustrated edition of
Paradise Lost, the first volume of which was pub-
lished in 1794.

50 SATAN AND HIS LEGIONS HURLING
DEFIANCE TOWARD THE VAULT OF
HEAVEN *c*.1792–4

Etching (black ink), 29⅜ × 19¹³⁄₁₆ (74.6 × 50.4)
Pressly: PR 25 IV
Trustees of the British Museum, London

[107]

The print is more precise in technique than the drawing, tightly controlled cross-hatching and stippling having replaced the flowing lines of the earlier work. Also, in the print Barry pays increased attention to the lower foreground corners, introducing at the left the portion of a figure and at the right a more dramatic rendering of the clouds. These elements, acting as a proscenium, help distance the figure of Satan, as does the extension of the space above him.

This scene of Satan and his legions is the earliest episode that Barry depicted from *Paradise Lost*, and because it differs in size from the three other Miltonic prints (nos 51, 55 and 57), it was presumably executed first. Its larger dimensions are similar to those of the details after 'The Crowning of the Victors at Olympia' and 'Elysium and Tartarus', and it may well have been etched at about the same time as the first print in this set, the 'Lord Baltimore' (no.36), which was published on 28 February 1793. Although the artist included an off-centre margin for lettering, this and the other prints in the Miltonic series were never captioned.

51 SATAN, SIN AND DEATH *c.*1792–5

Etching (black ink), $22\frac{1}{2} \times 16\frac{5}{16}$ (57.1 × 41.4)
Pressly: PR26 IV
Trustees of the British Museum, London

Satan, embarking on his journey to subvert God's newly created world, searches out the Gates of Hell. His daughter Sin, who had been engendered in heaven by his evil thoughts of usurpation, stands guard with the key tied around her waist. The other guardian is Death, who was produced in Satan's and Sin's incestuous union, and he in his turn had joined with Sin to conceive those Hell Hounds that surround her middle and kennel in her womb. Although Death at first opposes Satan, Sin rushes between the two mighty combatants who are soon reconciled.

Since Sin is tempting, she is fair above, but her true nature is revealed below in her odious serpent coils and encircling hounds. Barry, perhaps wisely, did not attempt to weld too closely her disparate halves. With the figure of Death he encountered an even more intractable problem.

> The other shape,
> If shape it might be call'd that shape had none
> Distinguishable in member, joint, or limb,
> Or substance might be call'd that shadow seem'd,

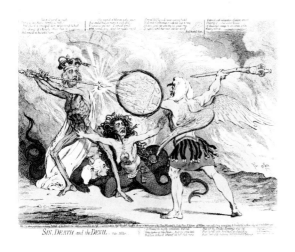

fig.21 James Gillray, 'Sin, Death and the Devil' 1792

For each seem'd either; black it stood as Night,
Fierce as ten Furies, terrible as Hell,
And shook a dreadful Dart.
(*Paradise Lost*, Book II, lines 666–72)

Edmund Burke had extolled Milton's description for its terrifying obscurity, but by its very nature such an evocative formless form defies delineation. Rather than attempt so difficult a conception, Barry reverted back to traditional images of Death as a skeleton wrapped in a winding sheet that here resembles a monk's cowl. Milton also wrote of Death that 'what seem'd his head / The likeness of a Kingly Crown had on', but here, as in many of his designs, Barry transfers the crown to Satan. While the poet underscores Death's ultimate supremacy, the artist is more interested in reinforcing Satan's majesty.

Though profoundly different in conception, Barry's composition owes a debt to James Gillray's satirical print 'Sin, Death, and the Devil' (fig.21), which is itself based on Hogarth's unfinished canvas of the same subject. Not only are Barry's figures arranged similarly to Gillray's but he too includes a portion of the massive gate, which, because its base is obscured by smoke, seems suspended in the background. In addition, as in Gillray's design, the foreground drops precipitously at the right, plunging down to the raging fires at the centre of Hell. Barry, however, totally transforms his source, creating an Infernal Trinity, which, though departing from the letter of Milton's text, conjures up its awesome spirit. By choosing a vertical format and a riveting close-up focus, he creates a sense of powerful compression locking these colossal figures into a monumental struggle of epic proportions; it is one of his boldest and most original images.

52 THE BIRTH OF SIN *c*.1792–4

Pen and brown ink over black chalk
9 × 8 (23.0 × 20.4)
Pressly: D49
Visitors of the Ashmolean Museum, Oxford

'The Birth of Sin' is one of six small, crude studies at the Ashmolean Museum that are among the earliest in the *Paradise Lost* series. All of these sketches are approximately square in format and are executed on paper cut from the printed sheets dated 23 April 1792 announcing the distribution of the Society of Arts prints. In this instance the outlines of the figures are unusually rough, having been executed in broad,

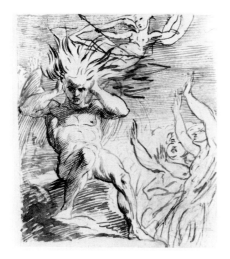

choppy strokes, and overall the sketch possesses a
nervous vitality absent in most of the other pre-
liminary designs.

Following Milton's text closely (see Book II, lines
746–67), Barry shows Sin as an armed goddess
springing forth from the left side of Satan's head,
which is already ablaze from his impassioned
thoughts. As early as 1775 he had commented on the
dramatic power to be found in Milton's description:
'her [i.e. Sin's] birth, though borrowed also from that
of Minerva's, has as much novelty, happy imag-
ination, and beautiful propriety in its application
here, as there was originally in the first invention'
(*Works*, II, p.239). He was in fact the first artist to
illustrate this scene, as Richard Westall's related
print (fig.22), published in 1794, is surely after his
design. Westall's version is melodramatic in com-
parison with a too elegant Satan and a sweetly
seductive Sin. Also, his angels rush away, while
Barry's raise their arms in amazement. These aston-
ished gestures not only link this drawing to a later
work showing Christ creating the world, a positive
response to Satan's negative creation, but they also
foreshadow the rebellious shout of those fallen angels
who, along with Satan, were to find Sin irresistible.

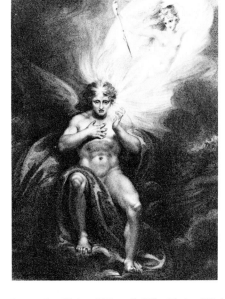

fig.22 after Richard Westall, 'The Birth of Sin'
engraving by J.P. Simon, 1794

53 SATAN AT THE ABODE OF CHAOS AND OLD
 NIGHT *c.*1792–5

Pen and brown and grey ink and grey wash
over black chalk, 22 × 16½ (56 × 42) (sight)
Pressly: D51
Royal Academy of Arts, London

Having departed from Hell, Satan plies through the
realm of Chaos in search of the newly created world
of man. Coming upon Chaos and his consort Ancient
Night, he enlists their aid in earth's subversion. In
the background are three more cowled figures who
make up part of Chaos' anarchic *entourage* (see Book
II, lines 890–1009).

Although Jonathan Richardson had recommend-
ed this subject as an excellent one for a picture as
early as 1734 in his book *Explanatory Notes and
Remarks on Milton's 'Paradise Lost'*, Henry Fuseli
was apparently the first to depict it in a drawing
of 1781–2 (fig.23). He was followed by Thomas
Freeman, a minor artist about whom almost nothing
is known, who exhibited a canvas entitled 'Satan
Departing from the Court of Chaos' at the Royal

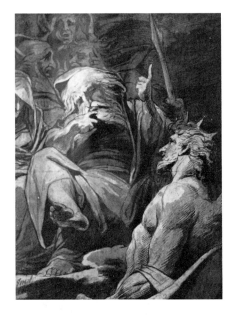

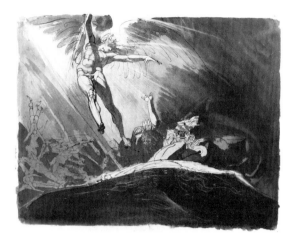

fig.23 Henry Fuseli, 'Satan Departing from the Court of Chaos' 1781–2

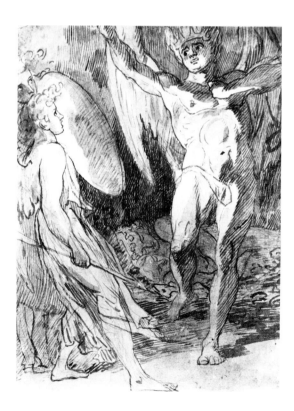

Academy in 1784 (this painting may be the one now in the Ackland Memorial Art Center, University of North Carolina). At about the same time William Blake executed a drawing of Satan approaching the Court of Chaos, now at the Yale Center for British Art. It is instructive to compare Barry's and Fuseli's interpretations of this same scene. Both employ a low point of view, but Barry avoids the extravagance of Fuseli's constricted poses, exaggerated expressions, and expansive, dynamic setting, relying instead on an adventurous use of a close-up focus and abrupt foreshortening to supply the dramatic tension.

54 THE DETECTION OF SATAN BY
 ITHURIEL *c*.1792–5

Pen and ink and wash over pencil
$20\frac{1}{16} \times 15\frac{11}{16}$ (50.8 × 39.8)
Pressly: D52
Nelson Gallery – Atkins Museum, Kansas City, Missouri (Gift of Mr & Mrs Milton McGreevy through the Westport Fund)

This drawing depicts the episode when Satan first draws close to Adam and Eve, having transformed himself into a toad in order to whisper unsettling thoughts into the sleeping Eve's ear. Ithuriel and Zephon, two of the angelic guards, have located the unwelcomed intruder, and when Ithuriel touches the toad lightly with his spear, Satan blazes up into his own likeness: 'Back stepp'd those two fair Angels half amaz'd / So sudden to behold the grisly King' (*Paradise Lost*, Book IV, lines 820–1). Again Barry relies on a highly constricted space, the angels pushing out against the frame under the shock of this encounter. He also effectively conveys Satan's prideful splendour, while suggesting in his anxious look, melancholy regret over his profound sense of loss.

> . . . abasht the Devil stood,
> And felt how awful goodness is, and saw
> Virtue in her shape how lovely, saw, and pin'd
> His loss; but chiefly to find here observ'd
> His lustre visibly impair'd; yet seem'd
> Undaunted.
> (*Paradise Lost*, Book IV, lines 846–51)

This design was to influence Edward Francis Burney, the nephew of Barry's friend Charles Burney and the cousin of Fanny, when executing his own version of this subject published in an illustrated edition of the poem in 1799.

55 THE DISCOVERY OF ADAM AND
 EVE *c.*1792–5

Etching with aquatint (black ink)
$22\frac{1}{2} \times 16\frac{3}{8}$ (57.1 × 41.5) (trimmed at
bottom)
Pressly: PR27 I
Visitors of the Ashmolean Museum, Oxford

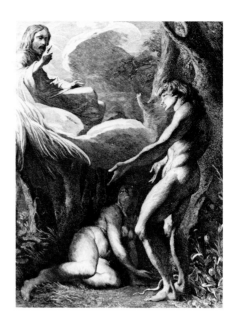

After the Fall of Man, Christ, seated on a bank of
clouds, descends to earth as judge and intercessor
only to discover Adam and Eve hiding in a grove of
trees. Adam points to Eve as the cause of his
downfall, and Eve in her turn points to the offending
serpent (see Book x, lines 85–208). This accusatory
chain of figures was a common solution for this scene
and can even be found in pre-Miltonic versions of the
Biblical account such as in Domenichino's painting
in the Barberini Gallery in Rome, where God the
Father appears in place of Christ.

Two preparatory drawings for Barry's print have
survived, a small study in the Ashmolean Museum
that belongs to the same group as 'The Birth of Sin'
(no.52) and a large, finished drawing in the Soane
Museum. Though heroic in scale and conception,
this work lacks the forceful energy of the earlier
designs in which Satan plays the major role.

56 STUDY FOR THE ETCHING 'MILTON
 DICTATING TO ELLWOOD THE
 QUAKER' *c.*1804–5

Pen and brown ink and grey wash over black
chalk, $22\frac{3}{4} \times 17\frac{1}{8}$ (56.8 × 43.5)
Pressly: D60
Trustees of the British Museum, London

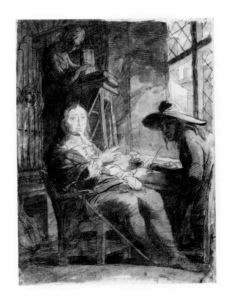

This sketch and the print after it would appear to
date later than the illustrations to *Paradise Lost*, for
the execution of the line in the drawing is weaker
than in the earlier works, lacking their dramatic
tension. On a visit to Barry's house, presumably
made late in the artist's career, the Earl of Buchan
saw a design of this subject, perhaps the one
exhibited here, and on 19 April 1805 he wrote to
commission a picture, specifying that 'the interview
of Milton with his Quaker friend in this study, which
I admired when I saw you last, would be what I
should particularly covet. – A great man in circum-
stances similar to your own' (*Works*, 1, p.296).
Despite Buchan's request, Barry never did execute

this work in oil and presumably was a long time in undertaking the print reproducing the drawing as Buchan did not learn of its existence until after the artist's death. Eventually, though, Buchan was able to secure through Barry's sister a sketch of this scene, which again could well be this exhibited work.

On the verso of this drawing Barry executed the design in a more schematic rendering in outline, and in its details it is closer to the print. The print, however, departs from both these versions in that Milton's portrait more faithfully resembles its source, William Faithorne's engraving of the poet at the age of sixty-two. In the drawing, in fact, Milton's features bear a closer resemblance to the artist's own.

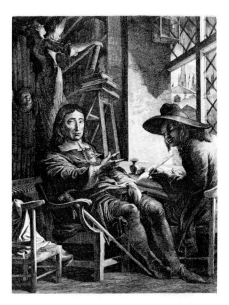

57 MILTON DICTATING TO ELLWOOD THE
 QUAKER *c*.1804–5

Etching and engraving with aquatint (black ink), $22\frac{5}{8} \times 16\frac{1}{2}$ (57.6 × 41.9)
Pressly: PR43 III
Trustees of the British Museum, London

Barry shows the blind Milton dictating to his friend Thomas Ellwood, while one of his daughters is either gathering or returning books which he had requested to be read to him. Although Ellwood's autobiography offers no confirmation of this, the artist presumably shows the poet dictating portions of his greatest epic (the posthumous impressions of this etching are in fact entitled 'John Milton Composing Paradise Lost'). Then, too, because the print is the same size as two of the earlier Miltonic etchings (nos 51 and 55), it can be seen as a climax to the *Paradise Lost* series. Barry may even have had in mind those lines where the poet speaks of his imprisoning blindness, only to call for a more penetrating vision:

> . . . thou Celestial Light
> Shine inward, and the mind through all her
> powers
> Irradiate, there plant eyes, all mist from thence
> Purge and disperse, that I may see and tell
> Of things invisible to mortal sight.
> (*Paradise Lost*, Book III, lines 51–5)

Barry clearly identified closely with Milton, a superior man whose art and uncompromising integrity had won him only poverty and persecution. He had already illustrated the life of another long-suffering poet, Torquato Tasso (no.71), but it is

interesting that he never did a similar work featuring the life of a painter. Perhaps he found it too painfully apt to depict scenes from the lives of those artists whose careers he felt offered instructive parallels to his own, and, in any case, given his competitive spirit, he must have found it difficult to enshrine a fellow painter, no matter how long ago he had lived.

Unlike the two other prints in this series for which preparatory studies have survived (nos 50 and 55), this work differs somewhat in style from the drawing (no.56). In the print, for example, the dynamic Mannerist energy found in the contrast of light and dark in the figure of the poet's daughter is nowhere present in the preparatory design, which employs instead softer shading and a less crisp line.

58 CHRISTIANITY OVERTHROWING
 IDOLATRY [?] c.1790s

Pen and brown ink and grey wash over pencil
$16\frac{1}{8} \times 12$ (41 × 30.5)
Pressly: D24
Trustees of the British Museum, London

This drawing was first identified as Christianity overthrowing idolatry in Laurence Binyon's catalogue of the British Museum's collection of British drawings published in 1898, yet the subject matter remains problematical. A celestial warrior steps off a bank of clouds, while an old man, who had been sacrificing at the smoking tripod on the right, recoils at his approach. There is a marked discrepancy in scale between the superhuman warrior, who possesses the calm grandeur of St Michael, and the figure of the old man. A pyramid-like structure is behind, while in the landscape at the left can be seen a figure at a gateway in a wall. At the Ashmolean Museum there is another, cruder drawing of this same subject, presumably preparatory to the one exhibited here. The Ashmolean version is a horizontal composition with the old man surrounded by amphorae and a vase but no tripod and with what appears to be a sarcophagus behind the warrior. The subject may be classical rather than Christian, but if Binyon's identification is correct, this drawing can be seen as a bridge between the Miltonic subjects based on the Old Testament and the following scenes from the New Testament (nos 59–61). Stylistically it is of course closely related to these last works.

59 THE BAPTISM OF CHRIST mid 1790s

> Pen and brown and grey ink and grey wash
> over pencil mounted on heavy paper
> $27\frac{7}{8} \times 20$ (70.8 × 50.8)
> Pressly: D25
> *Victoria and Albert Museum, London*

St John the Baptist, wearing a cloak of camel's hair tied with a leather belt, baptizes Christ, who stands in the centre of the composition. In spirit Christ's submissive pose recalls that of Adam in 'The Discovery of Adam and Eve' (no.55), whereas that of St John more closely resembles the imposing figure of Satan in 'Satan and his Legions' (no.49). The surrounding spectators do not react to the baptism itself but to the accompanying events in which the Spirit of God descends in the form of a dove from the opened heavens. Presumably they are reacting as well to God's voice proclaiming, 'This is my beloved Son, in whom I am well pleased' (*St Matthew* 3:17).

Like 'Christianity Overthrowing Idolatry' and the two other New Testament scenes exhibited here, Barry employs little hatching, relying instead on bold outlines and broad, varied applications of wash. Also, the plump cheeks of the mother at the lower left recall some of the Rubensian elements found in 'The Feast of Herod' (no.60), executed at about the same time. Unlike the Miltonic compositions, Barry introduces an expansive vista into the background (in this instance showing a section of the River Jordan), but even here the space is constricted with the densely packed boat of fishermen pressing up against the two protagonists.

60 THE FEAST OF HEROD *c*.1799

> Pen and brown ink and grey wash over pencil
> mounted on heavy paper
> $18\frac{7}{8} \times 25\frac{1}{8}$ (47.9 × 63.7)
> Pressly: D26
> *Victoria and Albert Museum, London*

St John the Baptist had condemned King Herod's marriage to Herodias, his brother's wife, thereby ensuring the queen's implacable hatred. Herod, enraptured by the dancing of Herodias' daughter Salome, swore to grant whatever she should wish, and, instructed by her mother, Salome requested the head of the offending saint. For his interpretation of this grisly scene, Barry relied heavily on Rubens' depiction of this story as it appears in Schelte à

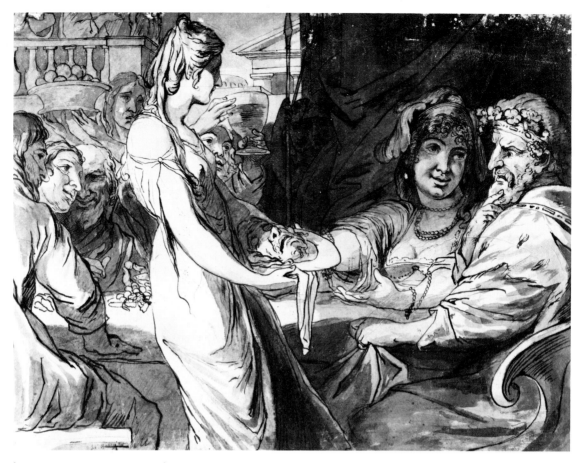

60

Bolswert's engraving (fig.24). He, however, reduces the number of participants and greatly condenses the image, even beheading in the process the musicians who are squeezed in at the upper left. He also classicizes many of the details, turning Salome's elaborate gown, for example, into a more timeless antique garment. Then too he strikes more forcibly a horrific note, emphasizing the look of agitation on the King's face and the tension in his hand clutching the tablecloth. The pathetic head of St John enjoys greater prominence as well, having now been placed in the exact centre. This subject surely had great appeal for the artist in that it combines two of his major themes: the martyrdom of a great man who had fearlessly spoken the truth without regard to the consequences and the evil that occurs when men (in this case the King) permit their judgement to be circumvented by scheming women.

fig.24 after Sir Peter Paul Rubens, 'The Feast of Herod', engraving by Schelte à Bolswert

61 JUDAS RETURNING THE BRIBE OF THE
 THIRTY PIECES OF SILVER *c.*1799

Pen and brown ink and grey wash over black
chalk, $18\frac{1}{4} \times 24\frac{15}{16}$ (46.4 × 63.3)
Pressly: D27
Trustees of the British Museum, London

Judas, repenting his betrayal of Christ, returns his
payment of thirty pieces of silver to the chief priests
and elders before departing to hang himself. A
lengthy caption, which would indicate that Barry
intended to execute this subject as a print, draws a
parallel between this New Testament story of
corruption and depravity and his own expulsion
from the Royal Academy:

> This Example of the Baneful effects of Currupt
> Influence operating upon weak Virtue is
> earnestly recommended to the deep con-
> sideration of this good People of Great Britain &
> Ireland by James Barry who glorifies & gives
> thanks to Almighty God for having been
> beneficiently enabled to make those Patriotic
> exertions in ye publick service for wch he has
> been by a [not clear] combination deprived of his
> Professorship & seat as a Royal Academician.

Judas would seem to be a composite of those
academicians whom Barry felt must now have
repented their conduct, and the thirty pieces of silver
he is returning correspond to the artist's annual
salary of £30 that he received as professor of painting
and that now reverts back to the Academy. The smug
and aloof High Priest surely represents Benjamin
West, the Academy's president who painted a
number of such figures into his Biblical pictures, and
one might suppose too that the scribe is a stand in for
John Richards, the Academy's secretary. Judas and
the High Priest are far larger than the majority of
their companions, in particular the scribe writing at
his equally small desk with its precariously sloped
top. Judas' blazing hair also defies rational expla-
nation. Such discordant details and proportions
reflect, as much as does his choice of subject, the
vehemence of the artist's anger over his expulsion.

VII BARRY AS PRINTMAKER

Barry's prints are the least known aspect of his work, yet they often best convey his extraordinary originality as an artist. In all, forty-three prints can be attributed to him, and in some cases later states differ so radically from earlier ones that they initially appear to have been made from a separate plate. Deeply absorbed by the physical effort required to make a print, he would obsessively rework a single plate, each state of which has some of the spontaneity and immediacy of a drawing. He also experimented in a wide variety of media and techniques, employing etching, aquatint, engraving, soft-ground etching, roulette work, freehand stippling, open biting, mezzotint, and lithography. His prints are often unusually large, at times stretching to the limits the capacities of contemporary presses and paper. Conceived on a monumental scale, they are coarsely executed with an astounding vigour unmatched by any other artist of this period. In his lifetime few could tolerate the bold originality of his execution, the antithesis of the polished, but mechanical, performances of his professional contemporaries, and it is only in recent years that some have begun to praise rather than condemn his prints for their crude, nervous energy.

Barry took up printmaking in order to secure a wider audience for his paintings and to bring in extra revenue. His reproductive prints, however, are never exact copies; instead they are creative extensions of his paintings. Printmaking was never an appendage to his work in oils, but quickly became a competing means of expression to which he devoted a great deal of his time in his later years. Prints too opened up new avenues of subject matter by providing him with the means of offering a more explicit and topical social commentary than did his paintings. He almost immediately seized on them as an effective vehicle for expressing many of those issues that reflected his deepest concerns.

In the eighteenth century it was unusual for a painter to turn to printmaking. William Hogarth and William Blake, the two most famous examples of artists who were both painters and printmakers, had of course begun their careers as engravers. Barry, on the other hand, took up printmaking in earnest in 1776, long after he was an established painter. He may well have been stimulated by the example of John Hamilton Mortimer, a fellow history painter who had begun the year before to execute etchings after his own drawings of character heads from Shakespeare. Barry, in his turn, may have influenced his friend George Stubbs to return to printmaking. Although Stubbs had earlier etched his own exquisite plates to his book *The Anatomy of the Horse* (London, 1766), he apparently did not begin to issue independent prints until 1777. Along with Stubbs and Thomas Gainsborough, Barry was one of the most distinguished painter-etchers of his century.

Barry began executing prints in 1776, and all his important early works are a combination of etching and aquatint. This first medium is easily learned, and Barry may even have etched some book illustrations as a youth in Cork. In this process, the artist takes a copperplate covered in a film of wax on which he simply draws with an etching needle. This instrument easily removes the wax, exposing the copper beneath. Next the plate is immersed in acid which bites only into the exposed areas. Varying strengths of line can be obtained by repeated immersions with stopping-out varnish being applied each time to those areas that have already been bitten deeply enough. After the plate has been cleaned, ink is applied and then wiped off the surface, remaining only in the lines that have been bitten into the copper. At this point the plate is ready for printing. Etching and engraving are often used in combination, and in the case of engraving the lines are incised directly into the copper with the use of a tool called a burin. Engraving requires a great deal more physical effort and expertise, and Barry apparently used the 'graver or dry needle' primarily to touch up areas that had already been lightly etched (see his note on printmaking in the Lewis Walpole Library Albums, vol.1).

Aquatint, on the other hand, is a tonal medium which can give a print the appearance of a wash drawing. Powdered resin is first fixed to the plate by heating it from underneath, and then the plate is immersed in acid which eats away at the spaces between the grain. As with etching, the longer the exposure to the acid, the darker that particular area will print, and a number of varying tones can be achieved through repeated baths and the use of stopping-out varnish. This medium, however, does not permit the blending of tones, each area remaining distinct. When Barry executed his first prints, aquatint had just been introduced to England only five years earlier. In experimenting with it he was following closely in the footsteps of Gainsborough and Paul Sandby. Barry was unusual, however, in

that he used this new method for historical subjects, which had traditionally been executed in line; Sandby and Gainsborough were more typical in restricting it to landscape.

Taken together with those works in 'Prints and Propaganda', the majority of Barry's etchings and aquatints are exhibited here. 'King Lear and Cordelia' (no.63), 'The Birth of Venus' (no.65), and 'The Phoenix or the Resurrection of Freedom' (no.21) are all dated 1776 with the last two even more specifically dated to December. 'St Sebastian' (no.62) was probably executed slightly earlier in that it is smaller in size and was completed before Barry adopted the practice of including a publication line. On almost all these works the engraver's name is given as some form of abbreviation of Archibald Macduff. Presumably Macduff, who remains something of an enigma, assisted Barry in applying the aquatint, the technique being at that time still a secret. The etched lines, however, preceded the aquatint and are undoubtedly entirely in Barry's own hand.

Throughout the next two years Barry continued to issue prints with some frequency. First came 'The Fall of Satan' of February 1777 (no.23), followed by 'Job Reproved by his Friends' of 1 March (no.24) and two reproductive prints, 'Jupiter and Juno' (no.68) and 'Philoctetes' (no.69), issued in May and September 1777 respectively. In May 1778 appeared 'The Conversion of Polemon' (no.26) and four months later 'William Pitt, Earl of Chatham' (no.27), which proved to be the last large plate until after the paintings at the Society of Arts had been completed. From the beginning, Barry employed a relatively coarse grain, and he often immersed the plate as many as five times in acid, producing six different tones counting the white of the paper. He exploited the luminous effects obtainable in aquatint and delighted in the bold sense of pattern made possible by the sharp divisions between tones. In addition, at times he applied the varnish with a brush in such a way that

the boundaries between the zones are handled with a painterly richness.

In 1792, when Barry published the set of prints after the Society of Arts paintings, he reissued the early prints as well. In the later printings (see nos 64, 66, 67 and 70) the aquatint has been burnished out, and the plates transformed into works depending solely on line. Printed in black ink rather than brown, these later states are not meant to recall wash drawings as had the aquatint impressions, but, like the set of Adelphi prints, they follow the more prestigious format traditionally employed for historical subjects. In the case of a work such as 'King Lear and Cordelia' the transformation is so complete that it takes careful scrutiny before one realizes that the later states are in fact executed from the same plate as the earlier ones.

fig.25 James Barry
'St Sebastian' c.1776

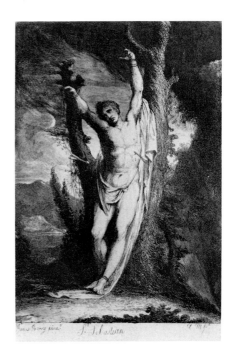

62 ST SEBASTIAN c.1776

Etching and aquatint (brown ink)
$10\frac{15}{16} \times 7\frac{1}{4}$ (27.8 × 18.4)
Pressly: PRI II
Hunterian Art Gallery, University of Glasgow

Unlike the preparatory drawing (no.14), St Sebastian now points heavenward, offering a spiritual release to the cruel drama enacted below. The left side of his body is etched in myriad crisscrossing

lines that tend to flatten his broad, muscular torso. Compared to the bold, dynamic lines he quickly evolved, the execution here is lighter and more niggling. This rare impression is one of nine prints purchased directly from the artist by Dr William Hunter. In pristine condition its rich and sensual textures offer an excellent example of the heavy application of aquatint in the early plates.

The etching is signed 'pinx!', and a painting of this subject was indeed included in Barry's posthumous sale. However, because the painting appears only as an annotated entry in Christie's copy of the sale catalogue, it could not have been a sizable work and may well have been just an oil sketch. Barry also executed another print, in reverse, of this same scene (fig.25). In this work he experimented with the medium of soft-ground etching. Because it bears the dealer's impressed stamp in its centre, it obviously was executed on the back of a plate, probably the one used for the print exhibited here.

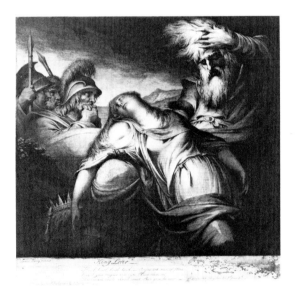

63 KING LEAR AND CORDELIA 1776

Etching and aquatint (dark brown ink)
(touched proof; the bottom portion is from
the first state and has been pasted on)
$21\frac{3}{4} \times 21\frac{11}{16}$ (55.3 × 55.1)
Pressly: PR5 III
*Yale Center for British Art, New Haven
(Paul Mellon Collection)*

This print reproduces the painting exhibited in 1774 (no.5). Three aquatint impressions are known, this particular one representing the last state in this small group. The ink is now unusually dark, adding to the sombre mood of despair. The artist has also touched up the impression with watercolour, the brushwork revealing that he planned to add to the density in certain areas such as Lear's beard and the landscape behind. Curiously, there are a number of lines lightly etched across the lower part of the design, providing a thin, atmospheric veil. The nineteenth-century critic William Hazlitt may well have had in mind this daring and highly unconventional image when he complained about Barry's work, 'His prints are caricatures even of his pictures: they seem engraved on rotten wood.'

64 KING LEAR AND CORDELIA *c.*1790

Etching with engraving (black ink)
$20\frac{1}{8} \times 21\frac{13}{16} (51 \times 55.4)$
Pressly: PR5 IV
Museum of Art, Rhode Island School of Design,
Providence, (Mary B. Jackson Fund)

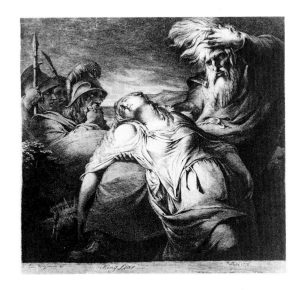

Although the conversion from an etching with
aquatint to a work depending entirely on line did not
take place until around 1790, Barry inscribed the first
publication date of 1776 at the lower right after he
had cut off the bottom portion of the plate containing
the original publication line and the quote from
Shakespeare. Technically this is the most radically
transformed of all the prints. He must have bur-
nished the copperplate to the point where he was
almost beginning anew, only a few lines from the
early states remaining, particularly along the right-
hand margin. Yet, unlike a print such as 'Philoctetes'
(nos 69 and 70) where a new element is introduced,
there is no pronounced change in content, only in
execution. In the later states of 'King Lear', there is
greater coherence to the design. The figure of
Cordelia, for example, is more sculpturesque, re-
attaining the prominence she had enjoyed in the
painting (no.5) which the print reproduces.

65 THE BIRTH OF VENUS 1776

Etching and aquatint (brown ink)
$15\frac{7}{8} \times 22\frac{15}{16} (40.3 \times 58.3)$
Pressly: PR7 II
Trustees of the British Museum, London

This print offers a different version of Venus' birth
than does the painting 'Venus Rising from the Sea'
(no.3). Following an alternate tradition, Barry now
depicts her nestled in a large shell held aloft by
Neptune. This print is one of his most successful
aquatints, in that it comes closest to the style of his
wash drawings with their sensuous tonal qualities
and emphasis on abstract surface rhythms. In the sky
there are six different tones forming highly complex
patterns, and the brushstrokes applying the varnish
are clearly visible in the richly textured lower edge of
the shell. The valves of this shell, despite their
receding ribbing, tend to flatten out against the
picture surface, and even Venus' exaggeratedly full
thighs are compressed within a shallow plane. The
sensuous curves and countercurves are continued in
the sea creatures sporting beneath and in the three

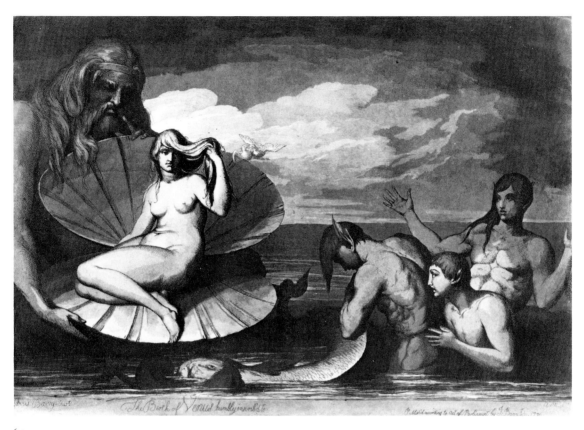

65

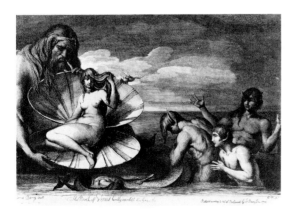

worshipful tritons pressed together in a compact grouping. Unusual for such an early date is the artist's dramatic play with scale. Neptune is an immense colossus who cannot be adequately contained even within the print's expansive format. Barry takes delight too in such exotic details as the tritons' bizarre ears, a shape that is repeated in the tailfins and the overhanging hair.

In this instance Barry had difficulty deciding on an appropriate dedication. The phrase 'humbly inscrib'd to' was later followed by 'our unparalleled females', which was then replaced by 'Her Grace the [blank]'. His penchant, however, for dedicating his prints, again underlines how much more closely they are linked to contemporary affairs than are his oils.

66 THE BIRTH OF VENUS *c.*1790

Etching with engraving and traces of aquatint (black ink), $15\frac{7}{8} \times 22\frac{15}{16}$ (40.3 × 58.3)
Pressly: PR7 V
Trustees of the British Museum, London

In the state following this one, Barry added after the date 'Dec. 1776', 'PPRA [Professor of Painting to the Royal Academy] 1791', confirming that these re-worked images belong to a later period. In this instance, in contrast to 'King Lear and Cordelia', more is lost than is gained in the transformation from a combination of etching and aquatint to line only. The delicacy and luminosity of the earlier image is lost in the enshrouding network of lines.

67 THE FALL OF SATAN *c*.1790

Etching with engraving and traces of aquatint (black ink), $32\frac{3}{8} \times 23\frac{5}{8}$ (82.3 × 60)
Pressly: PR9 VI
Victoria and Albert Museum, London

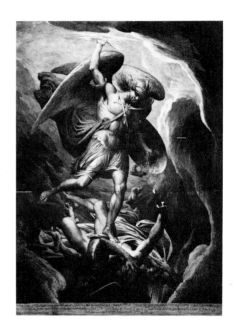

A great deal of the aquatint from the earlier states (see no.23) survives into this later, reworked image, where the transformation is not as radical as in many of the other designs. Characteristically in terms of his late style, Barry changed the curved bolts of light-ning in St Michael's hand to ones in which all of the angles are sharply acute. Unfortunately, though, some of the graceful beauty of the saint's figure has been lost in the extensive introduction of hatching; the line which is so delicately rendered in the early states is unable to provide an adequate superstruc-ture for the additions. A converted print such as this one contrasts dramatically with the Miltonic prints (nos 50, 51 and 55), which, though executed only a few years later, were conceived from the beginning as line engravings. It forms a rather anaemic com-panion to these vigorous, heroic images, for which, however, it helped prove a training ground.

68 JUPITER AND JUNO ON MOUNT IDA 1777

Etching and aquatint (brown ink)
$9\frac{15}{16} \times 7\frac{9}{16}$ (25.2 × 19.2)
Pressly: PR11 I
Visitors of the Ashmolean Museum, Oxford

This print presumably reproduces the painting of Jupiter and Juno on Mount Ida that Barry exhibited at the Royal Academy in 1773. It is based on that episode in Homer's *Iliad* when Juno seduces Jupiter in order to lull him to sleep so that she might aid the Greeks against the Trojans without her husband intervening. As an aid to her plan, she wears about her middle Venus' cestus, a garment that makes her charms irresistible.

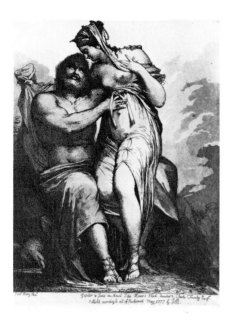

In the print the massive god and goddess tower above the viewer. Jupiter's broad shoulders and barrel chest make even the Belvedere Torso (fig.7), on which his figure is based, look underdeveloped in comparison, and his left thigh bears little resemblance to human anatomy in order for the knee to extend out so far from behind Juno's body. One critic was so taken aback by the exhibited canvas that he maliciously scolded, 'What hinders our calling Juno a *drunken, clumsy whore*, just broke out of *bridewell*, and embracing her *bedlamite patagonian* paramour upon a *dunghill?*' (*Morning Chronicle*, 6 May 1773). Another critic condemned the artist for, among other things, showing Juno inappropriately twisting his hair about her fingers (see *Morning Chronicle*, 10 May 1773). Because this last detail is not in the print, this may be an early instance of an artist altering a composition in response to a newspaper critique. At any rate this gesture returns with added emphasis in Barry's later version of this same scene (no.86).

This print is appropriately dedicated to Charles Townley, a well-known collector of classical antiquities. Barry must have known Townley well. Both men were Roman Catholics and had been in Rome at the same time. In addition, back in London Barry sketched works from Townley's collection.

69 PHILOCTETES 1777

Etching and aquatint (brown ink)
$17\frac{7}{8} \times 14\frac{1}{2}$ (45.4 × 36.9)
Pressly: PR12 I
Trustees of the British Museum, London

The emotional impact is stronger in the print than in the painting it reproduces (no.2). Barry accomplishes this, in part, by bringing the figure forward so that there is less space at top and bottom. He also enlarges the sky, its stormy expanse heightening the sense of drama, and against it he silhouettes Philoctetes' head, his hair now blowing violently in the wind. Even such a small adjustment as altering the bandage so that it no longer covers the stiff, spikey fingers of the left hand increases the sense of pain and anguish. Then too by adding to the scene of the original, ill-fated sacrifice visible in the carved relief, he makes its meaning more intelligible.

Barry dedicated this print to the politician Sir George Savile. On 19 April 1777 he had already approached Savile, who was also one of the vice presidents of the Society of Arts, requesting his help

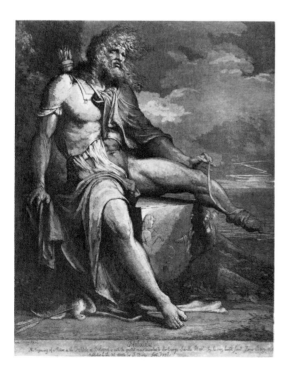

in securing an annuity while he was at work on the Adelphi project, and this dedication, appearing five months later, may have been part of this campaign to win his support. Barry, however, must also have wished to pay tribute to Savile the politician, who was a friend of Edmund Burke and a supporter of liberal causes. Savile had already defended the actions of the rebellious Americans and was to author the Roman Catholic Relief Act of 1778. Although he was ineffectual in promoting the artist's financial scheme, Barry continued to admire him greatly. At one point he even considered including him along with William Pitt the Elder and Charles Pratt, Lord Camden, as one of the three judges in 'Crowning the Victors at Olympia' but ended by placing him in the more appropriate canvas 'The Distribution of Premiums in the Society of Arts'.

70 PHILOCTETES *c*.1790

Etching with engraving and traces of aquatint (black ink), $17\frac{15}{16} \times 14\frac{1}{2}$ (45.5 × 36.8)
Pressly: PR12 II
Yale Center for British Art, New Haven
(Paul Mellon Collection)

Barry not only removed most of the aquatint, transforming the work into an image created almost entirely through line, but he also introduced a gnarled tree to the right of Philoctetes, striking a still wilder note under the influence of the works of Salvator Rosa. Phallic imagery, presumably on an unconscious level, is often encountered in Barry's art, and here one of the tree limbs and the arrow penetrating the dove unmistakably fall into this category, as if these images of potency were needed to counteract the crippling effects of Philoctetes' wound.

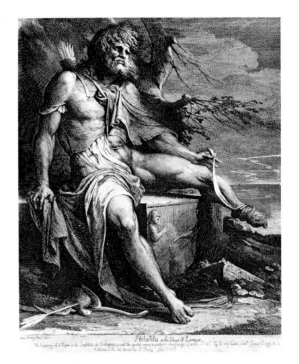

After having used aquatint extensively in his first years as a printmaker, Barry was later to employ this technique sparingly, but his interest in experimenting with different media is characteristic of his entire career. Only a few years before his death he had turned to mezzotint (see no.97) and had also attempted lithography (see no.74), this last a medium that was then as novel as aquatint had been earlier. Yet, it is as an etcher and engraver that he created his best work, and it was not until the 1790s that he began to reach the peak of his powers. The large set of Adelphi details and the prints illustrating *Paradise Lost* (nos 50, 51 and 55) should be grouped among this number. Four additional impressions of *Satan, Sin and Death*, a print that belongs to this last series, have been included here in order that his development of a single image might be more closely examined. Throughout his career as a printmaker, Barry worked frequently on a large scale, but his last major print of Pandora (no.77) is by far his largest. It is as long as the plate for 'Crowning the Victors at Olympia' and 'Elysium and Tartarus' but considerably wider than these two works, having at this point even outgrown the capacity of his own press.

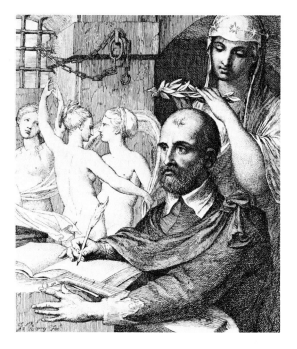

71 TASSO IN PRISON CROWNED BY URANIA AND ATTENDED BY THE THREE GRACES *c*.1780

Etching (black ink), $11\frac{3}{8} \times 9\frac{1}{4}$ (29 × 23.6)
Pressly: PR16 1
Visitors of the Ashmolean Museum, Oxford

In the late eighteenth century, the life and work of the Italian poet Torquato Tasso (1544–95) were attracting increasing attention. Tasso's most celebrated epic was *Gerusalemme liberata*, and the posthumous sale of Barry's effects reveals that he owned a copy of Philip Doyne's translation *The Delivery of Jerusalem*, published in Dublin in 1761. In 1763 John Hoole published another translation *Jerusalem Delivered* and in 1785 an Italian biography appeared in Rome. Then with the publication of Goethe's play *Torquato Tasso* in 1790 the myth of the creative artist in conflict with a hostile society was firmly established throughout Europe.

Barry's print would appear to be the earliest depiction of Tasso in prison, a subject that was to enjoy great popularity in the following century. It in fact may well predate the two continental publications of 1785 and 1790, in that it probably was executed around the time he was painting Tasso into

'Elysium'. The head is identical in both the print and
the painting, although in 'Elysium' the poet, who is
seated to the right of Homer, is shown with his head
propped on his hand in the conventional pose of
melancholy. For Barry's textual source, one need not
look beyond Doyne's 1761 translation. In the be-
ginning of this two-volume work, there is a brief
biography by Henry Layng, who attributes Tasso's
imprisonment in the madhouse of St Anna from 1579
until 1586 to the poet's love for Leonora d'Este, the
Duke of Ferrara's sister. Following earlier specu-
lation, Layng impugns the duke's motives, arguing
that under the guise of helping to protect Tasso he
was attempting to prevent his seeing Leonora, and
the poet's recurring bouts of insanity were the
product, rather than the cause, of his incarceration.
While from Layng (and from Hoole for that matter),
Barry would have imbibed the legend of the per-
secuted poet, Doyne's own introductory essay must
have planted the seed for his specific conception:
'The poet shou'd converse as much with angels as
with men; Urania, immortal muse! is an inhabitant
of heaven. 'Tis thus that a poem is distinguished
from history, not by numbers only, but by a poetical
fury and divine transport, that appears in every part.'
In Barry's design, the heavenly muse Urania en-
circled by stars bestows on Tasso a laurel crown.
Urania is also a surname of Venus, and in his second
lecture at the Royal Academy, Barry associated
beauty (which Venus Urania represents) with the
Three Graces, who dance in harmony beside her (see
Works, I, p.399). These images of beauty and grace,
the poet's natural companions, are purposely con-
trasted with the gloomy and oppressive prison
interior to which the transported Tasso is oblivious.
Piranesi's nightmarish *Carceri* probably influenced
the cell's design with its massive pillar, ponderous
arches, small, barred window, and ominous chain.

Barry presumably shows Tasso at work on one of
his epics, the lute beside him, like Orpheus' lyre,
calling attention to his poetic voice. His head has
been handled with care, but the body is remarkably
crude even when Barry's love of mannered distor-
tions is taken into account. The right arm is too short,
while the left is oversized. Both hands, however, are
eloquently expressive. In particular, the open, tense
gesture of the left hand underlines that this is a
moment of epiphany, and in reaching out toward the
artist's signature it makes clear the strong bond
between Barry and his subject.

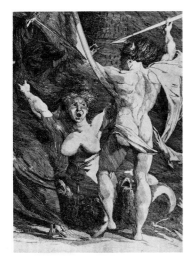

A

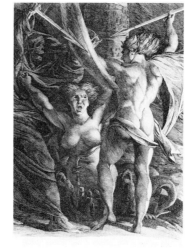

B

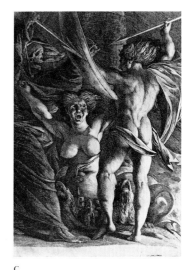

C

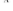

D

72 A–D SATAN, SIN AND DEATH *c.*1792–5

> Etching (black ink)
> A $22\frac{1}{2} \times 16\frac{1}{4}$ (57.1 × 41.2)
> Pressly: PR26 I
> B $22\frac{1}{2} \times 16\frac{5}{16}$ (57.2 × 41.4)
> Pressly: PR26 III
> C $22\frac{1}{2} \times 16\frac{1}{4}$ (57.1 × 41.2)
> Pressly: PR26 VI
> D $22\frac{5}{8} \times 16\frac{5}{16}$ (57.4 × 41.4)
> Pressly: PR26 VII (an impression of 26 III
> on the verso)
> *Trustees of the British Museum, London*

Five of the nine known states of 'Satan, Sin and Death' are in the exhibition, and in them one can follow the print's development from its inception through one of its last transformations. No.72A is the earliest surviving proof; in its fluid lines the underlying, pulsating rhythms can be most clearly seen. By the third state (no.72B), the design has already been fully realized with the figures firmly delineated through the use of extensive cross-hatching. In the subsequent fourth state (no.51), the artist introduces numerous minor adjustments, but by state six (no.72C) he has more radically altered the overall conception, having at this point lightened a number of areas, thereby softening the contrasts. Then from state seven (no.72D) through the ninth and last state he again works toward a denser image.

 These impressions make clear how intently Barry

wrestled with a design, even after having reached a 'final' solution. There is a constant interplay between subtraction and addition. He often burnishes out various elements lightening certain areas at the same time he is reinforcing and darkening others. Satan's legs form an interesting gauge of how extensive the alterations could be. In the third state (no.72B) the shading is particularly bold, forming jagged, abstract patterns of searing energy. By the sixth state (no.72C), he has adopted softer modulations, but then reintroduces starker contrasts (no.72D), though not reverting to the bold execution of the first conception. The changes are by no means always for the better. By the final state, not exhibited here, the image seems far more laboured compared to the earlier impressions, and an important detail such as the background arch disappears altogether beneath the dense web of proliferating lines.

73 JONAH 1801

Etching and engraving (black ink)
$23\frac{7}{16} \times 17\frac{9}{16}$ (59.5 × 44.5)
Pressly: PR32 III
*Yale Center for British Art, New Haven
(Paul Mellon Collection)*

This print after Michelangelo's figure of Jonah on the Sistine Ceiling was based on a drawing that Barry had made years earlier when he was in Rome. Yet, he had only recently come fully to appreciate this dynamic side of Michelangelo's art, the evidence for which can be seen in a number of his late works. For figures embodying 'spirit and energy', Barry had already singled out this composition for special praise in his third lecture: 'His sublime Jonas, his Haman, and some figures in the Last Judgement, are above all comparison, for sound, intelligent drawing. . . . Although foreshortening, when too often affected, or in too violent a degree, is not less displeasing than it is vicious, yet a small degree of it, as in the body and thighs of Michael Angelo's Jonas, gives a happy taste and beauty to the drawing even of a single figure, where it is thought to be least admissible' (*Works*, 1, pp.423–4).

Like the large set of prints illustrating the Society of Arts paintings and the lithograph of the head of Lear (no.74), 'Jonah' presents a detail of a larger work as a finished composition. In adapting the subject, Barry left out much of the original context, dropping the framing architectural elements and

placing the figure within a rectangular format. The vine behind Jonah has also been discarded, and at the right there are a few changes made to the character of the accompanying genii and of the fish that has just disgorged the prophet. The austere background, however, is not as neutral as it first appears. Through the simplest of means, Barry suggests a number of shifting patterns of light and shadow, and the clouds open up at the upper right, permitting Jonah an unobstructed view beyond. Barry imparts an extraordinary energy to his descriptive lines, a technical *tour de force* that is unimaginable without the prints illustrating *Paradise Lost* as a background. He executed this work on a heavily pitted plate, its pocked surface adding to the sense of raw power.

Barry dedicated 'Jonah' to the Duke of Bridgewater. The Duke along with the Earls of Carlisle and Gower had purchased the Italian and French paintings from the famous collection of the Duke of Orleans, which had left France after the political upheavals, and then had exhibited these pictures in London from December 1798 to August 1799. Barry was extremely enthusiastic over seeing again these works that he had studied as a student in Paris, but the motives of the duke were not as noble and patriotic as he implies. The duke and the two earls made a handsome profit in the transaction, selling those works that they did not choose for their own collections. Barry, however, meant the print to be read not only as praising the duke but also as damning the Royal Academy. For years he had been crusading for a national gallery of art, and it was his stinging criticism of the Academy for not purchasing some of the offered works that helped lead to his expulsion. Thus, Jonah, a prophet who suffered more than did those to whom he delivered his unwelcome insights, was an appropriate choice for his subject. Blake's second state of the print which he entitled 'Joseph of Arimathea Among the Rocks of Albion' follows Barry's lead in adapting a figure from a fresco by Michelangelo to comment on England's troubled condition.

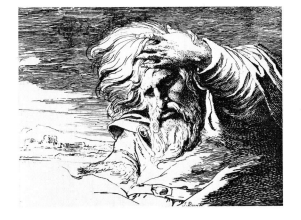

74 KING LEAR *c*.1803

 Pen lithograph (black ink)
 $9\frac{1}{8} \times 12\frac{11}{16}$ (23.2 × 32.2)
 Pressly: PR38
 Victoria and Albert Museum, London

This work is Barry's sole lithograph, a medium that had only recently been invented. On 30 April 1803 it appeared in *Specimens of Polyautography*, a collection of two sets of six prints that marks the first extensive use of lithography as an artistic medium. Some of the other artists who participated along with Barry in this pioneering venture were Henry Fuseli, Benjamin West, Thomas Stothard and Thomas Barker of Bath. Compared to other media, lithography was extremely easy to learn. In this instance Barry had only to draw directly on to a prepared stone with pen and a particular type of greasy ink. Next the printer applied water, which was repelled by the grease. This was followed by a roller with printer's ink. Since the grease absorbed this ink, while the water, in its turn, repelled it, the stone was then ready for printing.

When trying out this new medium, Barry turned to a familiar subject, excerpting the emotive head of King Lear. The bold cross-hatchings, the closely spaced, nervous parallel lines and the suggestion of stipple in the hand and face are all techniques that he had learned from etching but in his late years had been fully absorbed into his drawing style. Throughout he skilfully contrasted areas of white with passages of dense blacks, while Lear's compressed left arm dramatically projects from his flattened, disembodied side.

75 JUPITER AND JUNO ON MOUNT IDA
 *c.*1804–5

 Etching and engraving with use of mezzotint
 rocker (black ink), $12\frac{1}{16} \times 14\frac{1}{8}$ (30.6 × 35.8)
 Pressly: PR39 I
 Visitors of the Ashmolean Museum, Oxford

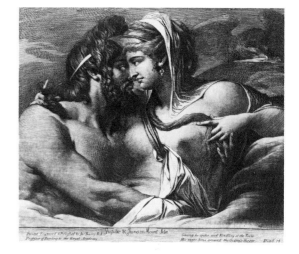

Despite the fact that the plate is inscribed 'Professor of Painting to the Royal Academy', the print probably postdates Barry's expulsion (this is certainly true of 'Jonah'). All but two of the surviving impressions are posthumous, suggesting a late work, and the use of the mezzotint rocker also seems to be characteristic of the late years. As in the following print (no.76), Barry employed the rocker to lay down a soft tone over the plate's surface, creating an almost palpable, unifying atmosphere. Because the print shows a bit more of the image than now appears in the painting it reproduces (no.86), it suggests that the canvas may have been slightly cut down at some later date.

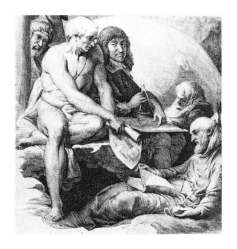

76 SCIENTISTS AND PHILOSOPHERS *c*.1804–5

Etching and engraving with use of mezzotint rocker (black ink), $13\frac{1}{4} \times 12\frac{7}{8}$ (33.7 × 32.8)
Pressly: PR40 [Literature: Pressly, '"Scientists and Philosophers": A Rediscovered Print by James Barry', *The Journal of the Royal Society of Arts*, CXXIX, July, 1981, pp.510–5]
Royal Society of Arts, London

This print reproduces the lower left-hand corner of the painting 'Elysium and Tartarus', and to some extent it can be viewed as a reworking of the lower half of the large print reproducing this section of the canvas (no.37). To the left sits Thales with a scroll on which are inscribed some of his discoveries: the origins of eclipses, the tropical and polar divisions of the earth, and how to tell the height of the Egyptian pyramids by the length of their shadows. He is followed by Descartes, Archimedes and Roger Bacon.

Because of the plate's size, it could never have been intended as part of either the small set after the Adelphi paintings or the large set reproducing selected details. It seems doubtful that it was even intended for wide circulation as the copperplate itself was imperfect, a large indentation appearing on its left side (the right side of the printed image). In addition, no contemporary impressions are known, suggesting a late work of which there were few trial printings.

The question arises as to why Barry bothered to spin out yet another variation on this old theme. In this version Thales' heroic, nude figure owes a great deal to the artist's continuing study of Michelangelo, and his features resemble Barry's own (see fig.33). In addition, Thales now sits over the entrance of a dark cave, surely an allusion to Plato's famous allegory which forms such a perfect accompaniment to the theme of reserved knowledge. In *The Republic*, Plato describes men who are chained at the back of a cave facing the rear wall. Behind them a fire casts shadows of various objects on to the wall, and for the chained men these shadows are their only reality. One of the imprisoned figures is then released to face the light, and until his eyes can adjust he is more confused than enlightened. The ascent out into the sunlight is still more painful, but with each advance he gains in knowledge. If upon returning to his companions he should try to share his new wisdom, they would think him more confused and ignorant than before, even

killing anyone who insisted that they undertake a similar journey. The allegory epitomizes Barry's belief that the road from ignorance to light is a difficult one and that the mental traveller risks his life at the hands of the bigoted majority.

77 PANDORA *c.*1804–5

Etching and engraving (black ink)
$24\frac{7}{8} \times 36\frac{1}{2}$ (63.2 × 92.7)
Pressly: PR41 II
Trustees of the British Museum, London

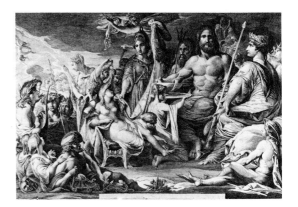

Though the proportions of the print differ from that of the painting (no.85) and the figures in the print are consequently squeezed closer together, the cast of characters remains the same. However, when making the numerous adjustments required by the new format, Barry took this opportunity to correct Hebe's pose. In the painting she is poorly positioned, appearing as if she is about to lose her balance as she hands the kylix filled with ambrosia to Jupiter. In this instance Barry may have been following too faithfully the awkward figure of Hebe in William Kent's 'Banquet of the Gods' in Burlington House (now the Royal Academy of Arts). In the print he remedied his mistake by having Hebe kneel firmly on both knees.

Just as the painting is one of Barry's last oils, this print is also one of the last he attempted. On 19 March 1804, he purchased the copperplate, which measured $25\frac{1}{2}$ by 37 inches, from Thomas Large at No. 84 Shoe Lane, Holborn (two receipts survive in the Lewis Walpole Library Albums, vol.II). By 11 February 1805, Lord Buchan was requesting an impression, but ten days later the artist replied that 'the plate of the Pandora is too large to take off any good proof from it in my own Press, so that I cannot even know, that it is finished, until I goe out to see it done at some other press.' In his late years Barry was deeply despondent, and since no lettering is to be found on the few impressions that have survived, he must never have considered this work as entirely finished. On 13 January 1806, just weeks before the artist died, Lord Buchan was still writing him in an attempt to secure an impression.

THE COPPERPLATES

All the forty-three prints attributed to Barry, with the exception of the lithograph 'King Lear', were executed on copper. Almost all of these copperplates are listed in the sale of the artist's effects held after his death, and, as a result, a large number went through posthumous printings. Barry's sister published the small and large sets of prints reproducing the Society of Arts series in 1808, and at some later date the Society obtained possession of these plates along with that of 'King Lear and Cordelia' (nos 63 and 64). Then in 1851 it received a bequest of sixteen more plates (Pressly nos 3, 4, 6, 7, 8, 9, 10, 12, 13, 14, 25, 26, 36[?], 39, 40 and 41). In 1872 it published an edition of twenty-nine of these works, appropriately including all those designs which reproduced its own series of paintings. Although the Society was generous in disposing of these impressions, no complete sets are known to have survived. Other plates that went through posthumous printings are 'Milton Dictating to Ellwood the Quaker' (no.57), which was published by A. Beugo in 1807; 'Minerva Turning from Scenes of Destruction and Violence to Religion and the Arts' (no.105), the plate for which was owned by William Hookham Carpenter, the Keeper of prints and drawings at the British Museum from 1845 to 1866; and 'The Discovery of Adam and Eve' (no.55), an impression of which is on paper bearing the watermark, 'Smith and Allnutt, 1818' (this etching is in the collection of the Art Gallery of South Australia at Adelaide and was substituted for the 'Portrait of the late James Barry' [presumably no.97] in the 1872 set of twenty-nine prints which the Society of Arts donated to the museum in 1882).

Despite the survival of many of the plates well into the nineteenth century, only two are still extant – 'The Distribution of Premiums in the Society of Arts' (no.33) and 'The Fall of Satan' (nos 23 and 67), both of which have remained in the possession of the Society of Arts. Although never intended as a pair, these two images work well together on a thematic level. One appropriately depicts a convocation of the Society itself and the other was executed in response to the proposed paintings for St Paul's Cathedral, another institution that had attempted to promote history painting. In addition, Barry not only included the cathedral in the background of 'The Distribution of Premiums' but also inserted another version of his proposed canvas of 'The Fall of Satan'. The deep gouges on the surfaces of these two copperplates bear witness to the energy with which the artist attacked his designs.

VIII NUDE FIGURE STUDIES

The study of the live model was at the core of academic training in the eighteenth century; in fact these life drawings were so closely identified with art institutions that they were often called academy figures (in France the Royal Academy even had for a time a monopoly on study from the nude). Barry sketched from the life throughout his entire career, and in the posthumous sale of 1807 there are a number of entries containing large groups of drawings, some or all of which are specifically identified as 'Academical' or 'Academy Figures'. His reliance on the live model was not unusual in a continental context but surpassed that of most British painters. He obviously felt a need constantly to return to the stimulus of observed nature, even employing a model when a pose was based on another work of art.

Barry had ample opportunity to draw from the life. As a student in both Paris and Rome he frequented those institutions that provided such instruction, and back in London he was actively involved in the life class at the Royal Academy. The Academy's Instrument of Foundation specified that nine academicians should be elected annually to serve as Visitors in the Schools of Design. Each was to serve one month during the year to set the figures and supervise the students' performances. Barry was elected a Visitor in 1774, the first year he was eligible, and from then until his expulsion he served for at least fourteen of the remaining twenty-five years (for a view of the Royal Academy's life class at Somerset House see fig.26). There are accounts of his drawing alongside the students, using for supplies packing paper, the pen and ink with which the students signed in, and the chalk used to mark the positioning of the model. In addition, he had the opportunity to sketch from the life while he was at work on the Adelphi series, since the Society of Arts paid him £45 for the expense of a male and female model.

fig.26 Thomas Rowlandson, 'The Life Class in the Royal Academy Schools at Somerset House' 1811

Barry's figure studies are almost always executed in pen and ink, often over pencil or black chalk. Black chalk is frequently used too in the shading and white chalk for the highlights. There is a tendency for the figures to fill the page, and at times their limbs or an object they are holding extend beyond the borders. The figures are aggressively executed with bold contours, and the line is considerably thicker than that used in his earlier drawings. Typical of his late style are the strong, dark areas built up by bold hatching. But despite the flattening of forms and abstract patterning produced by this hatching, the nudes are realistically presented and are often imbued with a certain pathos. Of course, Barry was hardly alone in interjecting hints of mortality into life drawings, but his is a particularly sensitive response to the poignant melancholy embodied in the study of the nude form.

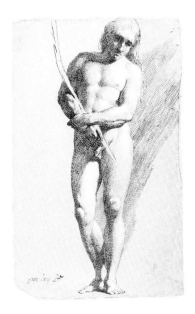

78 MALE HOLDING A PALM *c.*1780

Pen and brown ink over black chalk and
heightened with white chalk on heavy brown
paper, $21\frac{1}{4} \times 13\frac{1}{4}$ (53.8 × 33.8) (sight)
Pressly: D81
Royal Society of Arts, London

This is one of four nude studies owned by the Royal
Society of Arts. They all seem to be the gift of the
Rev. Robert Nixon, who having purchased them at
the 1807 sale presented them to the Society in 1813.
They are annotated 'James Barry RA' in a hand other
than the artist's own, presumably that of Rev. Nixon.
This particular drawing is similar to one owned by
the Royal Academy of Arts, and both of them are
studies for the victorious athletes in 'Crowning the
Victors at Olympia'. Because they do not correspond
exactly to a specific figure in the painting, they have
on occasion been misidentified as studies for an 'Ecce
Homo', but this 'misreading' only reaffirms the
strong Christian parallels that underlie the classical
subject.

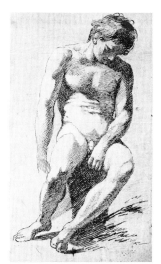

79 SEATED DEJECTED MALE *c.*1780s

Pen and ink with black chalk and heightened
in white chalk, $16\frac{3}{4} \times 9\frac{13}{16}$ (42.6 × 24.9)
Pressly: D86
Brian Sewell

This drawing is similar to a figure study owned by
the Royal Academy. Both show downcast seated
male nudes overcome by melancholy, although the
one in the Royal Academy includes the suggestion of
a landscape setting and is more refined in execution.
Barry's conception of a muscular male nude over-
whelmed by a paralysing lassitude is reminiscent of
Michelangelo's figures.

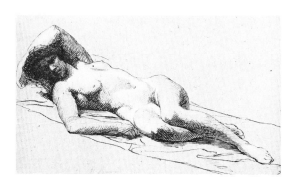

80 RECLINING FEMALE after 1780

Pen and brown ink over pencil and heightened
with white chalk on brown paper
$7\frac{7}{8} \times 12\frac{7}{8}$ (19.9 × 32.7)
Pressly: D87
Victoria and Albert Museum, London

Barry's studies of female nudes are often extremely
sensual. In this instance, with tight, economical lines
he captures a sense of the model's attractive but
ageing figure. She reclines on a slight diagonal, her
face almost obliterated by heavy shading.

[137]

81 SEATED FEMALE ON ROCK FACING
 LEFT c.1790s

Pen and brown ink over pencil and heightened
with white chalk on brown paper
$19\frac{9}{16} \times 12\frac{3}{16}$ (49.7 × 31)
Pressly: D88
Victoria and Albert Museum, London

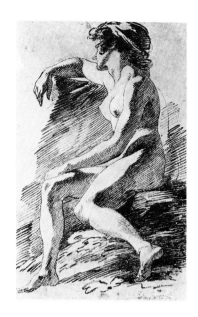

The density and degree of shading is somewhat
unusual in Barry's figure studies. The shadowed
areas are played off against the whites, forming bold,
abstract patterns that are, to some extent, inde-
pendent of the anatomy they describe. To the right
one can see his first false attempts at outlining the
model's back, but even here there is nothing tentative
about the line.

82 MALE WITH ARMS SPREAD WIDE SEEN
 FROM BEHIND c.1792–5

Pen and grey ink over black chalk on stained,
mealy brown paper
$19\frac{11}{16} \times 11\frac{3}{4}$ (50 × 29.9) (repaired)
Pressly: 89
*Yale Center for British Art, New Haven
(Paul Mellon Collection)*

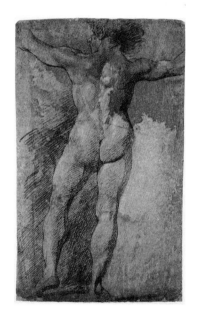

This is a preparatory study for the figure of Satan in
Satan, Sin and Death (nos 51 and 72A–D). In the
print, Barry reverses the shading, placing most of the
figure in shadow with the light coming from the
right. Rotating the figure slightly, he also gives Satan
a much more muscular, heroic cast. Overall there is a
considerable gap between the realistic treatment of
the nude figure study and the monumental character-
ization reserved for the historical design.

83 RECLINING FEMALE WITH HEAD PROPPED
 ON RIGHT HAND c.1790s

Pen and brown ink with black chalk and
heightened with white chalk on brown paper
$12\frac{5}{8} \times 20\frac{5}{8}$ (31.9 × 52.4)
Pressly: D91
Private Collection

In his treatment of this female nude, Barry empha-
sizes the voluptuous nature of her well-rounded

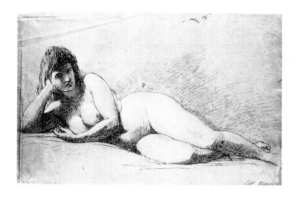

figure, which recalls the ample proportions of his Eve in the print 'The Discovery of Adam and Eve' (no.55). The shading is highly regular with the background executed almost exclusively in black chalk.

84 SEATED MALE WITH ARMS
 SPREAD c.1799–1806

Pen and brown ink over black chalk and heightened with white chalk on buff paper
$17\frac{7}{8} \times 12\frac{7}{8}$ (45.4 × 32.7) (irregular)
Pressly: D92
Trustees of the British Museum, London

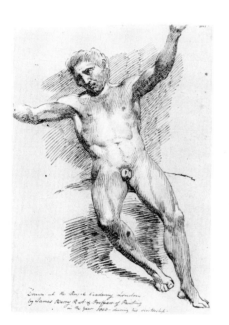

The inscription, which reads, 'Drawn at the Royal Academy London by James Barry RA & Professor of Painting in the year 1800 – during his visitorship', cannot be correct since Barry had been expelled from the Academy in the preceding year. Yet on stylistic grounds this study is a late work and could well have been executed during Barry's last visitorship in 1799. Despite his choice of a receding pose, he flattens out the figure and applies the shading, for the most part, more weakly than he had in earlier compositions. In addition, the anatomical distortions are more pronounced than is usual in his life drawings, and the figure is poorly related to the background, half seated and half reclining against an undefined object. Yet, the disembodied feeling present in this work is often characteristic of the artist's late style, and the mournful face and outstretched arms add another dimension, associating this figure with the Crucifixion.

IX LATE HISTORICAL COMPOSITIONS

From 1784, when he finished work on his murals at the Society of Arts, until his death twenty-two years later, Barry completed only four history paintings. Profoundly discouraged over his lack of patronage and haunted by his own delusions, he found it increasingly difficult to generate and complete ambitious projects. In addition, with the exception of 'Iachimo and Imogen' (no.48) executed for Boydell, all these late canvases are reworkings of earlier subjects: 'King Lear and Cordelia' (no.47) is an expanded version of the painting exhibited in 1774; 'Jupiter and Juno', a version of the painting exhibited in 1773; and 'The Birth of Pandora', the final realization of a project conceived in Rome. The one surviving oil sketch from this late period 'The Baptism of the King of Cashel by St Patrick' is itself a return to a subject painted by the artist when he was a young man in Cork. His career is marked by this persistent returning to old themes.

Barry's art also continued to comment on contemporary affairs. 'The Act of Union Between Great Britain and Ireland' commemorates the legislative merger of the two islands, while its companion 'Minerva Instructing her Rural Companions' demonstrates that painting is meant not only to celebrate but also to participate in the political process. His drawing 'Passive Obedience' is the most explicitly political of the late works, while 'Agrippina' may have an underlying political message as well. Although he stated his intention of engraving 'The Act of Union' and must also have intended to etch both 'Agrippina' and 'Passive Obedience', none of these works were ever engraved.

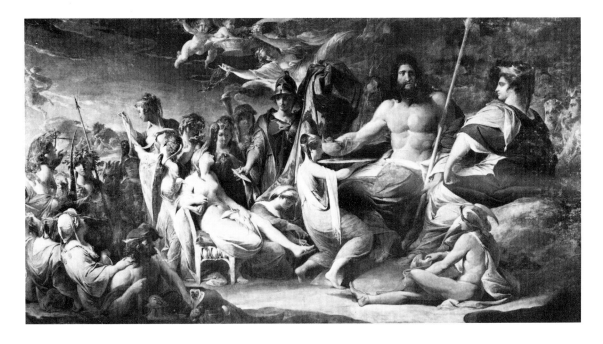

85 THE BIRTH OF PANDORA

Begun by 1791, completed 1804
Oil on canvas, 110 × 205 (279 × 521)
Pressly: P36
City of Manchester Art Galleries

Barry first conceived of executing a large painting showing Pandora showered with gifts by the classical gods and goddesses when he was in Rome. He exhibited a preparatory drawing of this subject at the Royal Academy in 1775 in hopes of securing a commission, and, not finding a patron, eventually undertook the canvas on his own initiative. He did not complete his picture until 1804, less than two years before his death.

The story of Pandora is told by the Greek author Hesiod. To punish man for Prometheus' theft of fire, Jupiter ordered Vulcan to create the first woman, who was then bestowed with gifts from the gods and goddesses that she might prove irresistible. Sent down to Epimetheus, Prometheus' brother, Pandora became the agent of Jupiter's revenge when she opened the lid of the jar that had accompanied her. Once released, the numerous evils that had been trapped inside turned man's life into misery, only Hope remaining to help him endure his new afflictions. As recounted by Hesiod, the tale presents Jupiter as cunning and vindictive, and needless-to-say the whole story has a strong misogynistic bias. Barry, however, chose to ignore these aspects of the story by focusing on Pandora's adornment in heaven rather than her tribulations on earth. He was far from alone in offering this interpretation. For one thing, the name Pandora means 'the gift of all', giving her a decidedly positive persona. Other modern artists had also shown her in a benign light, but Barry probably took his cue from Phidias, the most famous sculptor of antiquity, whose relief of Pandora showed twenty gods present at her birth bestowing gifts upon her. Barry was also at pains to point out the long recognized parallels between this classical story and the Biblical account of the Fall. Like Eve, Pandora, and through her mankind, was given an injunction along with various gifts, the disobeyal of which brought painful consequences. As the artist remarked in this context, 'These vestiges of paganism [which are to be found in classical mythology], like their temples, may be consecrated and made use of for good and Christian purposes' (*Works*, II, p.147).

For Barry each deity embodied a particular perfection, and he saw this subject as an opportunity to recapture the grandeur of the lost classical depictions of these heroic figures. As he later noted, this attempt 'might indeed well satisfy me, as it included the whole of the art' (*Works*, II, p.383). A print by Louis Schiavonetti after a drawing by Barry (fig.27) offers the only surviving record of his early conception of this subject, and it shows how closely his initial design was related to the fresco 'The Council of the Gods' (fig.28), then attributed to Raphael and now to his school. His later painting, however, shows a considerable development away from the austere, frieze-like arrangement to a far more complicated organization. The assembly is now compressed, and, even allowing for some loss to the canvas, the figures push out beyond the edges at either end. Minerva stands at the centre of a shallow semi-circle, and the groups, composed around receding diagonals, fan out from this relatively unobtrusive centre. A diagonal running counter to this arrangement binds Minerva, Pandora and Vulcan into a meaningful trinity. The lighting is also

fig.27 after James Barry, 'Pandora'
engraving by Louis Schiavonetti, 1810

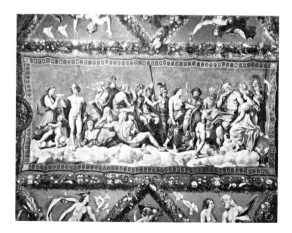

fig.28 School of Raphael, 'The Council of the Gods'

unusually dramatic: dawn comes raking in from the left, creating contrasting pockets of light and shadow. As in his early conception, the artist manipulates scale to denote a figure's rank within this sublime hierarchy, but he now also exaggerates their individual characteristics, representing them more forcibly than before.

On the left sits Apollo playing his lyre, and among his admiring listeners are Bacchus followed by Pan. Next in line, Mars looks up to Venus, who sullenly surrenders her cestus to Cupid for Pandora's adornment. The Three Graces busily attend to Pandora's toilet, while Minerva presents to her the peplus, a tapestry woven for the Panathenaic festival. To Minerva's left stands Hymen, the god of marriage, with his torch. He had not appeared in the earlier design etched by Schiavonetti, but by the same token Janus, who had appeared in the print, is no longer in attendance in the painting. To Minerva's right sit Pluto and Neptune, followed by a commanding Jupiter about to pass the festal bowl filled with nectar to an equally impressive Juno. Between these last two can be seen the Parcae or Fates preparing Pandora's destiny and bringing forward the ill-fated casket. At the far right are the goddesses Vesta, Ceres and Diana, and behind them sits Cerberus, guarding the knowledge of future events that the Fates possess. In the background at the left Aurora precedes the coursers of the chariot of the sun, while overhead hover celebrating Horae and Putti.

In the foreground at the left sit three of the Muses, followed by Vulcan. Barry wrote of this last figure, 'Vulcan is sitting with certain residue near him, which might be supposed to have resulted from the experiments for his masterwork of Pandora' (Works, II, pp.154–5). This residue consists of images of generation and the metamorphoses of lower forms into higher ones. On the right is a serpent with an egg issuing from its mouth: it is the Egyptian Cneph, who was earlier depicted in human form on the scroll in the painting 'Orpheus'. The egg is the mundane world, and the serpent symbolizes the supreme wisdom that gives birth to it. The serpent encircles a vase of water, water being the basis of life, and in the vase swim tadpoles which emerge into a higher sphere as frogs. Plants spring up from seeds, and a fledgling hatches from an egg placed over animating fire (also a form of divination). In his left hand Vulcan holds a butterfly emerging from a chrysalis, the traditional symbol of the soul journeying from a debased to a more exalted state. In choosing his imagery, the artist may well have had in mind the Four Elements, of which the universe was traditionally said to be composed: Water, Earth, Fire and Air. Even Pandora's chair contains a miniature cosmology. The legs represent the lotus, a plant associated with water, and the rail is composed of an egg-and-dart pattern, where the eggs alternating with arrows symbolize the fertile, universal mother impregnated by the divine will. Pandora is of course the greatest of all these images of creation, securely seated on this elaborate metaphysical base. Without Barry's text published posthumously in *The Works*, such esoteric interpretations of his symbolism would be almost impossible to make, but his references are more tantalizing than explicit.

In the foreground on the right sits Mercury putting on his winged sandals that he might take Pandora down to earth, and near the centre Hebe hands a kylix filled with nectar or ambrosia to Jupiter. While the other deities also partake of this ambrosia, one sip of which grants immortality, it is a gift that is withheld from Pandora (except as an anointing oil for her hair). Dawn is only just breaking, and an arduous journey filled with torments must first be endured before she and her descendants can fully partake of life everlasting.

86 JUPITER AND JUNO ON MOUNT
 IDA *c.*1785–1805

Oil on canvas, 40 × 50 (101.5 × 127)
Pressly: P35
Sheffield City Art Galleries

In this canvas Barry returned to the subject of Jupiter and Juno on Mount Ida, an earlier version of which he had already exhibited at the Royal Academy in 1773, executing a print after it in 1777 (no.68). The first design had been influenced by a terracotta sculpture by the Swedish artist Johan Tobias Sergel, whose stay in Rome had overlapped with Barry's own. In this later interpretation he turned to a different source, Giulio Romano's drawing of Jupiter and Juno. This cartoon is now known only through engravings (see for one example fig.29), but Barry would have seen it at firsthand when he studied the collection of the Duke of Orleans as a student in Paris. In this instance he far outstrips his model, creating a scene of sublime drama in place of Giulio's flirtatious couple. In a

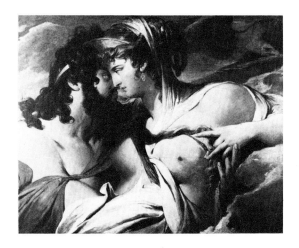

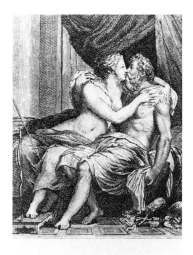

JUPITER ET JUNON.

fig.29 after Giulio Romano, 'Jupiter and Juno', engraving by Bernard Lepicie

scene from Homer's *Iliad*, Juno is shown seducing Jupiter in order to put him to sleep that she may aid the Greek army unhindered. Like the stories of Pandora and Eve, this is yet another tale about a woman deceiving a man, an example of masculine wisdom succumbing to feminine charms. Juno is placed in the centre slightly higher than Jupiter, her profile overlapping his – her victory is not in doubt. The incredible force of their passion is effectively conveyed, but it is a love that is intermingled with treachery. In this context, the intensity often found in paintings of the kiss of Judas may form a part of Barry's conception as well.

Precise dating of this picture is difficult. Unlike his other history paintings it was neither exhibited nor commented on in the newspapers. The composition must have been formulated by the mid-1780s in that it influenced William Blake's drawing 'Har and Heva Bathing: Mnetha Looking on' (Fitzwilliam Museum, Cambridge), which dates from about this time, but the canvas itself may not have been executed until later. Whatever its precise date, it is one of Barry's most remarkable creations, showing him at the peak of his powers. The divine pair are bonded closely together, their garments, along with the intertwined strands of hair, establishing stately, interlocking rhythms. At the same time each figure remains distinct. Juno's blond hair is played against Jupiter's black, her creamy skin against his ruddier hue, her white garments against his red one. Barry too uses the most elemental geometries: the heads are in profile, while Juno's right breast is seen in profile and her left in a frontal view. The confined nature of the space makes the god and goddess appear even more monumental and majestic. The opaque cloud at the lower right parallels Jupiter's cloak, while clouds and Jupiter's eagle fill out the two upper corners, increasing the sense of compression.

The painting is one of the most successful and original examples of the abstract, linear style that flourished throughout Europe in the years around 1800. In its frieze-like clarity, its gently swelling surfaces, and ponderous, linear rhythms it is a masterful statement in an idiom that was to find its counterpart in France in the art of Ingres. Its indulgence in a perverse, voluptuous eroticism also strikes an increasingly familiar note in the art of the Romantic period. Finally, its radical close-up focus and sense of a highly constricted space give it an emotional impact of almost overwhelming intensity.

87　THE BAPTISM OF THE KING OF CASHEL BY
　　ST PATRICK, A SKETCH c.1799–1801

Oil on paper laid down on canvas
$24\frac{3}{8} \times 24\frac{3}{4}$ (62 × 63)
Pressly: P34
An Taisce – National Trust for Ireland and the
Commissioner of Public Works in Ireland

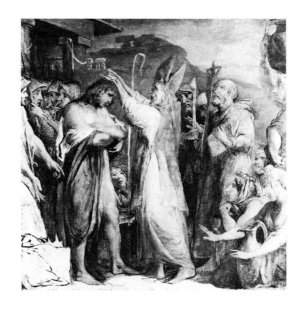

In 1763 Barry submitted to an exhibition of pictures
held by the Dublin Society for the Encouragement of
Arts, Manufactures and Commerce a painting of St
Patrick baptizing the King of Cashel. This, his first
exhibited work, proved so successful that it was
purchased for the Irish House of Commons by three
parliamentarians. Thinking that his canvas had been
destroyed when the House of Commons burned in
the fire of 27 February 1792 (it in fact survived and is
now on loan to the National Gallery of Ireland),
Barry executed this sketch of the same subject. It
shows St Patrick baptizing his important convert
unmindful that in setting down his crozier he has
driven it through the foot of the king. The penti-
mento reveals that the crozier originally pierced the
king's right foot, but in the final solution it is
positioned in a less sensational manner behind. As
the following two works demonstrate (nos 88 and 89),
around 1800 Barry was intensely interested in
political events in his native country, and it is this
interest which must have inspired him to return to
this subject of an earlier Ireland of heroic grandeur in
which a valiant ruler submits totally to the virtuous,
if somewhat absentminded, saint. In the architec-
tural elements the artist offers a brief survey of Irish
antiquity. High on the hill is a dolmen, impressively
recalling an early period of primitive grandeur;
ranged on the side of the hill is a row of trilithons,
marking the beginnings of a rude post-and-lintel
system; and in the foreground stands a Doric temple,
associating this phase of Irish civilization with the
rugged virtues of the classical Greeks.

88　THE ACT OF UNION BETWEEN GREAT
　　BRITAIN AND IRELAND c.1801

Pen and brown and grey ink and grey wash
over black chalk mounted on heavy paper
$28 \times 20\frac{5}{8}$ (70.9 × 52.4) (irregular)
Pressly: D40
Visitors of the Ashmolean Museum, Oxford

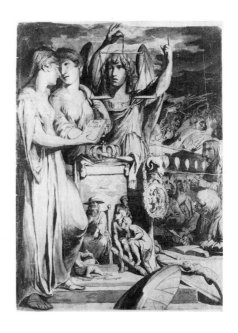

This drawing is Barry's first conception, at least that

has survived, of a proposed painting celebrating the Act of Union between Great Britain and Ireland. This act, which was passed on 1 January 1801, provided for the legislative union of the two islands. William Pitt the Younger, the head of Britain's government, had earlier pressed for Irish reforms, but they were too slow in coming and discontent erupted in the Irish Rebellion of 1798. In order to remedy a deteriorating situation, Pitt first engineered the dissolution of the despotic Irish parliament, and he then planned, after securing the Act of Union, to introduce Catholic emancipation, thereby allowing Ireland's oppressed majority to be represented in parliament for the first time. King George III, however, opposed emancipation, and Pitt resigned rather than force the issue.

Despite the unfortunate conclusion of Pitt's scheme, Barry stubbornly held to the hope that the Union would eventually lead to meaningful reforms in a country that had already suffered so much from a long legacy of misrule. The artist wrote twice to Pitt hoping to secure a commission from the government to paint a picture commemorating this potentially promising event. Failing to get a response, he attempted early in 1801 to revive the project of placing paintings in the centre of the east and west walls in the Great Room of the Society of Arts. On this occasion he hoped to place his painting 'The Act of Union between Great Britain and Ireland' between 'The Thames' and 'The Distribution of Premiums', pictures that already offered a commentary on contemporary England, but his plan was eventually rejected.

In this early conception of his subject, Great Britain and Ireland meet as equals, the scale held by the angel being evenly balanced. The Bible held by the sister countries testifies to their mutual Christian faith, whether Anglican, Protestant or Catholic. On the front of the altar is a scene illustrating one of Aesop's fables, in which the rods, easily broken singly but not together, demonstrate that in union there is strength. In the right background, images of destruction, envy, deceit, war and folly are dispersed by divine thunderbolts. Lower down on the right, a statesman (possibly William Pitt) lectures his colleagues on the benefits of this happy merger.

89

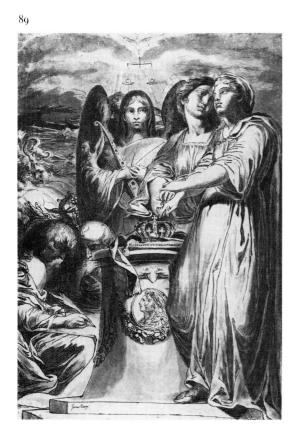

89 THE ACT OF UNION BETWEEN GREAT BRITAIN AND IRELAND

89 THE ACT OF UNION BETWEEN GREAT
 BRITAIN AND IRELAND *c.*1801

Pen and brown ink and grey wash over black
chalk, $27\frac{3}{8} \times 19\frac{5}{8}$ (69.6 × 49.7)
Pressly: D43
Trustees of the British Museum, London

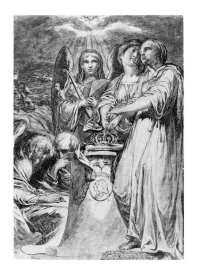

fig.30 James Barry, 'Study for
"The Act of Union Between Great
Britain and Ireland"' *c.*1801

This is the latest version to have survived of Barry's
preparatory studies for the Act of Union. It is similar
to another drawing also in the British Museum
(fig.30). In both works Barry gave the recording
angel on the left a large wing, but in the version
exhibited here he pasted a contoured piece of paper
over the wing and sketched in the background on top
of it.

The final conception differs substantially from the
Ashmolean version. Gone are the historical figures,
who were inappropriate to an allegorical com-
position. Also, the clutter found in the first work is
greatly reduced. In the Ashmolean drawing the left
leg of the personification of Ireland was originally
straight, but, rejecting this rigid pose, the artist
added a bent left knee and extended her right leg
down one step. Although this is a more graceful
solution, the figure now intrudes on the relatively
large scene of the father with his sons and the bundle
of sticks. Even though, as revealed in an inscription
in the drawing reproduced in fig.30, Barry had
second thoughts about dropping this vignette from
his final version, its removal creates a more monu-
mental effect.

The two drawings at the British Museum also
differ in execution from the work at the Ashmolean.
The artist abandoned the softer lines and extensive
use of wash in the first work for bolder, heavier
contours and extensive hatching. Ultimately, the
final conception is more austere and abstract. For
example, the altar is now circular in shape and the
head of the presiding angel almost forms a perfect
oval placed on top of a flawless cylindrical neck.

90 MINERVA INSTRUCTING HER RURAL
 COMPANIONS *c.*1801

Pen and brown and grey ink and grey wash
over black chalk mounted on heavy paper
$25\frac{3}{4} \times 15\frac{1}{8}$ (65.3 × 38.4)
Pressly: D44
Visitors of the Ashmolean Museum, Oxford

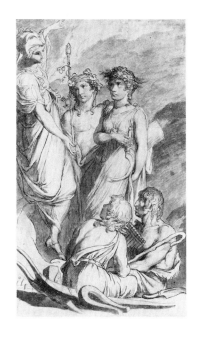

The impressively elongated figure of Minerva, watched by the deities Bacchus and Ceres, descends on a barrier of clouds to instruct a farmer and a shepherd. This work was intended to appear opposite 'The Act of Union' in the Great Room of the Society of Arts. Stylistically it is closest to the Ashmolean version of 'The Union', and its narrower shape is better suited for the confined spaces over the fireplaces. ('The Union' had of course been originally conceived independently of the Society of Arts murals.) 'Minerva Instructing her Rural Companions' would have been flanked by 'Orpheus' and 'A Grecian Harvest-Home', in that it shows a more advanced stage of civilization than does the first painting and prepares one for the rural community presented in the second. Also, it underscores the recurring theme that the art of painting, which, for Barry, is represented by the wise Minerva, is the one indispensable agent in pointing the way to society's cultural advancement.

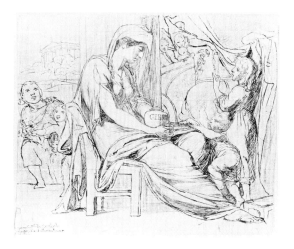

91 AGRIPPINA MOURNING OVER THE ASHES
 OF GERMANICUS c.1790s

Pen and brown ink and black chalk on paper covered with pink wash
$16\frac{1}{2} \times 19\frac{3}{8}$ (41.8 × 49.2) (irregular)
Pressly: D21
Visitors of the Ashmolean Museum, Oxford

The primary source for the story of Agrippina and her husband Germanicus is to be found in Tacitus' *Annals*. Germanicus, the nephew and adopted son of the Roman Emperor Tiberius, had been so successful against the German tribes, hence his name, that the emperor saw him as a threat. From Rome Tiberius sent him to the Eastern provinces away from the admiring populace. Then in Syria in 19 A.D. at the age of thirty-four, Germanicus died after a short illness, convinced that he had been poisoned by order of the emperor. Agrippina, the stoic, grieving widow, returned to Rome with the cremated remains of her husband fruitlessly to demand justice. She disembarked at the Adriatic seaport Brundisium, making her way overland to the capital. Barry depicts a halt along the journey, inscribing the drawing at the lower right: 'a female attendant on this side shewing Agripina [sic] to Claudius Drusus & more Children'. Unlike the emperor, who was conspicuously absent, Claudius Drusus, the brother of Germanicus, had

come out from Rome as far as Terracina to meet his sister-in-law. He approaches from the left, while on the right Caligula, who had accompanied his mother along with her youngest child Julia, lifts the drapery to reveal in the chariot his mother's other four children, Nero, Drusus, Agrippina the Younger and Drusilla, who have journied out from Rome with their uncle.

The closely related subjects of Agrippina landing at Brundisium and her mourning over the ashes of Germanicus enjoyed unusual popularity in Britain at this period. West inaugurated this tradition, exhibiting two versions of Agrippina landing at Brundisium at the Society of Artists in 1768, one of these paintings securing for him the patronage of King George III. The subject of Agrippina landing was also attempted by Gavin Hamilton (R.A. 1772, collection Tate Gallery), James Nevay (S.A. 1773), John Francis Rigaud (R.A. 1776) and Alexander Runciman (R.A. 1781). Agrippina mourning over the ashes of Germanicus proved equally popular being attempted by many of the same artists: Gavin Hamilton (R.A. 1770), James Durno (S.A. 1772), Benjamin West (R.A. 1773), John Flaxman (R.A. 1777) and Alexander Runciman in an etching.

Stylistically Barry's drawing is closest to those of his works that can be securely dated to the 1790s, placing his study at the end of this period of concentrated interest in the life of Agrippina. Of the surviving depictions of this subject, it resembles most closely the etching (fig.31) by his friend

fig.31 Alexander Runciman, 'Agrippina'

Alexander Runciman, who had recently died in 1785. Both artists show Agrippina seated in profile, her large figure barely contained within the picture space and dwarfing those of her children. Both too have modelled her figure on antique sources, Runciman's most closely resembling grave stelae and Barry's the celebrated statue of Agrippina in the Capitoline Museum in Rome. Barry also would seem to have intended to execute his drawing as a print, since there are incised lines on its surface. His interpretation, however, differs from that of Runciman and those others who focused on the mourning Agrippina in that he chose a public, rather than a private, sentimentalized display of grief, and this change in emphasis offers a clue to his meaning.

Writers on Tacitus frequently pointed out the contemporary lessons to be learned from his histories, but of course these interpretations were coloured by the opinions of the individual commentator. In his translation of Tacitus' works published in 1793 with a dedication to Edmund Burke, Arthur Murphy found close parallels between the Roman historian's descriptions of the anarchic mobs and Burke's writings exposing the French regicides as imposters in their championing of civil liberty. The story of Agrippina, however, is one part of the *Annals* that would not support the anti-republican sentiments stressed by Murphy. If considered in a political light, this tale offers a warning against a system of government that concentrates power in the hands of a single individual. Tacitus associates both Germanicus and his father Drusus with the virtues of the old republic, and his sympathies clearly lie with Germanicus and his abused wife, who stand in stark contrast to the picture he paints of a cunning and corrupt Tiberius. When West painted in 1768 his picture of Agrippina that won him favour with the king, it was simply an antique tale of heroic virtue without political undertones. The virtual disappearance of Agrippina as a subject from British art at the time of the French Revolution is perhaps a reflection of its having become politicized in light of contemporary events, and Barry's drawing, which places the aggrieved widow on public display, may well have been intended as a reminder to men such as Murphy and Burke that it was a monarchal form of government that had perpetuated such abuses, abuses that the sympathetic Roman populace would not have tolerated had the political power been theirs.

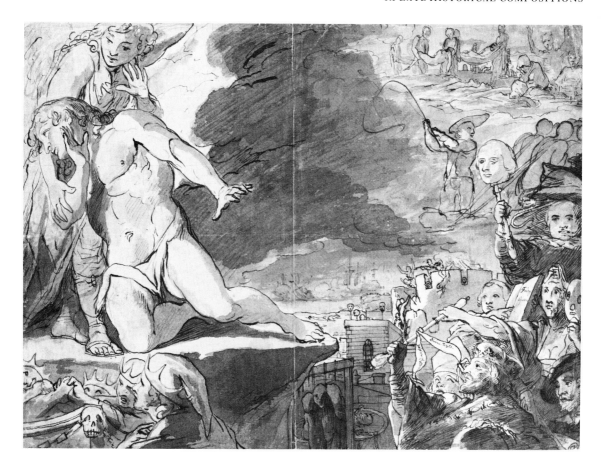

92 PASSIVE OBEDIENCE *c.*1802–5

Pen and brown ink and grey wash with black
chalk, 16¾ × 23 (42.7 × 58.4)
Pressly: D28
Art Museum, Princeton University
(Mather Collection)

Although the historical personalities are taken from
earlier generations, this drawing is an attack on the
contemporary situation in Great Britain. The saintly
figure, who represents the truthful, virtuous man,
recoils from King James I, who holds a sceptre tied
with a ribbon labelled 'Passive Obedience' and
'Divine Right'. These phrases remind one of Barry's
comments in a draft of a letter to Lord Shannon
written in 1778: 'the absurd, slavish and execrable
notion of the *divine, indefeasible, uncontroulable* right
of *Kings* and *the passive obedience* of *subjects* was a
doctrine first introduced by the Reformers. . . . But

the Catholicks on its appearance attacked it with all
their might, and asserted the liberties and rights of
the people, from whose will and choices alone Kings
can derive any equitable or just pretensions'
(no.102). In this drawing Barry is continuing the
Catholic fight against abusive tyranny. His conduct
is in contrast to such creative figures as Sir Peter Paul
Rubens and Edmund Spenser, who are shown
participating in this oppression, the consequences of
which can be seen in the horrifying imagery. At the
left the fools swearing an oath over the altar parody
the earlier altar of peace and prosperity in the
Ashmolean version of 'The Act of Union' (no.88).
With its dizzying changes in scale, its radical cutting
of figures, bizarre metamorphoses and oppressive
central void, 'Passive Obedience' is a work of
startling boldness that creatively extends many of the
conventions found in satirical art into the realm of
history painting.

X THE SUFFERING HERO:LATE SELF-PORTRAITS

Barry's varied and compelling self-portraits form his greatest artistic legacy. Responding to a deep need to proclaim himself an artist, his painted autobiography extends over his entire career, and in its range and intensity it is perhaps unique in British art. His self-definition as an important practitioner of a noble vocation helps explain this preoccupation, but feelings of insecurity about his ability to perform adequately in this exalted role also accompany his grandiose sense of pride. The self-portraits are a solemn declaration of his steadfast dedication and an anxious assertion that the promise is being fulfilled. In his oils the images are both complex and sublime, as has already been seen in his Roman self-portrait of *c*.1767 (no.15) and his historical portrait 'Ulysses and a Companion' of *c*.1776 (no.20). In 'Crowning the Victors at Olympia' (no.28C), first exhibited in 1783, he appears as the Greek painter Timanthes, and his later painting based on this work (no.94) has many of the qualities of a heroic narrative, the province of history painting. It is Barry's final statement in oils defining his persona, and it contains a constellation of images that comment on his entire career. The one oil sketch and the drawings are studies of a more intimate nature. In them the artist portrays himself with an emotionally riveting directness almost unmatched in the British School.

93 SELF-PORTRAIT, A SKETCH *c*.1780

Oil on canvas, $16\frac{1}{2} \times 13\frac{1}{2}$ (42×34.3)
Pressly: P63
Victoria and Albert Museum, London

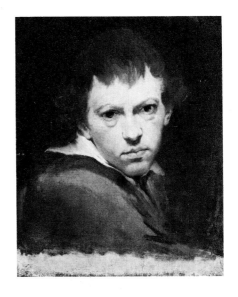

Recalling Edward Fryer's comment that in Barry's face 'one could see lines prematurely engraven by the workings of impassioned mind, so that he appeared older than he really was' (*Works*, I. p.337), one might tentatively date this work to around 1780, when the artist was in his late thirties or early forties. This small, intimate portrayal in a Rembrandtesque mode may well have been executed as part of the preparation for his self-portrait as Timanthes in the painting 'Crowning the Victors at Olympia' (no.28C). Of course the figure only loosely approximates the final pose, but this is also the case of the male model (see no.78) which was sketched in preparation for a figure of an athlete that appears in this same painting.

It is a work of gripping power. At this period only Fuseli was capable of such an emotionally intense self-image. One senses the artist's defiant determination in the face of his bitter loneliness and haunting

fears. In later years W.H. Curran described Barry's appearance, and his account captures some of the fierce, almost demonic, energy present in this painting:

> His face was striking. An Englishman would call it an Irish, an Irishman a Munster face; but Barry's had a character independent of national or provincial peculiarities. It had vulgar features, but no vulgar expression. It was rugged, austere, and passion-beaten; but the passions traced there were those of aspiring thought, and unconquerable energy, asserting itself to the last, and sullenly exulting in its resources (*Sketches of the Irish Bar*, London, 1855, II, p.174).

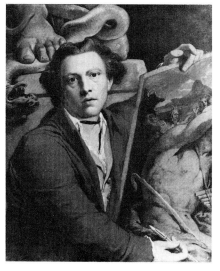

94

94 SELF-PORTRAIT

Head *c*.1780, remainder completed 1803
Oil on canvas, 30 × 25 (76 × 63)
Pressly: P67
National Gallery of Ireland, Dublin

In 'Crowning the Victors at Olympia' (no.28C), Barry appears as Timanthes seated next to a statue of Hercules trampling down Envy. In his hands he holds his recreation of one of the Greek artist's lost paintings showing satyrs cautiously approaching a sleeping cyclops. The self-portrait exhibited here is based on that earlier image (the head, however, is the final preparatory study for it). As discussed at the end of the introductory essay 'The Artist as Hero', this painting reverberates with complex associations. It is a highly personal statement of Barry's perilous predicament as a modern man of genius who is doomed to recast the heroic past in a debased present.

95 SELF-PORTRAIT *c*.1800–5

Pen and brown ink over black chalk with white highlights on coarse brown paper
$19\frac{3}{4} \times 16\frac{1}{2}$ (50.3 × 42.5) (irregular)
Pressly: D63
Visitors of the Ashmolean Museum, Oxford

Of the two late self-portrait drawings exhibited here, this work is probably the earlier in that the artist appears less gaunt than he does in the following study. Both are imposing works executed with heavy, coarse lines. Both too are probably candlelight

studies whose crude, energized lines create rich, animating patterns of light and dark. In this particular self-portrait, Barry shows himself in the act of sketching his own image, having faintly blocked in his hand in the bottom margin. The internal evidence of the drawings themselves indicate that he was right handed (the diagonal lines most frequently run from lower left to upper right), but in this instance he shows himself sketching with his left hand just as his image would appear in a mirror. An unedited record of his appearance, this drawing is executed with unrelenting honesty.

In addition to this and the following work, Barry executed two other self-portrait drawings, both of which show him in right profile. The one in possession of the Royal Society of Arts (fig. 32) was executed in middle-age and has an oval frame drawn around it; the other in the Pierpont Morgan Library is a small, late study drawn in imitation of a classical cameo (fig. 33).

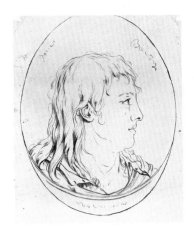

fig. 32 James Barry, 'Self-Portrait' *c.*1780 fig. 33 James Barry, 'Self-Portrait' *c.*1800–5

96 SELF-PORTRAIT *c.*1802

Pen and brown ink over black chalk
$11\frac{1}{2} \times 9\frac{1}{2}$ (29 × 24) (sight)
Pressly: D64
Royal Society of Arts, London

This drawing was presented to the Society of Arts by the engraver Charles Warren, who penned the following note on the back:

This portrait of Barry the painter I purchased at the sale of his effects which took place shortly

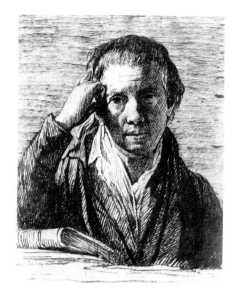

after his death. It was a favourite candle light study of his, but never intended to be made public – as it was his intention that no portrait of him should be seen past the meridian of his life. He drew this a few years before his death with pen and ink, and in his usual painting dress. From my long acquaintance with him I can answer for its being a strong characteristic likeness of that artist and most singular man. Chas. Warren.

Warren almost certainly overstates Barry's reluctance to have any late portraits of himself to become well known, but clearly an intimate study, such as this one, is more in the nature of a private rather than a public image. In this case even the print related to it (no.97) was never widely circulated.

Like the Ashmolean self-portrait this work depicts Barry as weary, pensive and disillusioned. Both drawings in fact are representations of a familiar type – the melancholy artist. Melancholy had long been associated with creativity, and Barry's drawings are particularly moving portrayals of the despondent, solitary genius who is so much a part of the Romantic imagination.

This work is even cruder in its execution than the Ashmolean drawing. There is an almost brutal quality to the vigorous cross-hatching, and the right arm does not connect with the shoulder. As in the Ashmolean drawing and the Victoria and Albert oil sketch, the background is completely filled in, while the ground plane is only cursorily sketched or left unfinished. These vibrating images hover with a hallucinatory intensity.

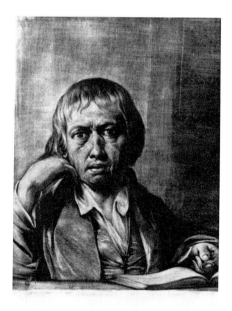

97 SELF-PORTRAIT begun c.1802

Mezzotint (Black ink), $13\frac{7}{8} \times 9\frac{15}{16}$ (35.3 × 25.3)
Pressly: PR36
Trustees of the British Museum, London

The print is related to the above self-portrait drawing (no.96), and because it can be dated with some accuracy, it helps to pinpoint the date of this other image as well. In a letter to the Society of Arts of 2 May 1804, Barry wrote that he had a mezzotint head of himself that was executed almost two years ago, but he added that it was not quite finished and no impressions had been taken. The year before, on 13 July 1803, he must also have been referring to this

same work when he wrote to Cooper Penrose, an Irish friend, that 'nothing has been done to the portrait since Mr Edward saw it, so that you cannot have an impression' (*The Monthly Magazine*, XVI, 1 September 1803, p.107). Since the print bears no caption, he may never have felt that it was finished, and because so few impressions have survived, he obviously did not intend it for a wide audience. In this interpretation of the self-portrait drawing, his slumping figure is now placed low on the page, his features even more haggard than before. The crumpled face reminds one of Henry Fuseli's wickedly amusing comment associating Barry's appearance with that of his decrepit and battered home. Earlier, on seeing him get up from sitting to George Dance for his portrait, Fuseli exclaimed in a thick German accent, ''Dat fellow looks like de door of his own house' (*The New Monthly Magazine*, V, March, 1816, p.135).

Barry undertook mezzotint late in his career, and this is only one of two works executed by him that are solely in this medium. First developed in the seventeenth century, mezzotint quickly became well-established in England, so much so that it became known as *la manière anglaise*. In Barry's day it was almost exclusively a medium reserved for the reproduction of paintings. In conception, it is the reverse of other printmaking techniques in that the engraver works from dark to light. First he pits the surface of the plate with a rocker so that if it were inked and printed at that point it would produce a sheet of uniform, velvety black. Then he burnishes the plate, and depending upon the extent of his scraping, he can produce white areas or an unlimited range of greys.

Mezzotint is a tonal rather than a linear medium, and Barry's adoption of it late in his career is a reflection of his increased interest in the depiction of light and shadow. In this instance, however, his use of the medium is extremely crude. In the background the transitions from the dark right-hand side to the lighter left are unusually abrupt, the artist deliberately rejecting the refined nuances so characteristic of the polished performances of his professional contemporaries.

From the beginning of his career, Barry viewed himself as a writer and a critic, his correspondence from France and Italy revealing a sensitive and independent spirit. Even at that early date he hoped to publish his observations. One reason that this goal was important to him was that in the eighteenth century the writer enjoyed greater prestige than did the artist. For example, Reynolds, as the author of the *Discourses*, certainly cultivated this aspect of his career, and Barry was of course to challenge Sir Joshua directly when composing his lectures as professor of painting at the Royal Academy. But an even stronger motivation was his passionate desire to educate the public to appreciate what he as an artist was struggling to accomplish. For him, the content was always of greater importance than the form, and his writings are consequently convoluted and repetitive. In addition, because of his persecution mania, there are certain refrains that are tirelessly repeated throughout his career, but the force of his personality keeps breaking through even when he lapses into standard complaints.

Surprisingly there is little difference between the voice one hears in the books and that in the letters. Often, in fact, the books are written as epistles, which even incorporate earlier correspondence. The letters, on the other hand, contain a minimum of pleasantries in that they too are single-mindedly devoted to those issues that Barry considered central to his painting. The reader must work for them, but buried within his books and correspondence are numerous perceptive and original observations on the meaning and practice of art.

98 AN INQUIRY INTO THE REAL AND IMAGINARY OBSTRUCTIONS TO THE ACQUISITION OF THE ARTS IN ENGLAND

London, T. Becket, 1775. 8 vo, pp.vii + 227
Victoria and Albert Museum, London

Barry had begun writing this, his first book, in Rome, and it was published early in January 1775. It is an impassioned plea for the promotion of history painting in England, setting out the importance of this activity to national greatness and detailing the obstructions that had traditionally plagued it. The imaginary obstruction cited in the title was the assertion that England could never produce creative men of genius because of natural causes, its climate being unfavourable. Barry effectively disposed of this argument, which had been put forward by French and German critics such as Du Bos, Montesquieu, and Winckelmann. The real obstructions, on the other hand, involved England's misguided expenditures on art, its propertied classes determined to amass inferior works gathered from the Continent. In the realm of history painting, the English should become patrons instead of collectors, supporting their native school rather than burying it under imported rubbish. The entire country would benefit, since, according to the author, great art and a healthy society go hand in hand.

Burke received a copy of the book as soon as it was published, replying almost immediately on 15 January 1775 (see *Works*, I, pp.249–50). After thanking Barry and praising his work for its 'many fine thoughts and observations, very well conceived, and very powerfully and elegantly expressed', he chastized him for its inferior organization detailing numerous lapses in 'methodical distribution'. Burke, too, justly complained of the author's attacks on his fellow artists, which, even if merited, marred the content for the general public.

99 AN ACCOUNT OF A SERIES OF PICTURES,
IN THE GREAT ROOM OF THE SOCIETY OF
ARTS, MANUFACTURES, AND COMMERCE,
AT THE ADELPHI

London, William Adlard, Printer to the
Society, 1783. 8 vo, pp.221.
British Library, London

Given their size and the complicated nature of their
programme, the Adelphi murals require exegesis.
Barry not only discusses the paintings at length but
he is again concerned with settling personal grudges.
Horace Walpole's brief summary of its contents is
particularly apt: 'Barry has expounded all in a book
which does not want sense, though full of passion and
self, and vulgarisms, and vanity' (Walpole to William
Mason, 11 May 1783, *Horace Walpole's Correspon-
dence*, 1955, XXIX, p.301). Barry concluded with an
appendix outlining the events leading up to his pro-
posal to undertake this series and his subsequent
negotiations with the Society. In the following year
he published an addendum which elaborates on dis-
putes alluded to in the first edition and addresses
several new ones.

100 A LETTER TO THE RIGHT HONOURABLE
THE PRESIDENT, VICE-PRESIDENTS, AND
THE REST OF THE NOBLEMEN AND
GENTLEMEN, OF THE SOCIETY FOR THE
ENCOURAGEMENT OF ARTS,
MANUFACTURES, AND COMMERCE,
JOHN-STREET, ADELPHI

London, Thomas Davison, 1793. 8 vo, pp.101.
British Library, London

Essentially this book is a continuation of *An Account*
of 1783. It offers descriptions of the small set of prints
after the Adelphi paintings with a long discussion of
the large detail 'Lord Baltimore and the Group of
Legislators' (no.36). Barry concludes with a testy
summary of his involvement with the Society up
until that time.

101 A LETTER TO THE DILETTANTI SOCIETY,
RESPECTING THE OBTENTION OF CERTAIN
MATTERS ESSENTIALLY NECESSARY FOR
THE IMPROVEMENT OF PUBLIC TASTE,
AND FOR ACCOMPLISHING THE ORIGINAL
VIEWS OF THE ROYAL ACADEMY OF GREAT
BRITAIN. THE SECOND EDITION. WITH
AN APPENDIX, RESPECTING THE MATTERS
LATELY AGITATED BETWEEN THE
ACADEMY AND THE PROFESSOR OF
PAINTING

London, J. Walker, 1799. 8 vo, pp.292
British Library, London

The first edition of this book, which helped lead to
Barry's expulsion from the Royal Academy, was
completed in 1797 and published in the following
year. It is addressed to the Society of Dilettanti, an
organization founded over sixty years earlier that was
actively engaged in educating public taste in the arts.
Barry looked to this society to assume those obli-
gations on which in his opinion the Royal Academy
had defaulted. He was particularly damning in his
accusations that the Academy had spent consider-
able funds on pensions for themselves rather than
undertake the nucleus of what would eventually lead
to a national collection (the National Gallery was not
established until 1824).

Although the book is discursive and abusive (he
once even referred to the conduct of the controlling
members of the Royal Academy as 'this most odious
of all jacobinical confederacies, where the mere scum
and offal direct and govern'), it is filled with some of
his most interesting reflections on the relationship of
the artist to society. He was quick to point out those
particular difficulties under which he felt the serious
artist laboured in England. After claiming that 'a
motley, shameless combination, some of whom
passed for my friends' had robbed him in order to
prevent him from carrying on his work, he compared
himself to England's leading politicians:

> In the higher concerns of life such mean
> proceedings are common enough, particularly in
> this country; and such great men as Messrs.
> Burke, Fox, Sheridan, or Pitt, may laugh at the
> malignity or impudent rascality that pursues and
> would impede them, surrounded and kept in
> countenance as they are, by large parties of

powerful confederates, united with them in the same interest. But politics in private life, employed to destroy the credit and interest of a man labouring to serve the public in the arts, where he must necessarily be insulated, and without confederates. – Good God! how horrible!

He then went on to compare conditions in England with those enjoyed by the history painter Jacques Louis David in republican France:

And how much are you, David, to be envied, blest as you are, amongst a public but little acquainted with this bear-garden business, and which, even in its worst times, was habitually exercised in honestly and urbanely meeting the efforts of art with an indulgence, estimation, and reception, so adequate and so generous!

Immediately after his expulsion, Barry published the second edition exhibited here to which he had added a lengthy appendix discussing the events leading up to this affair.

102 'COMMONPLACE BOOK'

Private Collection, Ireland

This collection of handwritten notes, numbering well over four hundred pages, has remained in the possession of Barry's descendants. The pages are not in chronological order, having been bound together at some point after the artist's death. Apparently from an early age Barry was an inveterate note taker as he is said to have copied out Burke's *Enquiry into our Ideas of the Sublime and Beautiful* when still a young man in Cork. The notes gathered in this collection offer an invaluable record of some of those books and issues that interested him. He transcribed, for example, long passages from works dealing with religious questions, Ireland, Latin America, and aspects of antiquity, and he also recorded favourite verses by a number of poets. Of even greater value are those pages containing his own musings, including reflections on some of his pictures.

The manuscript book is opened at a portion of a draft of a letter dated 4 January 1778, bearing the title 'A Letter to Lord Shannon on the political situation of the Roman Catholicks of Great Britain & Ireland; in which the raising of Roman Catholic regiments is

taken into consideration'. Lord Shannon was the head of one of Ireland's influential, ruling families, and these exhibited pages reveal how impassioned was the artist's plea for the improvement of the condition of Roman Catholics, even arguing in the last paragraph of the pages displayed here that a universal massacre of them was preferable to the continuation of existing, demeaning policies.

A letter of 2 December 1780 (Lewis Walpole Library Albums, vol.II) from Joseph Pollock, a Dublin barrister and radical publicist, demonstrates that Barry's concern over his country's destiny was known and appreciated in influential circles in Ireland. Pollock wrote to inform the artist that he had earlier in the year been made a brother of the Order of Saint Patrick, a Dublin political as well as convivial society. As Pollock pointed out, the 'monks' were made up of 'the first minority names in this kingdom', including such distinguished men as Barry Yelverton, its founder, Lord Charlemont and Henry Grattan. The artist's prestige must have indeed been high for him, a Catholic living in England, to have been included in this illustrious group of barristers and members of the Irish parliament. Pollock touches on the issue raised by Barry in his own letter to Lord Shannon over the advisability of Catholics serving in the companies of volunteers that had sprung up as a home guard while many of the regular troops were fighting in America, but of greater interest is his comment that the artist's works were being seen in Ireland: 'I have several times been highly gratified by shewing the few sketches of yours which I brought over. Even in the frozen North I have found uneducated men who could admire them.' By the word 'sketches' Pollock probably meant prints, as he goes on to praise the aquatint 'Philoctetes' and had earlier mentioned 'The Resurrection of Freedom'.

103 'LETTERS FROM JAMES BARRY ESQ. & PAPERS RELATIVE THERETO SINCE OCTOBER 1798'

Royal Society of Arts, London

This is the second of two volumes containing correspondence concerning the paintings in the Great Room. The first book is entitled 'Papers on Barry's Pictures', while this second collection in-

cludes correspondence beginning with the artist's letter to the Society of 1 October 1798, in which he details the additions he made to the murals during the preceding summer. Typically, this first letter also concerns itself with 'scoundrel attacks that have been made upon my reputation', and even remarks that the recent burglary of his house was the work of an organized campaign to frustrate and discredit him.

104 Letter from Barry to David Steuart Erskine, Eleventh Earl of Buchan, 21 December 1804

National Portrait Gallery, London

Lord Buchan had been attempting to raise an annuity on Barry's behalf, and he was eventually successful, although the artist did not live to see even the first payment. Barry begins his letter with an apology for not having replied to Buchan's last two letters. Clearly he had been extremely depressed, but he blames his state of mind on the 'desperate, brutal rage & malignity', fostered by the conspiracy he perceived arrayed against him, rather than on the melancholy disposition traditionally said to affect great men.

The letter also reveals his continuing interest in lithography. Buchan had been the one responsible for securing his participation in Philipp André's *Specimens of Polyautography*, which consisted of two sets of lithographs, containing six prints each, published on 30 April 1803 (see no.74). Philipp represented his brother Johann Anton André, a music publisher in Offenbach who held the patent for lithography in England. After the failure of his publication, he returned to Germany, but the letter reveals that Barry was eager to see further explorations carried out in this new medium.

105 Francis Burroughs, 'A Poetical Epistle to James Barry, Esq'

London, 1805
Victoria and Albert Museum, London

A letter of 6 October 1804 from Francis Burroughs to Barry (Lewis Walpole Library Albums, vol.1) offers a glimpse into the intimate nature of their friendship. Apparently, Burroughs and his wife, who lived in Nottingham Street only a short distance from the artist's home, had quarrelled the previous evening with their depressed guest, as Burroughs writes, 'Both Fanny & myself were much *agitated* last night after you left us, more than I have ever been before.' Earlier in the same letter he complained, 'if, inadvertantly, I have been savage you have been severe. But that can never occur again – I beseech you therefore, with all the ardour of affection which I feel & powerful interest which I take in all that concerns you, to lay aside these chimerical hopes of finding what I fear is not to be found – a fit companion & disinterested female friend!' He pleads with Barry to indulge himself by abandoning his meagre way of life and moving to more hospitable quarters, even if it means selling part of the principal he had invested in the funds. He goes on to pledge himself to a project which will 'raise you above *your hopes* without lessening your dignity.' Surely he had in mind the book *A Poetical Epistle*, which was published in the following year. It is a highly sympathetic, if dull, offering to Barry's genius, but the artist's arresting frontispiece redeems the publication. In this small, vigorous etching, Minerva, the muse of painting, turns from scenes of destruction similar to those found in 'Passive Obedience' (no.92) toward the scene of a harmonious society nourished by the arts. In Barry's interpretation, Minerva does not have the power to protect the arts from society's violence and depravity, but, as Burrough's apologue makes clear, the artist invites the viewer, like a modern Hercules or Adam, to choose between virtue and vice, that is between allowing present abuses to

continue or to help abolish them by patronizing the arts:

> The goddess, high exalts her heav'nly voice
> Reveals the scene, and leaves us TO OUR CHOICE.

106 THE WORKS OF JAMES BARRY, ESQ

ed. by Dr Edward Fryer, 2 vols, London,
T. Cadell and W. Davies, 1809. 4to,
pp.vii + 558 and 670 + [18]
Victoria and Albert Museum, London

Reflecting changing perceptions about the status of artists, publications devoted to their lives and works were appearing with greater frequency in the late eighteenth and early nineteenth centuries. This large two-volume edition is one of the more impressive memorials. The editor was Dr Edward Fryer, a physician, who, though a generation younger than Barry, had been a close friend in his later years. All four of the artist's books are reprinted, and included as well are his lectures and essays that he had intended for publication. Introducing the whole is a biography by Fryer, which, structured around the artist's correspondence, supplies an indispensable factual basis for subsequent studies of Barry's works.

The two volumes are opened at their frontispieces. In volume one appears Picart's engraving after William Evans' drawing of a life mask made shortly before Barry's death. The frontispiece to volume two is an engraving after a design, executed in 1801, for a new medal for the Society of Arts that was to replace the earlier one of 1757 created by Barry's old employer James Stuart. The design shows the busts of Minerva, the protectress of the arts, and of Mercury, who represents manufactures and commerce, encircled by a wreath composed of the shamrock, rose and thistle, signifying the United Kingdom of Great Britain and Ireland. Although this conception was not accepted, the Society instructed John Flaxman, who won the commission, to base his medal upon it.

CHRONOLOGY

1741

11 OCTOBER Born in Cork, Ireland, the eldest child of John and Juliana Reardon Barry. Although his father was said to be a Protestant, he was raised as a Roman Catholic by his mother.

1763

Travelled to Dublin, where he won a premium for his picture 'The Baptism of the King of Cashel by St Patrick' at the exhibition held by the Dublin Society for the Encouragement of Arts, Manufactures, and Commerce.

Edmund Burke, informed of Barry's arrival by Dr Joseph Fenn Sleigh, a mutual friend, began to take an active interest in his career.

1763–4

In Cork Barry had worked with the landscape painter John Butts, and in Dublin he studied under Jacob Ennis at the Dublin Society's drawing school.

1764

Accompanied Richard Burke, Edmund's brother, to London.

1764–5

Worked for James 'Athenian' Stuart, a job secured for him by Edmund Burke.

During this time he apparently lodged at Mr Harris's, a stonecutter, who lived opposite Winflow Street, Oxford Road (this is the address on a letter of October 1765 from James Loach, an old acquaintance from Cork, Lewis Walpole Library Albums, vol.II).

1765–71

During these years, Barry studied on the Continent, his trip financed by Edmund Burke and his kinsman William Burke. He was in Paris from November 1765 until September 1766, arriving in Rome shortly thereafter. Having made only a brief trip to Naples and Herculaneum early in 1769, he left Rome on 22 April 1770, spending the remainder of the year touring northern Italy before returning to London. While in Bologna he painted his picture 'Philoctetes on the Island of Lemnos' for the Accademia Clementina, of which he had been made a member.

1771

SPRING Exhibited his first painting at the Royal Academy, 'The Temptation of Adam', which had been executed in Rome.

Took lodgings at Mrs Grindall's, Orange Street, Leicester Fields (at this time Orange Street ran only from St Martin's Street to Charing Cross Road) but soon moved to Queen Anne Street, Cavendish Square.

1772

SPRING Exhibited three history paintings at the Royal Academy: 'Venus Rising from the Sea', 'Medea Making her Incantation after the Murder of her Children', and 'The Education of Achilles'.

Moved to 29 Suffolk Street, probably in the summer of this year.

2 NOVEMBER Elected an associate member of the Royal Academy.

1773

9 FEBRUARY Elected a Royal Academician.

SPRING Exhibited 'Jupiter and Juno on Mount Ida' and portraits of Christopher Nugent and Giuseppe Baretti at the Royal Academy.

Instrumental in promoting the Royal Academy's plan to decorate St Paul's Cathedral with religious paintings, a plan, however, that was soon squelched by the Archbishop of Canterbury and the Bishop of London.

1774

The Society of Arts, Manufactures, and Commerce approached ten artists, Barry among them, to decorate the Great Room of its new building in the Adelphi. Upon completion, the artists were to receive the profits deriving from an exhibition, but they declined the Society's invitation.

SPRING Exhibited three history paintings at the Royal Academy – 'King Lear and Cordelia', 'Antiochus and Stratonice' and 'Mercury Inventing the Lyre' – and a portrait of Sir John Hort.

JULY Quarrelled bitterly with Edmund Burke over a portrait of Burke commissioned by their mutual friend Dr Brocklesby. Although this disagreement was smoothed over and the portrait completed, within a few years the two men appear no longer to have been on speaking terms.

1775

JANUARY Publication of Barry's first book, *An Inquiry into the Real and Imaginary Obstructions to the Acquisition of the Arts in England.*

SPRING Exhibited at the Royal Academy 'The Death of Adonis' and a drawing of 'The Birth of Pandora'.

1776

This was the last year that he exhibited at the Royal Academy, submitting 'The Death of General Wolfe' and 'Ulysses and a Companion'.

Turned to printmaking, which quickly became an absorbing interest that continued throughout his career.

1777

5 MARCH Valentine Green submitted to the Society of Arts Barry's proposal to decorate without any assistance its Great Room, asking that he be free to choose his own subjects and that the Society cover the costs of canvas, colours, and models. The Society also later agreed to give him the profits deriving from two exhibitions of his work.

1780

In recognition of his support for a more independent Ireland, he was made a member of the Order of St Patrick, a prestigious Dublin patriot's club composed of some of the most prominent liberal barristers and members of the Irish parliament. Earlier he had also been made a member of a club of dissenters that met at St Paul's Coffeehouse, which included such political radicals as Richard Price and Joseph Priestley.

1782

4 MARCH Elected professor of painting to the Royal Academy. His principal duty was to deliver annually six lectures to the Academy's students. Two years went by before he was ready to deliver the first, and several more before he had composed all six.

Henry Laurens, a representative of the United States Congress, invited Barry to travel to America to paint the exploits of George Washington, an invitation which he declined.

1783

28 APRIL Opening of the first exhibition of the series of six paintings in the Great Room of the Society of Arts. Published the book *An Account of a Series of Pictures, in the Great Room of the Society of Arts* to accompany the exhibition.

Met the philosopher William Godwin, with

whom he became close friends. He also became a staunch admirer of the reformist writer Mary Wollstonecraft, whom Godwin married shortly before her death in 1797.

1784

APRIL Opening of the second exhibition of his paintings at the Society of Arts. The profits from both exhibitions totalled only £503.12.0.

1785–6

Moved probably late in 1785 from Suffolk Street, first taking up lodgings in the house of a horse doctor living in 'Charlotte Golden Square' (a letter in the Lewis Walpole Library Albums of 18 November 1785 has Barry's old address crossed out and this new one appended), but soon thereafter he settled at 8 Sherrard Street (now known as Sherwood) off Piccadilly Circus.

1786

Included among those artists approached by John Boydell to participate in the Shakespeare Gallery, for which he eventually completed two pictures, 'King Lear Weeping over the Body of Cordelia' and 'Iachimo Emerging from the Chest in Imogen's Chamber'.

1788

AUGUST Probably in this month Barry moved to 36 Castle Street East, where he was to remain until his death.

1790

13 JANUARY Barry wrote to the Society of Arts that the paintings in its Great Room were entirely finished, since he had just added to 'The Distribution of Premiums' the head of the Prince of Wales, who had finally sat to him.

Although the relationship between Barry and Sir Joshua Reynolds had long been a strained one, Barry took Reynolds' side in a well-publicized dispute at the Royal Academy over the president's support for the election of Joseph Bonomi as an academician.

1792

23 APRIL Announced that the set of prints after the Society of Arts paintings and the revised early etchings were ready for distribution.

Probably in this year he began work on his *Paradise Lost* project.

1793

Published *A Letter to the Society of Arts*, which, for the most part, describes his prints after the Adelphi paintings.

1794

NOVEMBER House robbed of £290 in cash, an act he attributed to the cabal at the Royal Academy who he claimed was attempting to hinder his efforts to move to more suitable quarters where he might better pursue his work.

1798

In the summer he retouched portions of his series of paintings at the Society of Arts.

Published *A Letter to the Dilettanti Society*, his controversial book attacking the Royal Academy.

1799

16 JANUARY Society of Arts voted him a gold medal and two hundred guineas and made him a perpetual member not subject to contributions.

15 APRIL Expelled from the Royal Academy for accusations made against its members in his book *A Letter to the Dilettanti Society* and in his lectures as professor of painting.

Republished *Letter to the Dilettanti Society* with an appendix detailing reasons for expulsion.

1800

Met the Venezuelan General Francisco Miranda, with whom he became a close friend.

1801

Rebuffed in his attempt to add two paintings, one commemorating the Act of Union between Great Britain and Ireland and the other showing Minerva dispensing instruction, to the series of paintings at the Society of Arts. During the summer again retouched the Adelphi pictures.

Met David Steuart Erskine, eleventh Earl of Buchan, who began in the following year his efforts to raise for him an annuity.

1803

JANUARY Fell gravely ill, and after lying in bed for two or three days, he barely had enough strength to summon a hackney coach to take him to the home of his close friend Dr Anthony Carlisle, who helped him recover.

1804

Completed his painting 'The Birth of Pandora', his most ambitious work outside of the Society of Arts series.

18 DECEMBER Assaults on Barry's house by neighbourhood vandals became so severe that they were reported in the newspaper *The Morning Chronicle*.

1805

28 NOVEMBER Sir Robert Peele purchased the annuity raised for Barry, agreeing to pay him £120 quarterly for the remainder of the artist's life.

1806

6 FEBRUARY Fell seriously ill, losing consciousness while eating in Wardour Street.

22 FEBRUARY Died in the home of Joseph Bonomi, who had taken him in during his illness.

13 AND 14 MARCH His body lay in state in the Great Room of the Society of Arts, and after an elaborate funeral procession, he was interred in the crypt of St Paul's Cathedral.

BIBLIOGRAPHY

An extensive bibliography can be found in *The Life and Art of James Barry*. There is, however, an important omission that should be noted. In 1950 the Lewis Walpole Library in Farmington, Connecticut, acquired two albums of family papers that were compiled in the nineteenth century (the property of Robert Cole, they were sold at auction in 1867). Because they remained for a time uncatalogued, these albums escaped notice until now. Disappointingly they contain little of the artist's own writings: a few drafts of letters that often have survived elsewhere and a small, fragmentary collection of miscellaneous notes. They do contain, however, a number of revealing supporting documents. There are a few receipts and contracts which, for the most part, revolve around his affairs concerning his house in Castle Street, and of even greater interest is the detailed inventory of his effects made on 28 February 1806, just six days after his death, making it possible for the first time to reconstruct the contents of his house room by room. The albums also contain a third annotated copy of the Christie's sales catalogues of 10 and 11 April 1807 (the other two are in Christie's own library and the Victoria and Albert Museum) and a previously unrecorded 1833 edition of the pamphlet *A Description of the Series of Pictures painted by James Barry . . . Preserved in the Great Room of the Society for the Encouragement of Arts, etc*. But as far as Barry's career is concerned, the most important items are several letters written to him, most of which are cited in this catalogue. The main body of the material, however, revolves around the artist's family, with information about his brothers Redmond and Patrick and his sister Mary Anne Bulkley, in particular Mrs Bulkley's handling of the estate after her brother's death. The correspondence reveals that the James Barry who became the first female officer in the British army was indeed Mrs Bulkley's daughter Margaret as had been previously suspected (an article is now in preparation setting forth this evidence).

LIST OF FIGURE ILLUSTRATIONS

LIST OF LENDERS

An Taisce, National Trust for Ireland 87
Ashmolean Museum 10, 13, 25, 30, 33, 36–40, 42, 52, 55, 68, 71, 75, 88, 90, 91, 95

Bologna, Pinacoteca Nazionale 2
British Library 99–101
British Museum 12, 21, 27, 29, 31, 32, 35, 43, 49–51, 56–8, 61, 65, 66, 69, 72, 77, 84, 89, 97

Crawford Municipal Art Gallery, Cork 20, 46

Lord Egremont 6

Hugh Lane Municipal Gallery of Modern Art, Dublin 3
Hunterian Art Gallery, University of Glasgow 23, 62

City of Manchester Art Galleries 85
John Murray 19

National Gallery of Ireland, Dublin 1, 7, 14, 94
National Portrait Gallery, London 15, 44, 104
Nelson Gallery–Atkins Museum, Kansas City 54
New Brunswick Museum 8
Duke of Northumberland 45

Kathleen, Countess Plunkett 5
Princeton University Art Museum 92
Private Collections 9, 11, 17, 41, 83, 102

Rhode Island School of Design 64
Royal Academy of Arts 53
Royal Dublin Society 48
Royal Society of Arts 28 A–F (photographs) 76, 78, 96, 103

Brian Sewell 79
Sheffield City Art Galleries 86

Tate Gallery 47
Trinity College, Dublin 16

Victoria and Albert Museum, London 22, 59, 60, 67, 74, 80, 81, 93, 98, 105, 106
Victoria Art Gallery, Bath 18, 66

Yale Center for British Art, New Haven 4, 24, 26, 34, 63, 70, 73, 82